American WILDERNESS

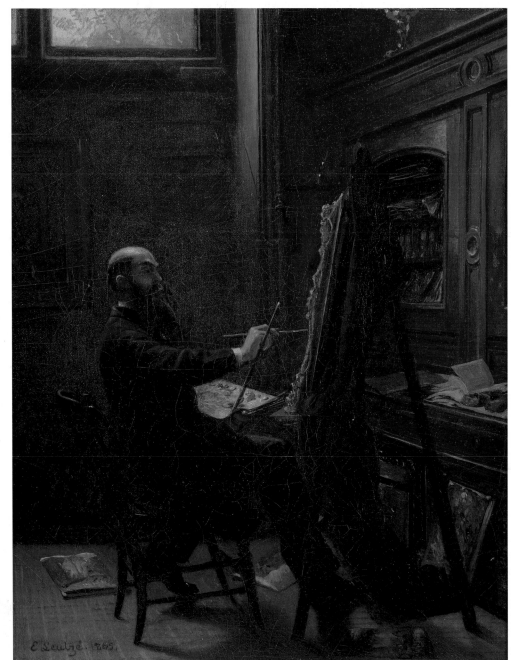

**Frontispiece.
Worthington
Whittredge in his
Tenth St. Studio, 1865**

Emanuel Leutze
(1816–1868)

Oil on Canvas, 15 × 12 in.
(38.1 × 30.5 cm.)

Reynolda House,
Museum of American Art

Winston-Salem,
North Carolina

American WILDERNESS

The Story of the Hudson River School of Painting

Barbara Babcock Millhouse

BLACK · DOME

Published by
Black Dome Press Corp.
1011 Route 296, Hensonville, New York 12439
www.blackdomepress.com
Tel: (518) 734–6357

First Edition Paperback 2007
Copyright © 2007 by Barbara Babcock Millhouse
Copyright © 1978 by Barbara Babcock Lassiter
A previous edition of this book was published in 1978, by Doubleday & Company, Inc.,
as *American Wilderness: The Hudson River School of Painting.*

ISBN-13: 978-1-883789-57-2
ISBN-10: 1-883789-57-5
Library of Congress Cataloging-in-Publication Data:
Lassiter, Barbara Babcock.
 American Wilderness: The Story of the Hudson River School of Painting/Barbara Babcock Millhouse;
foreword by Kevin Avery. — 1st ed. paperback.
 p. cm.
 Originally published: Garden City, N.Y. : Doubleday, 1978.
 Includes bibliographical references and index.
 ISBN-13: 978-1-883789-57-2
 ISBN-10: 1-883789-57-5
 1. Hudson River school of landscape painting. 2. Landscape painting, American—19th century. I. Title.

ND1351.5.L37 2007
758'.1730973—dc22

2007023187

Front Cover: *Sierra Nevada,* c 1871–1873, Albert Bierstadt (1830-1902), oil on canvas; 38 ½ × 56 ½ in. (97.8 × 143.5 cm.) Original purchase fund from the Mary Reynolds Babcock Foundation, Z. Smith Reynolds Foundation, Arca Foundation, and Anne Cannon Forsyth. Reynolda House, Museum of American Art, Winston-Salem, North Carolina.

Design: Toelke Associates

Printed in the USA

10 9 8 7 6 5 4 3 2 1

DEDICATION

For the Reynolda House docents on the
fortieth anniversary of the public opening
of the collection of American art.

TABLE OF

DEDICATION V

FOREWORD BY KEVIN AVERY VIII

INTRODUCTION XI

I. THOMAS COLE'S BOYHOOD 1

II. THOMAS COLE DISCOVERED 6

III. A NEW ACADEMY 13

IV. CATSKILLS AND SERMONS 17

V. COLE'S EUROPEAN TOUR 25

VI. A NEW PATRON 31

VII. DURAND TURNS TO LANDSCAPE 47

VIII. VOYAGE OF LIFE 54

IX. THE ART-UNION 65

X. DÜSSELDORF 74

CONTENTS

XI. SOUTH AMERICAN ADVENTURE 85

XII. CHURCH'S FAME SPREADS 98

XIII. BIERSTADT DISCOVERS THE ROCKIES 108

XIV. THE CIVIL WAR BEGINS 116

XV. CROSSING THE CONTINENT 129

XVI. THE WAR YEARS 136

XVII. POSTWAR EXUBERANCE 142

XVIII. THE RAILROAD WEST 160

XIX. THE FALL FROM FAVOR 167

LIST OF ILLUSTRATIONS 182

SELECTED BIBLIOGRAPHY 186

ABOUT THE AUTHOR 189

INDEX 190

FOREWORD

Books devoted to the Hudson River School today are legion, but none that I know quite performs the service that this one does, and so entertainingly. I first read *American Wilderness* in 1985 as I was reviewing the literature of the school to write an essay on the fall and revival of its reputation after its heyday in the Civil War era. Naturally, most of that literature is art historical: the earliest of it is critical in the dismissive and condescending way of connoisseurs in the childhood of America's Cosmopolitanism; later authors are tentatively, nostalgically, sometimes chest-beatingly admiring in a patriotic way during the World War II era; and since the 1960s the nineteenth-century American landscape phenomenon has been championed and interpreted in myriad ways reflecting its full restoration to our cultural inheritance. But if one could have scarcely complained that the art had been neglected, neither could one find an encompassing portrait of the society and the environment behind the products of two generations of the first true fraternity of American painters.

Still, I suspect there were few students of the art, including me, who felt the lack of a book like *American Wilderness*. That is, until I read the original 1978 publication. Admittedly, I perused its opening pages with some impatience, but then with mounting engagement, sympathy and appreciation. One follows the lonely Horatio Alger quest of Thomas Cole, the spark and overarching exemplar of the fraternity, as it flows into the nascent cultural community of New York City on the verge of its commercial rise; informs the founding of the town's first lasting art society; attracts a kindred spirit to the pleasures and rewards of landscape painting amid a largely wilderness and rural nation; then leaves that spirit (as well as a pupil and artistic descendant) to guide—as leader of the art society—a much larger new generation of landscape painters, whose professional and personal ties grow into fast friendships and healthy rivalries and whose work dominates the American art market and art discussion through the Civil War years. In a funny way, the story evokes the gathering complexity and essential simplicity of the river that gave the school its name, trickling down from little Lake Tear of the Clouds in the Adirondacks and other Upstate

tributaries to merge and widen and accelerate southward into the grand watercourse that defines the Empire City at its mouth.

To tell the "story" of the Hudson River School that's been crying to be told, Barbara Millhouse has relied largely on the early biographical and documentary sources of the participants themselves or their contemporary advocates. Unquestionably, many of the sources betray their blinkered advocacy in the fabulous-sounding anecdotes and embroidered rhetoric that sometimes filter right through the author's paraphrase. But if those are the book's hazards and faults as History, they are also a big measure of its charm as a wonderful tale which actually happened, of people who actually lived. Moreover, not only does the story's realness grow with the growing sophistication of its sources through the nineteenth century, so does the author's authority as marshal of many distant figures and facts. Besides, as the author told me long ago of the original publication, "I wrote it for high schoolers." That was an admirable premise, but in fact the book should be read by anyone interested in its subject—as well a few who suppose they are not. For all, it relates the social dimension of the New York landscape painting phenomenon as no other book that I know has yet done so purposefully. Novices will be borne along by a well-paced narrative of artistic enterprise and community; specialists will be gratified by the encapsulation between two covers of an aesthetic movement they have theretofore conceptualized from a host of artist monographs and exhibition catalogues.

The updated Black Dome edition, moreover, greatly improves on the original publication not only by expansion, revision, and correction of the text but, above all, by the inclusion of many more illustrations. These compensate, in great measure, for a function this book could not serve if it was to fulfill its narrative mission as succinctly and as attractively as it does: it neither analyses nor evaluates the paintings at much length, less does it relate the style and iconography of the paintings to one another in any way commensurate with the social ties that it reveals and celebrates. For those the reader must turn to the art literature. Nonetheless, the increased images in the current volume better stimulate wonder and curiosity about the art made by the individuals it describes. Of course, the re-reading of this book provokes in me the same question today that it did as I perused

the original publication a generation ago: why is there still no ideal history of the Hudson River School that would accommodate its historical and art historical dimension, both? That would be a far bigger, perhaps multivolume, undertaking. The delight of reading *American Wilderness* reminds us how much it is missed.

Kevin J. Avery

Associate Curator

Department of American

Paintings and Sculpture

The Metropolitan Museum of Art

INTRODUCTION

The story of our nation's earliest landscape painters and their remarkable rise to fame began in 1825, when Thomas Cole, a young artist, took a steamboat up the Hudson River to depict America's untamed nature. His paintings captured the rugged terrain and clear light of upstate New York so convincingly that leaders of New York City's tiny art community were astounded. Cole had achieved what they had long hoped for—that artists would find this country's wilderness a worthy subject for their art. By the time of his death in 1848, Cole had inspired enough followers to become known as the founder of this country's first school of landscape painting, which over three decades later was referred to as the Hudson River School.

When the movement began, New York was a thriving seaport at the southern tip of Manhattan Island. Since there were no museums or galleries where works of living artists could be exhibited, artists and businessmen banded together to start their own art organizations. In the following years the National Academy of Design, the American Art-Union, the Century Association, and the Tenth Street Studio Building grew into establishments that provided the support that fostered the rise and longevity of the Hudson River School. At the same time the city was experiencing tremendous growth in population and prosperity. By the late 1860s enthusiasm for native landscape painting rose to such heights that the largest paintings by Albert Bierstadt were bringing in as much as $25,000, the highest price that had ever been paid for an American work of art.

As word of the demand for landscape painting spread, an increasing number of artists were drawn to New York City, the point of departure to the Hudson River Valley and the Catskill Mountains. They did not restrict themselves to painting only one region, however, but traveled farther north to the Adirondacks, east to the Berkshires and White Mountains, and eventually as far south as the Andes and as far west as the Sierra Nevada. They intermittently sought fresh subject matter in Europe, North Africa, and the Middle East, but they were recognized foremost for generating excitement and pride in the natural beauty of the New World. No matter how far from the Hudson River they roamed, they returned in winter to their studios in New York City, where they found an increasingly receptive audience.

Although the National Academy of Design offered its members limited instruction in drawing, the first generation of landscape painters relied mostly on direct observation of nature. Even when they were fortunate enough to gain access to European academies, they professed that their true teacher was nature itself. Nature meant more than untouched forests, lakes, and mountains; the vastness and pristine beauty of the American wilderness was believed to be a sign of God's blessing on this nation. Consequently, artists tried to capture its precise character; distortion implied a lack of respect for God's works. As realistic as their completed paintings seem, they are in fact encoded with a symbolic language imparting the period's lament over the passing of time and the brevity of human life.

The Hudson River School lasted for over fifty years, but its duration was contingent on the discovery of new scenery. By the late 1870s railroads had opened the once-inaccessible regions of the Far West, and the public no longer had to depend on pictures to satisfy their curiosity about remote regions. Moreover, Americans were increasingly traveling to Europe where they became infatuated with the informal, evocative scenes of the French Barbizon School. Finding fewer buyers, many of the older generation of American landscape painters retired, moved to the country, and eventually died. For nearly one hundred years their paintings vanished from public view.

A burst of new interest was beginning to surface at the time Doubleday & Company invited me to submit a proposal for the first edition of this book, published in 1978 under the title *American Wilderness: The Hudson River School of Painting*. My enthusiasm for these paintings began in 1966, when the leading mid-nineteenth-century artist, Frederic E. Church, became the focus of a groundbreaking exhibition and monograph. Although this exhibition eventually led to an increase in scholarly and critical attention to other members of the school, only a handful of publications on the subject was available when I began writing.

The overriding challenge, considering the limited published material, was to uncover enough facts about the artists' lives to create a coherent narrative spanning two generations. This required not so much introducing new material as assembling existing material into a readable story that could be enjoyed by the general public. To accomplish this, I relied on the scholarly publications that existed before 1976, when the original manuscript was submitted.

I would like to express my gratitude to those scholars, whose research provided the groundwork for this publication. Many of the stories and quotations in the first chapters were drawn from Louis Legrand Noble's *The Life and Works of Thomas Cole*, edited by Elliot S. Vesell. Thanks to that book's rich offerings, it was possible to characterize a complex man who expressed his feelings in diaries, letters, and poems. For information on Cole's colleague and co-founder of the movement, Asher B. Durand, I looked to John Durand's biography of his father, as well as to the 1971 exhibition catalogue by David B. Lawall. John I. H. Baur made an important contribution to our knowledge of the second generation of landscape painters when he edited Worthington Whittredge's autobiography for the *Brooklyn Museum Journal*. Frederic E. Church received the most intensive study, which was published in 1966 as an exhibition catalog and monograph by David C. Huntington. These, as well as his letters and diaries, supplied basic information on Church, which has now been updated and supplemented with more recent findings. The role of Church's colleague, Albert Bierstadt, was illuminated by Gordon Hendrix's biography, from which were culled stories related to his early travel adventures.

Over the past three decades the proliferation of scholarly publications on artists associated with the Hudson River School has enriched this revised edition. Consequently, it provides a fuller account of artists about whom there was scant information available earlier. The roles of Jasper F. Cropsey, Martin J. Heade, Sanford R. Gifford, and John F. Kensett have been amplified herein and knitted into the fabric of the original story. For this new data I am indebted to the scholars acknowledged individually in the bibliography.

To augment biographical material, I felt that I needed to gain firsthand knowledge of the artists' favorite haunts. I hiked to the foot of Kaaterskill Falls and climbed up to the projecting rock from where Thomas Cole and poet-editor William Cullen Bryant were thought to have gazed out over the clove—a scene immortalized in Durand's *Kindred Spirits*. I explored the bluff where the popular resort hotel, the Catskill Mountain House, once stood, and spent hours roaming through Church's house, Olana, before it became officially an historic site. A four-day pack trip from Aspen to Crested Butte, Colorado, convinced me that Bierstadt's lighting effects had not been lifted from paintings of the Alps, as some scholars suggested, but were true to the character of the Rocky Mountains.

This new edition has benefited from additional trips, especially to Ecuador, the country that inspired Frederic Church's finest paintings. I have followed Church's route through northern Ecuador, albeit by automobile, not by muleback, which has helped me describe accurately the topography from Colombia south along the Chota Valley to the towns of Ibarra, Otavalo, and the Ecuadorian capital, Quito. As a result I was able to identify definitively the snow-capped peak on the left of *The Andes of Ecuador* as Cotacachi, which Church had several opportunities to sketch heading south along this route on his 1853 trip.

In this edition the language has been clarified, the chronology tightened, and interpretation of the paintings expanded. Whenever possible, I tried to link events to issues of national and cultural significance. In addition, a larger number of illustrations has been included to better demonstrate the range of the artists' work. Readers will also benefit from an index and a selected bibliography.

I would especially like to express my gratitude to Kevin Avery, associate curator of American painting and sculpture at the Metropolitan Museum of Art, for reading this manuscript and offering suggestions for modifications and additions, which led to a more nuanced and precise text. I would also like to thank him for his willingness to write the foreword.

Sincere thanks also go to Dr. Elliot S. Vesell, whose research on Thomas Cole was so important to the writing of the early chapters of this book, for graciously agreeing to read the manuscript and provide commentary for the back cover.

I would like to extend my gratitude to Jane Kelly, who spent countless hours editing the manuscript. Her knowledge and patience have been invaluable. In addition, both she and my assistant, Sherold Hollingsworth, deserve recognition for their assistance in obtaining permissions and organizing the illustrations.

Although the first edition has long been out of print, letters of appreciation continue to be sent, providing another incentive to move forward with this edition. In this regard I want to offer my special thanks to David Barnes, who expressed such enthusiasm after reading the first edition that he became a major inspiration for taking on this second edition. My hope is that this more extensive account of the lives and work of the pioneers of American landscape painting will continue to stimulate interest in and enjoyment of this fascinating period of American art history.

I

THOMAS COLE'S BOYHOOD

n the village of Bolton-
le-Moor, Lancashire, Eng-
land, young Thomas Cole whiled
away the long evenings by reading
aloud travelers' accounts of America.
His parents and sisters liked to listen sitting around a glowing fire in their
snug cottage. Annie and Mary chose the bench in the chimney corner;
Sarah, the youngest, rested her head on her mother's lap. James Cole sank
back into the cushion of his chair. His eyelids flickered, not with coming
sleep, but with daydreams touched off by vivid descriptions of the broad
rivers, wild mountains, and rich woodlands of America.

The quarrystone cottage was comfortable enough. Muslin curtains
hung at the windows, crockery was arranged neatly on the mantelpiece,
and a tall mahogany clock stood guard by the door. Several objects in the
room suggested a family of intellect and talent. Four or five books were
stacked on a shelf. Paper, ink, and quill were ready for use on the desk, and

sheets of music were tucked under Thomas's flute. Against one wall stood a quaint old piano with a worn ivory keyboard.

Like others living in Lancashire, the center of the English textile industry, James Cole manufactured woolen goods. He longed to make a fortune, but spent more time dreaming up new ideas than working out the details of older ones. Wanting his only son to have the advantage of a formal education, he managed to scrape together enough money to send him to a boarding school forty miles away. Born on February 1, 1801, Thomas was only nine years old at the time. He was a serious boy, but so afraid of the stern schoolmaster that he was unable to concentrate on his studies. After falling ill from harsh treatment and poor food, he was finally allowed to return home.

As soon as he recovered his strength, he was apprenticed to a calico printer and spent long hours carving designs on wood blocks, which were rolled with colored inks and pressed onto cloth to print the patterns. Thomas liked the job, but he disliked the uncouth boys with whom he worked. He felt that he was destined for a better life.

Many changes were taking place in the textile industry during these years. Mills in the district were converting to steam power. Men, women, and children, who once had spun wool and woven cloth in their cottages, now worked at machines in large, noisy factories. They were beginning to rebel against low wages, long hours, and dangerous conditions. At the same time, faster-growing rivals were swallowing up James Cole's woolen trade. The thought of leaving this troubled region of England for the vast new frontier of America grew daily more appealing to the Cole family.

In the spring of 1818, James and Mary Cole, their son Thomas, and their daughters set sail from Liverpool to Philadelphia, bringing with them enough cloth to establish a small dry-goods shop. To supplement the family income, Thomas continued engraving, but instead of going to a printing shop each day, he was allowed, for lower wages, to work in the rear room of the family's store.

After a time the Coles realized that the store was not as profitable as they had hoped. Hearing reports of better opportunities to the west, they decided to move to Steubenville, on the banks of the Ohio River. Thomas stayed behind in Philadelphia to continue work-

ing. After a few months he received a letter from his parents saying that they needed him to engrave wallpaper designs for their new venture. Having no money for stagecoach fare, he had to cross the state of Pennsylvania on foot. Accompanied by a friend, he set out on the dusty roads that wound through the foothills and over the Allegheny Mountains to Ohio. Each morning the two boys started traveling before daybreak. As they passed roadside cottages, they pressed their faces to the oilpaper windows to wish startled sleepers a jolly good morning. By midday they walked along singing songs and playing the flute. At night they slept at an inn or farmhouse.

They came to the Ohio River at Pittsburgh, where they caught a ride on a barge going downriver to Steubenville. The Ohio was like a wide highway rolling through the wilderness. The forests were thick with deer, rabbits, wild hogs, and turkeys. Twenty years earlier the first settlers of Steubenville had had to bar the doors against wolves and panthers. Now the town boasted a pottery, a mill, and some small shops. A brick courthouse dominated rows of wooden houses built along an unpaved street. There, in the center of town, Thomas found his family happily lodged in their new home.

Thomas joined his father in the wallpaper factory. He carved the wood blocks for printing wallpaper and painted decorations on muslin window shades. People in Steubenville admired his designs as well as the music that was often heard coming from the Cole house. Among the prized possessions the family had brought with them from England was their piano, the only one in town. Sometimes neighbors gathered outside the house to listen to Annie and Sarah play duets accompanied by Thomas on his flute. He also spent many happy hours tramping through the wilderness on the outskirts of town.

After a few years, the Coles again realized that their enterprise was not going to make the fortune they had anticipated. Their wallpaper was much too fine for most people to afford, and customers were few. Thomas began to look for other ways to help support his family. One day he met a portrait painter named John Stein, who was newly arrived in town. Mr. and Mrs. Bazaleel Wells, whose woolen mills were turning out the best broadcloth west of the Alleghenies, had commissioned him to paint their portraits. Neglecting his own work, Thomas went every day to watch Stein grind colored minerals into

powder, mix them with oil, and brush the paint on the canvas. Like many self-taught artists, Stein portrayed his subjects in a flat, linear manner. Thomas, nevertheless, was dazzled by the newcomer's painting skills.

Stein owned the first book about famous artists that Thomas had ever seen. He was so enthralled by the glory that could be achieved as a great artist, he could hardly put it down. He began to teach himself how to use a brush and control the application of the paint. Making his own brushes and borrowing some paints from a chairmaker, he practiced painting portraits of his family members. When, at last, he succeeded in catching their likenesses, he felt ready to seek commissions. He packed his flute, pigments, brushes, and a heavy grindstone in a bag slung over his shoulder and set out on foot to ply his new trade in Ohio.

Traveling from town to town, he painted a saddler, an officer, a shopkeeper, and a sea captain—and for his labors he was rewarded with a saddle (although he had no horse), a silver watch, a keychain, and a pair of shoes. He painted portraits for weeks before he received even one dollar.

The shy and sensitive young man did not particularly like his new career. Terrified of his sitters, he painted freely only if they happened to fall asleep. Moreover, he was unable to make any money and finally had to return home. His parents were having their troubles, too. Hoping to find greater opportunity in a larger town, they had decided to move to Pittsburgh. Once again Cole stayed behind to continue painting, but when some vandals broke into his room, tore up his canvases, and destroyed his brushes and paints, his efforts came to an end.

The discouraged young man went into the wilderness to ponder his future. Was he meant to be an artist? Could he succeed? He balanced a pebble on the top of an upright stick; then he stepped back with another pebble held in his fingers. "If I knock it off," he told himself, "I will pursue my career as an artist to the bitter end. If not, I will give it up." He aimed carefully and tossed the pebble. It hit the mark, knocking the other stone off the stick.

Practicing art in Steubenville had not proved profitable, so Cole retraced his earlier journey, stopping in Pittsburgh to help with his family's latest enterprise—manufacturing

carpets. In his spare moments, Cole roamed the forests outside of Pittsburgh. He discovered that the shapes and movement of trees, streams, and clouds often reflected his own emotions. He began to make sketches in the woods to discover whether he could transmit the feelings that nature aroused in him to his drawings.

Concluding that the East would be more hospitable to a painting career, he walked all the way from Pittsburgh to Philadelphia, carrying with him a small trunk and six dollars. As meager protection from the cold November wind, he clutched a tablecloth around his shoulders—the only wrap his mother had to give him. In Philadelphia he found lodging in the upper room of a house owned by a poor family. There was neither a bed nor a fireplace. His tablecloth served as his overcoat by day and his blanket by night.

The commissions offered to Cole by Philadelphia businessmen were far removed from the kind of art that he had envisioned bringing him fame. They wanted comic scenes for oyster houses and drinking scenes for bars. Cole once spent days painting the portrait of a corpse for a bereaved family. He took an opportunity, however, to study the works of artists at the Pennsylvania Academy of the Fine Arts, which had been established in 1805. Among the academy's collection of plaster casts of antique statues and copies of European masters, Cole was struck by some small landscapes in muted tones signed by Thomas Doughty, an American artist who had listed himself as a landscape painter in the city directory as early as 1820. Since no market existed in this country for any type of painting other than portraiture, Doughty was taking a bold step in declaring himself a full-time landscape painter. His friendship with the distinguished portrait painter and fellow Philadelphian, Thomas Sully, must have helped his career to some degree, since in 1824 he was elected an academician at the Pennsylvania Academy of the Fine Arts.

When Cole saw Doughty's work, he realized that he was seeing for the first time paintings that conveyed a glimmer of the distinctive character of American landscape. Confident that he could do better, Cole decided at that moment to devote himself to depicting the magnificent scenery of his adopted country.

II

THOMAS COLE DISCOVERED

Excited about his new direction, Thomas Cole left Philadelphia to rejoin his family in New York City, where they had settled after another business failure. Once a small town perched on the tip of Manhattan Island, New York had been growing rapidly for a number of years. Lower Manhattan was crowded with three- and four-story buildings topped here and there by domes, cupolas, and steeples. Grand houses looked out over the harbor from the Battery at the south end of the island.

Broadway, the principal street, was lined with stores of all kinds—bookstores, print shops, milliners, silversmiths, and coffee houses. Large signs on taverns and hotels welcomed visitors. Hackneys and private carriages rattled down the street among pushcarts, oyster wagons, wheelbarrows, and scavenging pigs. At night oil street lamps sent a spotty glow onto the brick sidewalks. About a mile and a half north, the bustle subsided and

the pavement tapered off into a dirt road that ran through Greenwich Village to the pastures, orchards, and woods beyond.

At the time of Cole's arrival, public excitement was building over the imminent completion of the Erie Canal. It had taken eight years of digging across the state of New York from Buffalo on Lake Erie to the Hudson River just north of Albany. In October 1825, Governor De Witt Clinton took the first voyage through the canal and down the Hudson River to New York City. Throughout the eight-day journey on the canal boat *Seneca Chief,* he was greeted from the shore by cheering crowds, ringing bells, and thundering cannons. Frigates and barges flying colorful banners awaited his arrival in New York harbor. The governor celebrated the completion of his hundred-mile voyage by pouring a keg of water from Lake Erie into the Atlantic Ocean. The two bodies of water were now joined. After the ceremony, throngs of people paraded into the streets, and bright rockets tore through the night sky. Now that farm produce from the Midwest could be sent safely and cheaply on the canal to New York City, the city's prosperity was assured.

From the first time Cole had glanced up the Hudson River to the distant cliffs of the Palisades, he had hoped to travel further upriver to explore the very heart of the Catskill Mountains. At length a New York merchant, George W. Bruen, who already owned several of Cole's paintings, encouraged him to try his skill on the natural beauty of New York State. He offered to pay his steamboat fare upriver, and Cole happily set off for this wilderness region. He spent weeks in the Catskills exploring and sketching. He struggled to record in his sketchbook every detail of the wilderness—the woodland debris, the strewn rocks, the knotted underbrush. Organizing the tangled growth, however, into a pleasing composition was not an easy task. It challenged the artist to the utmost. Laden with sketchbooks, Cole returned to his attic room on Greenwich Street in New York. Despite tight quarters and dim light, he managed to work up his sketches into three finished oil paintings. Taking them to a bookshop on Broadway, he persuaded the owner, William A. Colman, to place them in his window, where at first they drew little attention.

One day Colonel John Trumbull, the president of the American Academy of the Fine Arts, passed the shop. The old Revolutionary War veteran was at that time the most

influential man in New York art circles. Congress had commissioned him to paint historic scenes from the Revolution for the rotunda of the new Capitol in Washington, but these grand subjects had not attracted much notice. History painting still evoked European artistic traditions, even if the subject were American. When Trumbull saw Cole's wilderness scenes, he halted and peered intently through the glass. Here, he thought, was the answer to the call for a purely American subject and style. He did not need to read the titles to recognize the wild and lonely beauty of the Catskill Mountains. The American wilderness had inspired this young painter to compose landscapes unlike any Trumbull had ever seen and to imbue them with a majesty that awakened a new emotion in the old man.

Colonel Trumbull entered the shop and purchased the painting entitled *Kaaterskill Falls* (Fig. 1, second version). Carrying his carefully wrapped discovery under his arm, he rushed into the bitter November air and hurried to the painting rooms of William Dunlap, artist and art critic for the New York *Mirror*. Trumbull pulled Dunlap over to the window, unwrapped the painting, and held it at arm's length under the light. Dunlap squinted his one good eye. He saw a scene viewed from inside a cave behind a waterfall. Broken branches were caught among the rocks in midstream. Thick and twisted bushes edged the banks. Then, the plunging water disappeared over a ledge. He had never seen such a daring view.

While the two older artists were examining the painting, Asher B. Durand, a young engraver, dropped by. He was surprised to see the crotchety old colonel in such good spirits. Durand took a look at the landscape and agreed that he had never seen a painting that captured the wilderness of the Catskills so vividly. Before Durand had had a chance to remove his overcoat, Trumbull was leading him and Dunlap down Broadway to see the two paintings remaining in the shop window. Dunlap bought *Lake with Dead Trees (Catskill)* (Fig. 2), and Durand bought *A View of Fort Putnam*. Both agreed that Trumbull had discovered a genius.

Asher B. Durand also owed his recognition to the arrogant but kindhearted colonel. Born on August 21, 1796, Durand had spent his boyhood on a farm in Jefferson Village (now Maplewood), New Jersey. His French Huguenot and Dutch ancestors had

Fig. 1. Kaaterskill Falls, 1826

Thomas Cole (1801–1848)

Oil on Canvas, 25 × 35 ¾ in.

Wadsworth Atheneum Museum of Art, Hartford, Ct.

Bequest of Daniel Wadsworth

1848.15

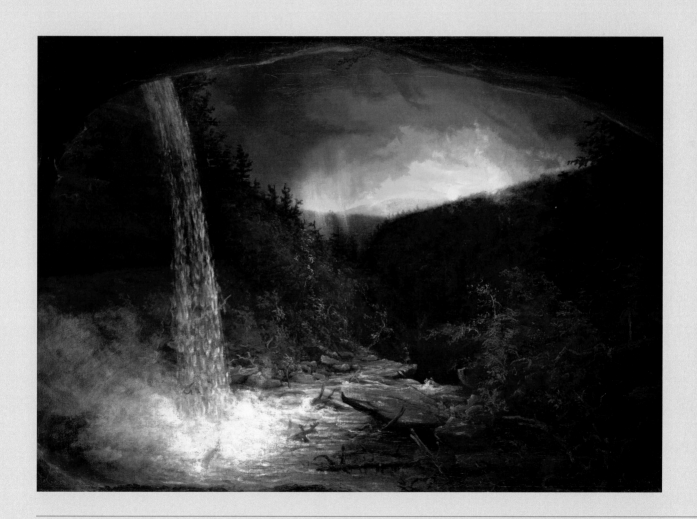

Fig. 2. Lake with Dead Trees (Catskill), 1825

Thomas Cole (1801–1848)

Oil on Canvas, 27 × 33 3/4 in. (68.6 x 85.8 cm)

Gift of Charles F. Olney, 1904

Allen Memorial Art Museum, Oberlin College, Ohio

AMAM 1904.1183

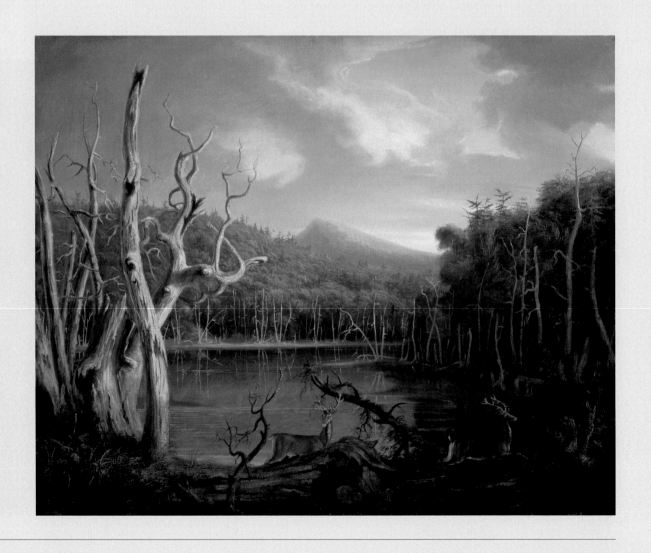

arrived in this country as early as the seventeenth century. His older brothers tended the farm, while he helped his father engrave monograms on the backs of watches. He worked on the engravings from an early age and attended school only a few months each year when an itinerant teacher came to the village.

At the age of fifteen, he left home to apply for an apprenticeship with an engraver in New York City, only to find that he would have to pay a thousand-dollar fee, which was too high for his father to afford. Persisting in his search for work, he was finally accepted on better terms by Peter Maverick, a prominent writing engraver who worked just outside of Newark, New Jersey. Durand became so skilled that, after five years, Maverick made him a full partner in his firm. In October of 1817, Maverick sent Durand to New York to open an office on the corner of Pine and Broadway.

About that time, Colonel Trumbull was engaged in selling advance orders for engravings of his oil painting, *Declaration of Independence.* He had planned to hire a leading English engraver to do the work, but had not received enough orders to pay his fee. Forced to look for the best engraver in his own country, Trumbull soon noticed the fine quality of Durand's work and offered the commission to him for three thousand dollars. Durand accepted and spent the next three years on the large and complicated engraving. It was not an easy task to produce the effect of an oil painting with black lines and dots, nor to engrave the faces of the forty-seven signers so that each would be recognizable, but the outcome was so successful that Durand became known as the finest engraver in America.

Durand's reputation was made just two years before Cole's arrival in New York City. Now the handsome, twenty-nine-year-old engraver with thick brown hair and blue eyes was waiting in the bookshop with two gray-haired artists for the name and address of the newcomer they all wished to meet. He offered to walk to Greenwich Street and invite Thomas Cole to Trumbull's painting rooms.

Durand returned accompanied by a slight young man with pale skin and red cheeks. His clothes were threadbare, his coat barely adequate for the weather. He stood before the two leaders of the New York art world like a schoolboy in the presence of the principal.

He did not know why these men asked so many questions. His hands moved nervously, and his voice faltered at times. Finally, the gruff colonel brought out Cole's painting, smiled, and said, "You surprise me, at your age, to paint like this. You have already done what I, with all my years and experience, am yet unable to do." Cole had often imagined that he would hear such praise some day, but when he did, he blushed with embarrassment.

Only a handful of men in the country cared about artists, and Trumbull knew them all. He quickly scribbled off letters urging them to see Cole's work on their next trip to New York. His nephew-in-law, Daniel Wadsworth of Hartford, Connecticut, liked *Kaaterskill Falls* so much that he commissioned Cole to paint a copy of it for him. Philip Hone, the diarist and one-term mayor of New York, offered fifty dollars for *Lake with Dead Trees (Catskill)*, twice what Dunlap had paid for it. Dunlap wrote glowing reviews of Cole's paintings for the *Mirror* and other newspapers of the day. From then on, Cole's fame spread rapidly, and this nation's first art movement, which would become known as the Hudson River School, was launched.

III

A NEW ACADEMY

These were promising beginnings, but the degree of interest in art in New York City in 1825 could not begin to approach the degree of interest in the great cities of Europe. In New York there were no art galleries or museums devoted to advancing American art, nor were there any formal schools where young artists could acquire training. There was only the American Academy of the Fine Arts—a poorly managed institution ruled by the whim of Colonel Trumbull. Organized in 1804, the American Academy had struggled from lack of funds during its early years. In 1816 it reopened in renovated galleries in the old Alms House on Broadway and Chambers Street near City Hall. Some paintings by American masters Benjamin West and Gilbert Stuart had been borrowed for that occasion, but the academy's permanent collection consisted mostly of copies of European paintings and

plaster casts of Greek and Roman statues. The board of trustees was composed of statesmen, bankers, merchants, and physicians who ran the institution according to eighteenth-century classical tradition. After De Witt Clinton, later the governor of New York, resigned as president of the American Academy, the board turned the institution over to John Trumbull. Members believed that, under the guidance of the country's leading historical painter, the academy would zealously serve the city's professional artists.

In the first quarter of the nineteenth century, most artists still hoped to become painters of historical scenes, which were filled with figures acting out an event of religious or political significance. In order to learn to draw and paint figures, an artist studied the sculpture that embodied the most perfect human proportions—that of ancient Greece and Rome. The American Academy owned the only study collection of classical sculpture in the city. In response to the demand from a growing number of aspiring artists in New York, the American Academy had reluctantly agreed to open its galleries to students from six until nine in the morning. The students had to rise before daybreak, make their way through dark streets, and wait at the academy door until it was unlocked. Sometimes they could hear the old doorkeeper puttering around inside, but if they pounded on the door, he would only shout insults at them. The doors were opened when it suited him.

The unhappy students appealed to Trumbull, but the academy president's generosity vanished when his authority was challenged. He dismissed their complaints and rebuked them, saying, "When I commenced my study of painting, there were no casts to be found in the country. I was obliged to do as well as I could." He reminded them that the board of directors had gone to great expense to import the plaster casts, and students had no say about how and when they were to be used. Memories of his own hardships filled the colonel's mind, and he blurted out, "You must remember that beggars are not choosers." This insult touched off a revolt.

Samuel F. B. Morse, a talented thirty-four-year-old painter and later inventor of the telegraph, heard about the plight of the young artists. He invited them to his painting rooms, where they discussed their problems over fresh strawberries and cream. He suggested that they establish their own drawing association. The first meeting of the New

York Drawing Society attracted nearly thirty artists, including Asher Durand and Thomas Cole. The artists agreed to furnish their own materials and to pay five dollars in dues. They unanimously elected Morse president.

The New York Drawing Society met three evenings each week in a room provided rent-free at the New-York Historical and Philosophical Society. They borrowed the plaster casts from the American Academy and, in order to illuminate them, placed a can containing twelve and a half gallons of oil and a wick four inches in diameter on top of a post ten feet high. This enormous lamp lit the casts, and each artist brought his own oil lamp to light his paper. Meetings were well attended, and the artists now believed they were free from Trumbull's domination.

About a month after the Drawing Society was formed, an unexpected visitor entered the smoky art room. Bent over their work, the artists did not notice that Colonel Trumbull was making his way through the shadows to the front of the room. In a loud, commanding voice he insisted that each member of the Drawing Society register as a student of the American Academy. He placed his large, leather-bound registration book on a table, opened a bottle of ink, and held out a quill. Not a single student rose to sign the register. The disgruntled colonel shrugged his shoulders and marched out of the room.

The Drawing Society hastily returned the borrowed plaster casts and organized meetings to discuss its relationship to the American Academy. Society members not only needed their own place to draw, but also their own place to exhibit. They questioned whether there was enough interest in New York to support two academies. Before they broke all ties with the older institution, however, they decided to make a final attempt to persuade Trumbull to appoint artists from their group to his board of trustees. Morse, Dunlap, and Durand volunteered to meet with Trumbull, but he rejected their plea, saying, "Artists are unfit to manage an academy. They are always quarreling."

After this humiliating refusal, the young artists resolved to organize a new academy. They met on January 14, 1826, and formed the National Academy of Design, the first institution in the United States governed solely by artists and devoted entirely to the exhibition of contemporary American art. Samuel F. B. Morse was president, and Asher B.

Durand and Thomas Cole were listed as founding members. They helped to organize the new academy's first exhibition. Durand looked for a suitable, large room to rent, and Cole searched the studios of member artists to find enough art to fill the walls.

Four months later, Governor De Witt Clinton, the mayor, public officials, the faculty of Columbia College, and fashionable members of society arrived at the opening of the first National Academy of Design exhibition, which was located in a rented house at the corner of Broadway and Reade Street. The guests walked up one flight of steps and entered a long room lit by three two-light gas branch burners. Young artists wearing white rosettes in their buttonholes greeted them at the head of the stairs. One hundred and seventy works were shown—original oil paintings, watercolors, engravings, and even architectural drawings—and they were all by living American artists.

From that time on, the National Academy held exhibitions each spring. The first year they had been unable to meet their expenses, collecting only three hundred dollars in admission fees. But attendance grew until, two years later, revenue from admissions had nearly tripled. Lighting was improved, and the galleries were kept open in the evenings so that merchants and professionals could come to see the exhibitions after work—a novel idea that doubled attendance. Collections began to be formed by people who had never before purchased a work of art.

IV

CATSKILLS AND SERMONS

The budding energy of New York artists had been demonstrated some years earlier by New York writers. Many travelers had written descriptions of New York State scenery, but none had brought to them the emotion that arose from the pens of Washington Irving and James Fenimore Cooper. Appearing in 1819–20, Irving's vivid descriptions of the glens and hollows where Rip Van Winkle took his twenty-year nap aroused wide-ranging curiosity about the wild beauty of the upper Hudson River. In 1823, when Cooper's first Leatherstocking novel, *The Pioneers,* came out, it included descriptions of Kaaterskill Falls and the lofty site upon which the Catskill Mountain House, the first resort hotel in the area, was being built.

Cooper also played an important role in these early years by gathering the leading talent of New York together at once-a-week lunches held at the sumptuous City Hotel, which occupied an entire city block. At his

instigation, writers became acquainted with artists such as Dunlap, Morse, Durand, and Cole. Lawyers, merchants, physicians, and professors from Columbia College were also invited to become members. Cooper had extravagant taste, and the lunches reflected it. The menus included stewed oysters, kidney pudding, pastries, and wine. Bread and cheese were used as membership ballots: the bread being a vote in favor of a candidate, and the cheese, a vote against. Consequently, these meetings became known as "The Bread and Cheese Club."

No cubes of cheese were put on the platter when poet and newspaper editor William Cullen Bryant was proposed for membership after his move to New York. He was unanimously accepted into the club and was to remain a loyal supporter of artists throughout his lifetime. Soon after he arrived from Massachusetts, he had learned of Cole's celebrated paintings and had compared the interest they aroused to the excitement caused by a great discovery. Many of Bryant's own poems described the beauty of the scenery that Cole depicted in his paintings. Although Cole was a reticent figure among the sparkling wits at Cooper's luncheons, Bryant, a newcomer to New York, and equally shy, took a liking to him. Their shared response to nature created a lasting friendship.

For a time the congeniality of these brilliant men and the novelty of the Hudson River landscape kept Cole's attention directed exclusively toward painting nature. He returned each summer to the village of Catskill, which afforded easy access to his favorite region of the mountains. He enjoyed climbing peaks to catch the last rays of a sunset and hiking through the thick brambles to reach a secluded waterfall. He sought out the shelter of caves during thunderstorms and imagined, at every burst of thunder, trees crashing to the ground and rocks loosening from the mountainside. In gentler weather he contemplated the affection suggested by intertwined trees and the sadness evoked by drooping willows. Toward nature he felt the passion of a lover, but that love never waned and its pleasure never brought remorse.

Cole carried his sketchbook on these summer excursions. Although still small in size and tightly rendered, his paintings reveal his developing skill. He painted scenes of Kaaterskill Falls, Haines Falls, and the Catskill cloves. He painted wild scenery in all kinds

Fig. 3. Landscape, Scene from "The Last of the Mohicans," 1827

Thomas Cole (1801–1848)

Oil on Canvas, 25 × 31 in.

Fenimore Art Museum

New York State Historical Association

Cooperstown, New York

Photo: Richard Walker

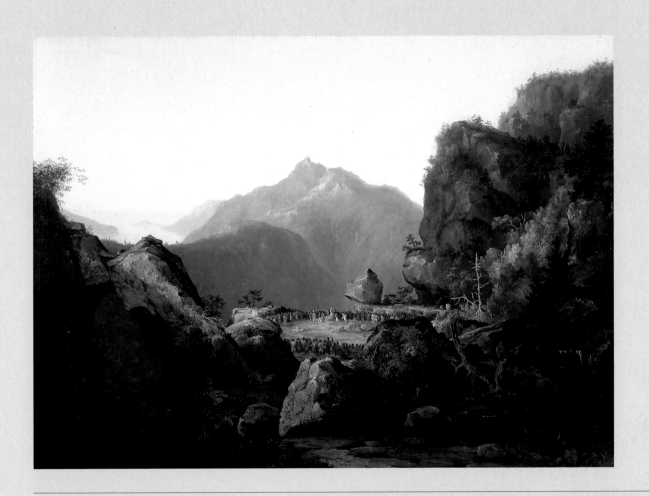

of weather—during violent storms and on quiet sunny days, at sunrise and sunset, or just after a storm when sunbeams burst through the clouds.

Sometimes Cole identified so intensely with nature that his trees and rocks took on a human quality. His public, however, saw in his images, not a mirror of human emotions, but a true representation of their own country skillfully presented for the first time in oil paintings. Art critics also admired his skill in capturing the character of American nature. One of them wrote: "The boldness of the scenery itself, the autumnal tints which are spread over the forest, and the wild appearance of the heavens, give it a character and stamp that we never see in the works of foreign schools." Collectors like diarist Philip Hone wrote that he had proved his love of country by owning a painting by Cole.

So admired were these landscapes that they were bought by collectors from Boston, Hartford, Philadelphia, and Baltimore as well as New York. One of Cole's most influential patrons was Robert Gilmor, a Baltimore merchant who liked Cole's paintings because they reminded him of scenery he had seen during walks in the mountains. He often suggested subjects for Cole to paint. After seeing a painting of an incident taken from Cooper's best-selling novel, *The Last of the Mohicans,* Gilmor asked Cole to paint another picture of the same subject for him. Rather than placing the scene at Lake George as Cooper had done, Cole selected the White Mountains, where he had sketched during a summer trip to New Hampshire in 1827.

Changing the location did not seem to bother Gilmor. He wrote to Cole, "I can see no objection to your going anywhere for a part of your scenery, though the tale is located near Lake George, so all that is necessary is that it should be appropriate." In the final painting (Fig. 3), Cole selected Mt. Chocorua and Lake Winnipesaukee, well-known features of the White Mountains, as the background for a dramatic episode from the novel in which Delaware Indians stand in a circle around the main character, Cora, who kneels at the feet of the Indian chief, Tamenund.

When Gilmor, who was careful to praise as well as criticize, received the painting, he wrote to Cole that he liked the atmospheric blue of the distant lake and the way it contrasted with the mountain, but he found the arrangement of the rocks in the foreground

Fig. 4. The Garden of Eden, 1828

Thomas Cole (1801–1848)

Oil on Canvas, 38 ½ x 52 ¾ in.

Amon Carter Museum, Fort Worth, Texas

1990.10

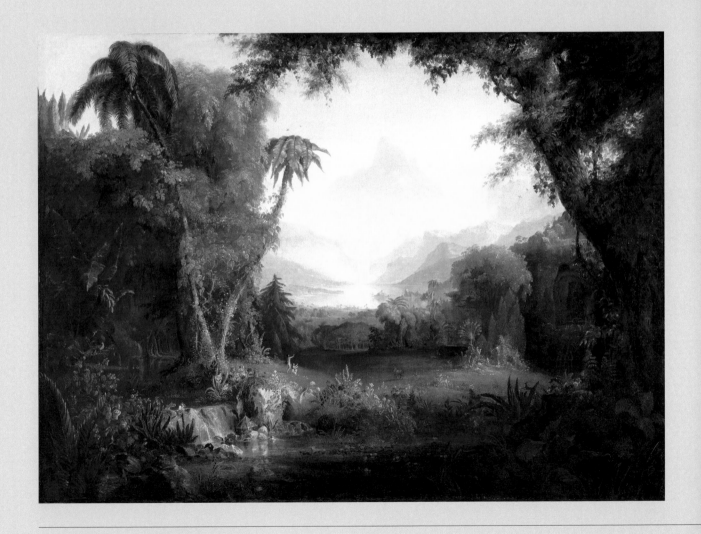

to be artificial and the precariously poised boulder near the Indians to be off balance. To him they seemed "forced and not ordinarily seen in nature." Apparently Gilmor was unaware that the oddly placed boulder is a familiar geological formation found in the White Mountains. Called a "rocking stone," it was thought to be connected to Indian rituals, so Cole undoubtedly used it to intensify the narrative.

In defense of his painting, Cole wrote to Gilmor that the great landscapes of the past had been based more on imagination than on reality. Gilmor agreed, but still argued that natural elements should be taken directly from nature or risk becoming repetitive and monotonous. A self-taught artist like Cole, he felt, was not experienced enough to attempt an imaginative landscape without its appearing artificial; he should stick to real American scenes.

Gilmor's words challenged Cole, who was determined to demonstrate that he could compete with the best artists of all time. Instead of following Gilmor's advice, he decided to embark upon a wholly imaginary work. He chose a subject of unquestioned significance, the Garden of Eden. Drawing on John Milton's description in his poem, *Paradise Lost,* Cole depicted the garden as a clearing in a tropical forest with the small figures of Adam and Eve awakening to the rising sun. Across the foreground, a stream flows out of a dark wood and cascades spill over golden rocks into a still pool with flowers blooming along its banks. In the background a familiar form looms: Mt. Chocorua, reversed and exaggerated in height, has been enlisted again, this time accompanied by an imaginary waterfall, a reflecting lake, palm trees, and even elephants.

During the winter of 1827–28, a continuous stream of people dropped by Cole's studio at 2 Greene Street to see the work in progress. Their interest increased his confidence that *The Garden of Eden* (Fig. 4) would sell easily, so he decided to paint a companion piece, *Expulsion from the Garden of Eden* (Fig. 5). He had to work quickly, but was able to complete it in time to send both paintings to the spring exhibition at the National Academy.

In *Expulsion* darkness envelops the tiny figures of Adam and Eve as they emerge from the Garden of Eden into a fearful, stormy landscape. A fierce wind bends the palm trees, torrents of rain pour from the swirling clouds, and in the foreground a wolf devours

Fig. 5. Expulsion from the Garden of Eden, 1828

Thomas Cole (1801–1848)

Oil on Canvas, 39 3/4 x 54 1/2 in. (100.96 x 138.43 cm.)

Museum of Fine Arts, Boston

Gift of Martha C. Karolik for the M. & M. Karolik Collection of American Paintings, 1815–1865

Photograph © 2007 Museum of Fine Arts, Boston

47.1188

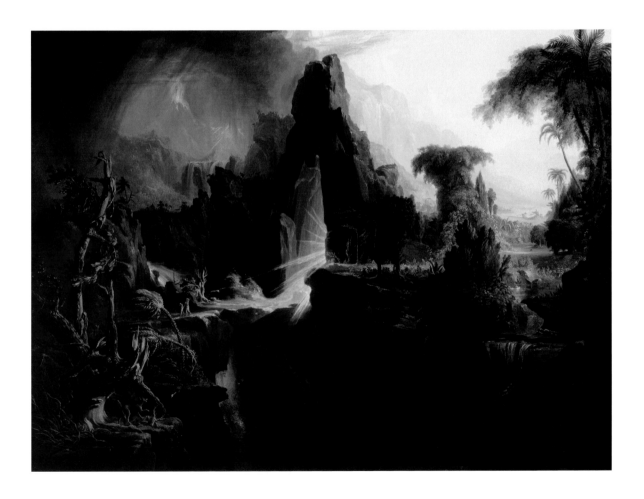

the carcass of a deer. For contrast, the soft meadows, golden rocks, and flowering gardens from which the pair had been banished can still be glimpsed on the far side of the Gates of Paradise.

Cole hoped Gilmor would purchase both paintings, but his patron found the terrain too fanciful and it bore no resemblance to American scenery. "I am literally overstocked with pictures," he wrote Cole apologetically. "I have some of my finest lying around the house like lumber for want of room to hang them up." He tactfully assured Cole that he should be able to sell them in New York City, "where there were so many rich and thriving men."

By the close of the National Academy exhibition, however, neither had been sold. Amidst many excellent reviews, one critic accused the artist of copying mezzotints of the same subject by a popular English artist, John Martin. Although Cole publicly denied having seen the prints, the criticism undoubtedly hurt the sale of the paintings.

Cole thought he might have better luck in Boston and arranged to have them exhibited there, but they found no buyers and, by December, were returned. Acting on Gilmor's advice, Cole decided to raffle them off—a common practice of the times. He tried to sell chances at twenty dollars each, but was unable to find enough buyers to raise the four hundred dollars he was asking for each painting. Humiliated by his failure, Cole had to return the money to the ticket holders.

In May 1829 he exhibited them again in New York at Elam Bliss's bookstore. With the damaging review forgotten, *The Garden of Eden* found a home with Charles Wilkes, president of the Bank of New York. The somber mood of *Expulsion* made it more difficult to sell, but one day he ran into Dr. David Hosack, who expressed interest in it. Hosack was a wealthy botanist and physician who had attended Alexander Hamilton on his deathbed after his duel with Aaron Burr. The biblical scene appealed to the old-fashioned taste of the portly physician, a founder and staunch supporter of the American Academy. He made an offer, and although it was lower than Cole had hoped, it was accepted. Cole now had enough money to take a long-awaited trip to Europe. He sailed on the *Columbia* on June 1.

COLE'S EUROPEAN TOUR

News of Cole's proposed trip to Europe spread concern among his friends. They were already worried about the turn that his art seemed to be taking. Had they lost their first painter of truly American scenes before he had fully matured? America's two best-known writers had already become entranced with Europe. Washington Irving, who had left the United States many years earlier, was still reveling in the splendors of Spain. James Fenimore Cooper had recently taken his family abroad to enjoy the honors that Europeans were bestowing upon him. Now, word spread that America's most popular landscape painter was departing, too.

William Cullen Bryant, who had become editor and part-owner of the *Evening Post,* was so distraught over the direction in which Cole seemed to be moving that he wrote a sonnet entitled, "To Cole, the Painter,

Departing for Europe." It warned Cole not to become so enamored of European scenery as to forget the natural beauty of American scenes:

Fair scenes shall greet thee where thou goest—fair
But different—everywhere the trace of men.
Paths, homes, graves, ruins, from the lowest glen
To where life shrinks from the fierce Alpine air.
Gaze on them, till the tears shall dim thy sight,
But keep that earlier, wilder image bright.

To allay the fears of his friends, Cole decided to take a quick trip to Niagara Falls, the grandest of all American spectacles. "I shall endeavor to impress its features so sharply on my mind," he wrote Gilmor reassuringly, "that in the midst of the fine scenery of other countries its grand and beautiful peculiarities shall not be erased."

Americans had long been dependent on England for their art training. Trumbull, Dunlap, and other artists of their generation had studied in the London studio of American-born Benjamin West, learning to paint portraits and historical subjects for which West was famous. Their aim had been to acquire styles like the famed English artists, but after the colonies won independence, American artists sought to develop their own national style. Artists no longer traveled abroad to imitate European paintings, but rather to study European technique with the intention of applying it to their own subjects. With no tradition of their own, however, the first generation of American landscape painters often returned home influenced more by European conventions than they were willing to admit.

In June 1829 twenty-eight-year-old Thomas Cole sailed for England. Although the ocean was calm, he suffered from seasickness during most of the four-week voyage. The sight of the English coastline came as a relief. Now that he was to see for the first time paintings by the famed English artists on exhibition at the Royal Academy, he dreaded the prospect that his work would not measure up. Founded in the eighteenth century by King George III, the academy was the oldest and most important art institution in Eng-

land. The distinguished portrait painter, Sir Thomas Lawrence, was currently serving as president, and its most widely discussed members were landscape painters John Constable and Joseph M. W. Turner.

Cole entered the Royal Academy trembling, but after looking carefully at the paintings in heavy gold frames, he felt relieved. Most of them did not meet his expectations. He liked Turner's *Ulysses Deriding Polyphemus,* a theme from Homer's *Odyssey,* but on the whole he thought that most of the artists produced "washy imitations." He decided that his work compared favorably with his English contemporaries and was pleased with himself for achieving so much on his own.

With renewed confidence in his own ability, Cole worked long hours in his London studio, producing mostly American scenes for English collectors. He sent one of his paintings to the poet and patron of the arts, Samuel Rogers, who was well known for helping young artists. Rogers responded by inviting Cole to dine with him at his house on St. James Place. Through a letter of introduction from Robert Gilmor, Cole also met Sir Thomas Lawrence. Over a breakfast of boiled eggs and tea, they discussed the future of American art. When the elderly portrait painter died the following year, Cole lost a valuable friend.

Social occasions, however, were rare, and Cole was lonely in London. He missed the companionship of his family. He complained of spending weeks in his studio without a single visit from an English artist. "I found myself a nameless, noteless individual in the midst of an immense selfish multitude," he wrote to Dunlap. Charles Robert Leslie, an American artist and biographer of John Constable, sometimes dropped in for a chat, but Cole had difficulty appreciating this friendly gesture inasmuch as he was keenly aware that Leslie did not think well of his paintings. The dreary climate increased his misery, and he slipped into despair.

He continued to paint, and his work was accepted at both the Royal Academy and its rival, the British Institution, the two best exhibition halls in London. In those days paintings were hung from baseboard to cornice, and lighting was uneven. Paintings of academy members were given privileged locations. When Cole arrived at his first exhibition, he was dismayed to find his paintings hung in dark, obscure corners. John Constable tried to

console him by admitting that his paintings used to be hung in the worst places, too. Cole had better luck at the newly founded Gallery of the Society of Artists, a group sympathetic to landscape painters. There, his painting, *Tornado in an American Forest,* was singled out by the English press for favorable reviews in a number of newspapers.

One popular place to visit in London was the private gallery of Joseph M. W. Turner, which he had built as an extension of his house. When Cole arrived there, a doddering old housekeeper opened the great front door to a vestibule lined with casts of ancient statuary. As Cole proceeded down the hallway, tailless Manx cats leapt out from rooms stacked with unfinished canvases and, like a disorderly army, escorted him into the gallery. It was ablaze with light and color. Turner's paintings were hung frame-to-frame against Indian red drapery, and some were propped against the walls. He had installed netting above the cornice from one end of the room to the other and placed sheets of tissue paper over it in order to diffuse light entering from the skylight.

As Cole studied the paintings, Turner strolled out from behind a shabby screen. He was a small man with a beakish nose, ruffled hair, and coattails that nearly reached the floor. He held himself up so straight that he seemed to lean backward. When he shook Cole's hand, he merely said, "Humph-humph," and nodded. Cole was surprised by Turner's lack of refinement, but his good nature soon overcame his coarse manners and thick speech.

One of Turner's great historical paintings, based on Dido, the legendary queen who founded the ancient city of Carthage, was hanging in his gallery. Turner held *The Rise of the Carthaginian Empire* in such high esteem that he had willed it to the National Gallery under the condition that it hang next to the work of the famed seventeenth-century landscape painter, Claude Lorrain. It showed a classical city being constructed around a harbor. Cole admired the care with which the waterfront activity was painted, but by this time Turner had departed from the realistic style of this early work.

In many of his recent paintings, forms and shapes had been dissolved in ochre, umber, yellow, and white. He was experimenting with the effects of light and atmosphere, making him a forerunner of Impressionism—the French school of art that would flourish later in the century. Cole, however, felt that Turner was too involved with the man-

agement of paint and not sufficiently interested in content. He wrote home that Turner's current paintings were "the strangest things imaginable: all appears transparent and soft, and reminds one of jellies and confections." He criticized English artists for their fondness of what they called "generalizing." Cole thought that generalizing was an excuse for lazy painting or imprecise rendering. As far as he was concerned, such pictures were "full of sound and fury, signifying nothing."

Five days before the opening of Royal Academy exhibitions, academy members were given an opportunity to touch up and varnish their paintings after they had been hung on the walls. Varnishing days were becoming highly competitive. Artists began to use the time to rework their paintings in order to outdo those hanging nearby. Turner habitually sent in unfinished canvases, which he completed—and sometimes almost entirely painted—after they were hung on the academy walls. His painting methods were so unusual that artists gathered around to watch. He was quite a sight standing on a bench in a tall beaver hat with pots and cups of paint at his feet. He spread layers of thin color over parts of his canvas with stubby brushes and rolled half-transparent lumps of paint into position with his palette knife. As if by magic an image suddenly emerged. Then he would pick up his tools and, without a word, walk away leaving his spectators to wonder how these unruly methods created such sensational effects.

At the National Gallery, Cole had his first opportunity to study genuine Old Masters. The collection, today one of the world's largest and finest, then consisted of only thirty-eight paintings by famous artists such as Rembrandt, Titian, Velasquez, Claude, and Poussin. Cole liked best the seventeenth-century landscape painters, Claude and Poussin, but he did not set up an easel in the gallery in order to copy their paintings. He feared losing his originality if he followed this common practice.

In May 1831, Cole left London for Paris. He went immediately to the Louvre, but was disappointed to find the walls hung with the works of contemporary French painters instead of Old Masters. "I was disgusted with their subjects," he wrote. "Battle, murder, and death. Venuses and Psyches, the bloody and the voluptuous, are things in which they seem to delight. They seem too artificial, laboured, and theatrical."

Cole left Paris hurriedly and, by the end of May, was sailing down the Rhone River to Marseilles to catch a steamboat to Leghorn, Italy. He proceeded by land to Florence where he rented a room in the same house with the American sculptor, Horatio Greenough. The warm and sunny Italian climate did not immediately cheer him. He realized that he was no longer responding to nature as he had in his early years. His sense of the beautiful had been deadened, and his emotions numbed. In such a mood he "looked upon the beautiful scenery, and knew it to be beautiful, but did not feel it so." This time Cole did not blame his unhappiness on his loneliness, but instead on having been in company too much. He felt that he needed more time alone.

By autumn his melancholy had passed, and Cole began enjoying the beauty of the Italian countryside. Although he adored the galleries of Florence, he did not copy any of the paintings there. He painted actual views of the city, the river, and the surrounding countryside. He loved the softness of the Italian skies and the gorgeous twilights, but remembering the warnings from home, he assured his American patrons that he had seen "no scenery yet which affected him so powerfully as the wilderness places of America." Leaving Florence, Cole settled in Rome in the former studio of Claude at the top of the Spanish Steps. Rome was the artistic capital of the early nineteenth century, just as Paris would be at the end of that century. Artists of the Romantic period relished the classical ruins, which inspired them to meditate on past deeds of heroism.

As Cole gazed upon the ruins of the Roman Coliseum in the moonlight, he imagined the spectacles that once occurred within the crumbled walls. Reminded of Turner's *The Rise of the Carthaginian Empire* and his subsequent painting depicting its decline, he contemplated the lesson to be learned from the changes that had taken place over time. He began to jot down detailed descriptions of compositions depicting the rise and fall of an empire.

While Cole was considering this grand theme, he heard about the cholera epidemic in New York. Fearing for the health of his parents and sisters, he decided to return home.

VI

A NEW PATRON

ole arrived in New York harbor after seven weeks aboard ship. The cholera epidemic had subsided, and he found his family in good health.

He rented painting rooms on the corner of Broadway and Wall Street and proceeded to unpack his belongings and European sketches. When Friday came, he searched through the newspapers to find out where the Sketch Club was meeting. Finally he saw, "S.C.–S.F.B.M." in the lower left-hand corner of the *Evening Post*. The initials meant that the Sketch Club was to meet that evening at the home of Samuel F. B. Morse.

Organized soon after the formation of the National Academy of Design, the Sketch Club had many of the same members as Cooper's Bread and Cheese Club, which had dissolved in 1826 when Cooper and his family left for an extended stay in Europe. Since many in Cooper's

group had been uncomfortable with its extravagant meals, members of the new club agreed to conduct meetings at each other's painting rooms and homes instead of a hotel and serve simple refreshments of dried fruit, crackers, honey, and milk.

Cole was happy to see his friends again and eager to hear how the National Academy had fared in his absence. It had moved into Clinton Hall (Fig. 6) on Nassau Street and had increased its space so that the gallery, the library, and the school could now be housed in separate rooms. Samuel F. B. Morse, just back from Europe himself, had resumed the presidency, and William Dunlap had been elected to the vice presidency. Asher Durand had been teaching the drawing class, and William Cullen Bryant had been lecturing on mythology. A recent gift of some valuable casts of ancient statuary had been placed on display in the front of the school room. At their last meeting, the board of directors had resolved, amid a good deal of laughter and some degree of opposition, to have plaster fig leaves applied to the statues for the sake of modesty.

Nearly every young artist had allied himself with the new academy, but the old academy was still tottering along. Dr. David Hosack, an American Academy board member, had met with the leaders of the new academy about the possibility of a merger, but they had refused. Having overcome their own financial difficulties, they did not want to be burdened with a dying institution.

In 1833 Cole exhibited a number of Italian views at the National Academy exhibition. The following year he sent a fanciful little painting entitled *The Titan's Goblet* (Fig. 7), showing a huge goblet containing a sea with villages on its brim and boats sailing on the water. Paintings such as this caused Cole's admirers to believe he had forgotten the American landscape.

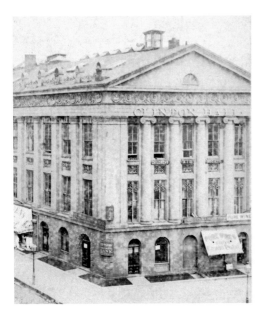

Fig. 6. Clinton Hall. *The National Academy of Design rented space in this building on Nassau Street.*

One day Cole noticed a small, dark-haired man making a quick tour of the gallery adjoining his painting room. He did not appear to be a casual visitor. He would stand for a moment close to a painting with his chin uplifted and his black brows drawn together, and then he would dart on to the next with a brisk side step. Later, Cole learned that the gentleman's name was Luman Reed.

Reed had grown up on the banks of the Hudson River in the small town of Coxsackie, New York, some twenty-five miles south of Albany. As a young man he had transported produce from nearby farms to New York City by sailing sloop. With money from its sale, he had bought manufactured goods in the city, which he carried back up the river to sell at his country store. Reed had a gift for hard bargaining and soon made enough money to set up his own wholesale grocery business in New York City. As one of a growing number of New Yorkers to benefit from the cheap and safe transportation of produce from the Midwest by way of the Erie Canal, Reed soon made a fortune. He had built a mansion on Greenwich Street and had begun to buy European paintings by Old Masters to hang on its walls. In time he discovered that his art collection consisted not of authentic works, but of copies—as were most of the so-called Old Masters in the United States at that time. He quickly sold the collection and turned to the work of living American artists.

Spending an afternoon in an artist's studio proved to be a relaxing diversion from business concerns. Reed listened sympathetically to the artists' problems and enjoyed telling them his own dream of converting the third floor of his new house into a painting gallery that would be open to visitors once a week. In a city with no museums where American painting could be permanently exhibited, Reed's idea was extremely important in furthering an interest in American art.

When Cole heard of Reed's intentions, he recognized an opportunity for which he had been waiting. Inspired by Turner's two paintings showing the rise and the decline of the Carthaginian empire, he had grown preoccupied with the idea of painting a series that would show the changes that occur in an empire over a period of time. The theme was to encompass five large canvases and require a spacious room for exhibition.

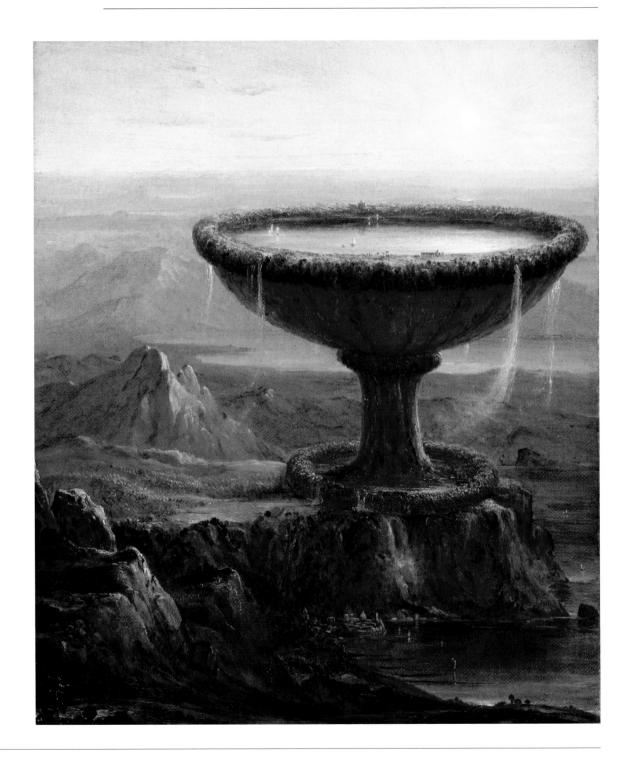

Fig. 7. The Titan's Goblet, 1833

Thomas Cole (1801–1848)

Oil on Canvas, 19 3/8 × 16 1/8 in. (49.2 × 41 cm.)

The Metropolitan Museum of Art

Gift of Samuel P. Avery Jr., 1904

Photograph © 1992 The Metropolitan Museum of Art

04.29.2

If Reed could be convinced to commission the series, his gallery would be a suitable place to show it. In September 1833 Cole wrote to him, "I mentioned to you a favorite subject that I had been cherishing for several years with the *faint* hope that some day or other, I might be able to embody it." Cole told Reed that he wanted to paint a series of pictures that showed the effects on a landscape of man's progress from a primitive state to civilization, then the destruction of that civilization and the land's return to its natural state. Reed, who never dictated subjects to artists, accepted the idea and commissioned Cole to paint the series for twenty-five hundred dollars.

The little merchant with quizzical brows and penetrating eyes had become so much a part of the artists' lives that they elected him a member of the Sketch Club. At meetings he became friendly with Asher Durand, who was still engraving bank notes. At that time each bank issued paper money of its own special design. Banks had to employ the finest engravers so their money could not be easily counterfeited. Since Durand had the best reputation in his field, he was swamped with orders, and his business had become highly profitable.

Durand had built his house on Amity Street near Washington Square on the outskirts of the city. He was living there happily with his wife, son, and three daughters when suddenly tragedy struck the home. One daughter died at age two, and after a long illness, his wife Lucy died. Left alone with three small children, Durand had to take stock of his life. He was making a good living and had gained prestige, but engraving was very tedious. He had serious doubts about continuing. Occasionally he had taken time off to paint a landscape, a portrait, or a biblical scene for National Academy exhibitions. He had been

offered a few portrait commissions, but not enough to give up engraving entirely. One day he confided to Luman Reed his desire to paint full time, and Reed offered to launch Durand on his new career by commissioning him to paint portraits of all the presidents of the United States for his gallery.

There had been seven presidents up to that time. George Washington, John Adams, Thomas Jefferson, and James Monroe were dead. Their portraits were to be copied from those painted during their lifetimes by Gilbert Stuart. Durand had already painted a portrait of James Madison, but he would have to ask John Quincy Adams and Andrew Jackson to sit for theirs. Reed arranged a sitting with Adams, who was living just outside Boston in Quincy, Massachusetts. In June 1835 the kindly merchant, the awestruck artist, and the staid former president dined together at Adams's home. Durand enjoyed the fine wines and champagne, and Adams enjoyed sitting for his portrait. It is one of Durand's finest characterizations.

Reed introduced Durand to many of his prominent friends, and the young artist was soon scheduled for portrait sittings months in advance. He wrote home that Mr. Reed "seems to think of nothing else while here but to promote my interests." Reed had often said that he thought it a privilege to be able to give encouragement and support to better men than himself. He liked to encourage Durand by telling him that if he were as good a painter as Reed thought he was, he would some day ride in a fine carriage. Durand did not share such a lofty dream; he hoped for no more than to be able to continue his work.

Durand had to fend for himself when he went to Washington to paint Andrew Jackson, who was then serving his second term in the White House. Much of his time was spent waiting to request a sitting with the president and waiting for an answer. Finally he was able to set up his easel in the president's office. What a contrast President Jackson made to the corpulent, sedate Adams. Jackson sat tall and erect, with a sharp-boned face marked by nervous energy. He moved incessantly, fiddling through stacks of paper on his right, studying documents on his left, scribbling notes in the middle, and signing papers on his knees, all the time puffing away on his pipe. Occasionally he bolted up and disappeared into the adjoining cabinet room. Through the closed doors, Durand heard heated disputes

**Fig. 8. View from Mt. Holyoke, Northampton, Massachusetts after a Thunderstorm—
The Oxbow, 1836**

Thomas Cole (1801–1848)

Oil on Canvas, 51 ½ × 76 in. (130.8 × 193 cm.)

The Metropolitan Museum of Art

Gift of Mrs. Russell Sage, 1908

Photograph © 1995 The Metropolitan Museum of Art

08.228

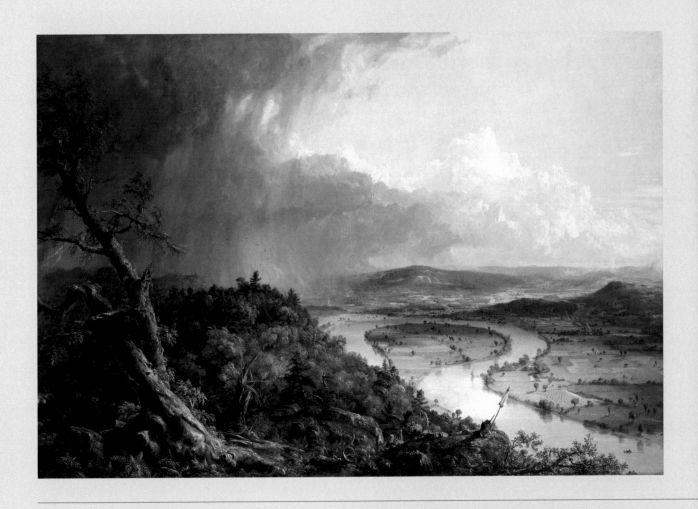

peppered with exclamations of "by the Eternal" and what Durand politely described as "less temperate expletives."

No sooner had Durand completed the presidential portraits than Reed put him to work painting scenes on the doors and walls of his art gallery. Meanwhile, in Catskill, where Cole had begun to rent quarters, he had completed the first and second paintings of *The Course of Empire* series. *Savage State* (Fig. 9) showed primitive man hunting deer in the forests, and *Arcadian or Pastoral State* (Fig. 10) showed the next stage—the plowing of fields and the building of villages. Each scene was located in an imaginary landscape around a bay.

The third painting, *Consummation of Empire* (Fig. 11), was the most difficult. The shore-line had grown into a classical city crowded with aqueducts, temples, and colonnades, all teeming with people enjoying their luxurious surroundings. Cole became bogged down in the wealth of detail. He found that human figures took an inordinate amount of time and ornate buildings were difficult to organize. He grew tired of painting "gaud and glitter."

Months later Cole was still working on the painting. He was becoming discouraged and could no longer recognize his mistakes in order to correct them. He felt that he had attempted a composition far too complicated and should perhaps begin again, this time making the horizon lower and the objects fewer. It began to look as if Cole, forever dissatisfied with his work, might despair altogether and abandon the project. Moreover, his finances were running low. During the two years he had worked on the series, he had earned no income from other sources. When he wrote to Luman Reed for help, his patron agreed to raise his price to five thousand dollars and advised him to take a break from the series to paint a picture for exhibition and sale.

Cole took Reed's advice and searched through his sketches for a scene that would be familiar to the public. He found a view of the Connecticut River Valley taken from the wooded summit of Mount Holyoke and worked it up into a finished oil painting entitled *View from Mount Holyoke, Northampton, Massachusetts, after a Thunderstorm—The Oxbow* (Fig. 8). Merging the themes of the savage and pastoral states into one painting, he contrasted the wilderness on the mountainside with the farms in the valley. Showing his own preference for the wilderness, he placed himself at his easel between two boulders on a heav-

ily wooded slope. Instead of looking at the scenery, however, he has turned his head to look toward the viewer of the painting. With a confidence not displayed before his trip to Europe, Cole painted the foliage with quick, lively strokes. He finished the painting in time for the National Academy Spring Exhibition of 1836, and *The Oxbow* was greeted with lavish praise. One visitor to the exhibition, Charles Talbot, admired the painting so much that he offered to pay five hundred dollars for it on the spot.

Cole went back to work on *Consummation of Empire* with his attitude toward his work greatly improved. He even joked that because it was a rainy day, it might "be a good time to paint the water in the fountain." When the painting was finally completed, Cole exclaimed, "I feel like a man who has had a long fatiguing journey and is just taking off his knapsack."

Durand was still painting the door panels of Reed's gallery in New York City, when Reed suddenly became ill. Deeply concerned, Durand kept Cole in Catskill informed about Reed's health. "His disease is said to be remittent fever with inflammation of the liver," he wrote. "I doubt not that you will look with the same anxiety as myself to the happy moment of his recovery."

Unfortunately Reed did not recover. Grief-stricken, Cole and Durand met at the funeral. A large portion of their incomes had depended on this generous backer. Durand worried about future portrait commissions, and Cole was concerned about his still-unfinished *The Course of Empire*. He did not know whether to continue with the series. It was an uneasy time for both artists. At length, Cole learned that Reed's widow would honor her late husband's commitments, and he set out to finish the final two paintings, *Destruction* (Fig. 12) and *Desolation* (Fig. 13).

The Course of Empire was exhibited as a single attraction at the National Academy in 1836. William Cullen Bryant described it as the "most remarkable and characteristic" of Cole's work. James Fenimore Cooper considered it "the work of the highest genius this country has ever produced." He said that it was "a new thing to see landscape painting raised to a level with the heroic in historical composition." Cooper predicted that the "day will come when the series will command fifty thousand dollars." As he was praising

Fig. 9. The Course of Empire: Savage State, 1833–36

Thomas Cole (1801–1848)

Oil on Canvas, 39 1/4 × 63 1/4 in.

Collection of the New-York Historical Society

1858.1

Fig. 10. The Course of Empire: Arcadian or Pastoral State, 1833–36

Thomas Cole (1801–1848)

Oil on Canvas, 39 ¼ × 63 ¼ in.

Collection of the New-York Historical Society

1858.2

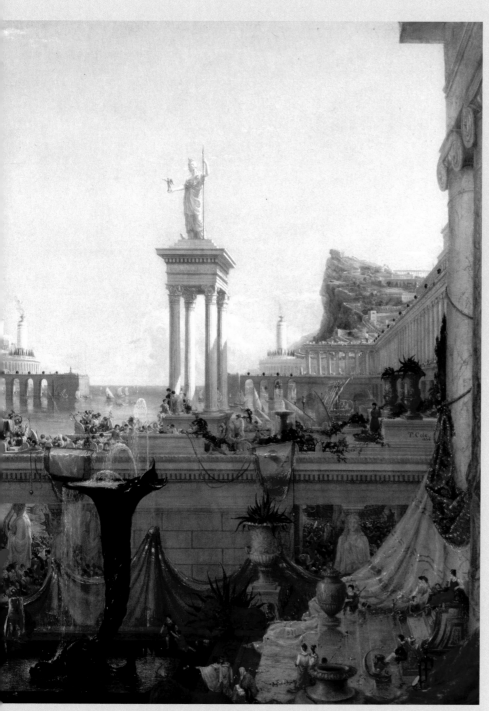

**Fig. 11. The Course of Empire:
Consummation of Empire,
1836**

Thomas Cole (1801–1848)

Oil on Canvas, 51 1/4 × 76 in.

Collection of the New-York
Historical Society

1858.3

Fig. 12. The Course of Empire: Destruction, 1836

Thomas Cole (1801–1848)

Oil on Canvas, 39 ¼ × 63 ¼ in.

Collection of the New-York Historical Society

1858.4

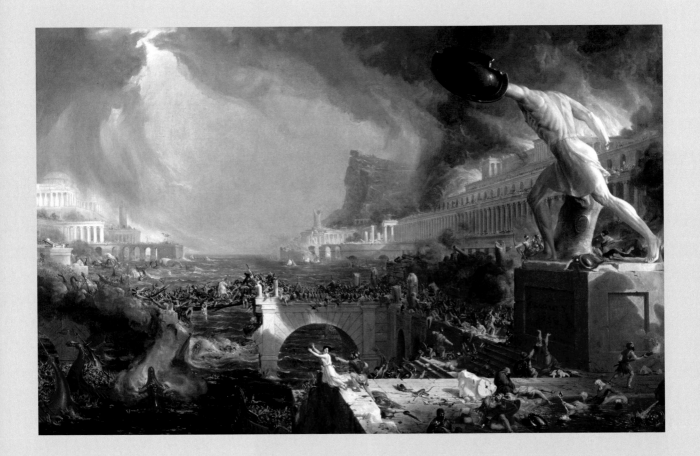

⚬VII⚬

DURAND TURNS TO LANDSCAPE

rom the decks of steam- boats and sloops sailing up the Hudson River, passengers could catch a distant glimpse of the white-columned porch of the famous Catskill Mountain House (Fig. 14). Docking at Catskill Landing, the boats discharged hordes of passengers heading for the hotel daringly perched on the edge of a cliff. In the summertime the village of Catskill was bustling with visitors, some enjoying the congenial atmosphere of the mountain resort, others seeking inspiration from the nearby natural wonders, still others curious to see the legendary home of Rip Van Winkle.

In winter the village grew quiet. Doors and windows of hotels and wayside taverns were boarded up. Snowdrifts blocked the roads, and ice froze over the river. Only local folks stopped in at the general store. Occasionally a summer visitor lingered through the long winter. Town residents recognized one of them as the artist Thomas Cole (Fig. 20).

During the years that Cole worked on *The Course of Empire,* he had spent longer and longer periods of time in Catskill. New York City had begun to fill him with "a presentiment of evil." It also had deadened his response to nature. Now ready to retire from the mainstream of city life, he decided to make the village his permanent residence.

Cole was a man of medium height with dark hair and a clean-shaven face. His eyes had a dreamy look about them and filled quickly with tears when he was moved. His skin was extraordinarily white. A friend described him as having an air of "mild femininity" about him, and another noted that he walked with a "peculiar rising and falling gait." He was often moody and introspective. He did not smoke and took only an occasional glass of wine. He was painfully conscious of his lack of poise, and parties

Fig. 14. The Mountain House. *Title Block from Thomas Nast's "Sketches among the Catskills," Harper's Weekly, July 21, 1866.*

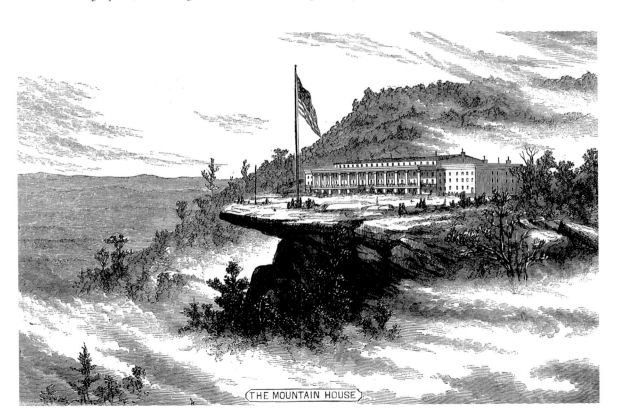

THE MOUNTAIN HOUSE

inhibited him so much that on leaving he felt as though he had just been released from jail. He was happiest when he could escape to the woods.

Cole kept his private thoughts in a journal. Sometimes in poetry, sometimes in prose, he described scenery he encountered on his long, solitary walks in the wilderness. His words revealed his close relationship with nature. On an overcast November afternoon, he jotted down: "Gloomy days have come at last, and brought with them to my mind a shade of their own sadness." The weather and seasons dictated his moods so that when the first signs of spring appeared, his happiness returned. He wrote elatedly: "The Spring has come at last. … The mountains have taken their pearly hue, and the streams leap and glitter as though some crystal mountain was thawing beneath the sun."

Cole longed to find others who shared his response to nature. He sometimes felt isolated and, at times, he drifted into deep despair. "My thoughts run in a different channel," he wrote; "if revealed, they would be little understood or appreciated." He asked himself, "But am I better or wiser for this sense and perception of the beautiful, which I imagine myself to possess in a greater degree than the many?" Cole was not certain. Coarse people made him irritable, and he grew impatient with those who did not share his love of nature.

Thirty-five years old and tired of bachelorhood, Cole was determined not to let this lonely state persist forever. In matters of love, however, he tended to be too idealistic. He wrote in his journal: "I find that when I fall in love it is with an ideal character, which I have attributed to some earthly fair; and as the ideal does not wear very well in this world, I too soon behold that the object of my adoration is no goddess." In a more practical manner, he reasoned that if his chosen lady were good-looking, amiable, and sensible, he would ask no more except that she make his "feelings her own and love one heart and soul."

Cole had taken a room at Cedar Grove, a farm in the village of Catskill owned by John Alexander Thomson, a gentleman farmer whose family had been long established in the area. He owned a hundred and ten acres running down to the Hudson River to the east and looking out to the Catskill Mountains to the west. The main house, which still stands today, has a wide porch, where Cole joined Thomson and his nieces on summer

evenings. One of these, Maria Bartow, had a sweet face framed by brown wavy hair parted in the center and tied behind with a ribbon. When she lowered her large brown eyes, Cole was reminded of images of the Madonna. She began to join him in his favorite pastime of gathering summer mosses. She felt in nature a mirror of her own moods as much as he did, and Cole's loneliness vanished. It was not long before Asher Durand in New York City, having already been informed of the attachment, received a note from a nervous groom. "Don't let me stand up to the parson without a single soul to keep me in countenance," Cole pleaded. "Come—Come—Come! I will not be disappointed."

Durand was not able to attend the wedding at Catskill that November. His duties as instructor and recording secretary at the National Academy were pressing and, despite Reed's death, his portrait commissions were flourishing. Under President Jackson's policies of easy credit, a great deal of wealth was created with a consequent demand for portraiture. The extravagance that Cole had depicted in *Consummation of Empire* symbolized New York in 1836. Reckless expansion and luxurious living had turned the city into a hotbed of bad taste and flaunted wealth. *The Course of Empire* had proved more immediately prophetic than its critics could have guessed.

By May 1837, panic had engulfed the nation. Banks closed, businesses went bankrupt, and thousands of workers lost their jobs. Stores along Broadway were boarded up, building construction came to a halt, and the shipyards lay idle. Almshouses were overflowing, and hundreds of unemployed begged on the streets. Angry crowds grew into violent mobs. Stores and warehouses were sacked. New York seemed transformed overnight from a city of frivolity and extravagance to a city of misery and crime.

Durand's promising career suddenly collapsed, but the crisis was not as severe in Cole's mountain village, and he tried to console his friend, "I am sorry that you are at times so depressed in spirits; you must come and live in the country. Nature is a sovereign remedy. You sit, I know you do, day after day, in a close, air-tight room, toiling, stagnating, and breeding dissatisfaction at all you do." Cole's solution was: "If you had the untainted breeze to breathe, your body would be invigorated, your spirits buoyant, and your pictures would charm even you."

As summer approached and his depression grew worse, Durand considered taking Cole's advice. With no portrait commissions coming in, he decided to turn his attention to landscape. Cole, he knew, would be glad to give advice. In the summer of 1837, Durand and his second wife (he had remarried in 1834) arranged to join Cole and his bride on a sketching trip to Schroon Lake in the eastern Adirondacks. They stayed in a farmhouse run by a hospitable family named Beebe and spent long days rowing on the lake and rambling about its shores, sketching as they went. In the evenings they returned to home-cooked dinners served on an old pine table.

Durand was relieved to be away from the turmoil of the city. Exploring scenery that was entirely new to them, he and Cole tramped through the forests in search of a view of the most majestic mountain in the region—Schroon Mountain (now called Hoffman Mountain). They clambered down one slope and up another, lured on as each peak before them promised a fuller view of the mountain. Together they skirted the swampy shore of a pond, scrambled through the black stumps of a recently burned-out area, and arrived at a new clearing. They passed a log cabin, whose inhabitants, Cole reported, were aghast at two strangers "sweeping across their domains without stopping to ask questions or say 'good day.'" When they reached the topmost knoll, they looked west, but the anticipated view of the peak was hidden by a clump of woods, which they found, upon entering, to be only a narrow strip of trees. As they emerged on the other side, the mountain rose before them in silent grandeur. The artists sketched for hours. The woods were so still that the running water far below sounded like "whisperings of midnight."

Cole allowed an entire year to pass before he attempted to work his sketches into a full-scale composition. He never tried to paint scenes immediately, waiting instead until the details grew vague and the essentials took the form of a moral statement. In the final rendition of *View of Schroon Mountain, Essex, New York, After a Storm* (Fig. 15), he arranged the composition so that the eye was led to its summit. According to one of his poems, this was the point at which the mountain held "communion with the sky" and "all earthly thoughts" were forsaken "for holier things on high." In contrast, a twisted, splintered tree in the foreground evoked earthly existence. Most viewers appreciated the depiction of

Fig. 15. View of Schroon Mountain, Essex, New York, After a Storm, 1838

Thomas Cole (1801–1848)

Oil on Canvas, 99.8 × 160.6 cm.

© The Cleveland Museum of Art

Hinman B. Hurlbut Collection

1335.1917

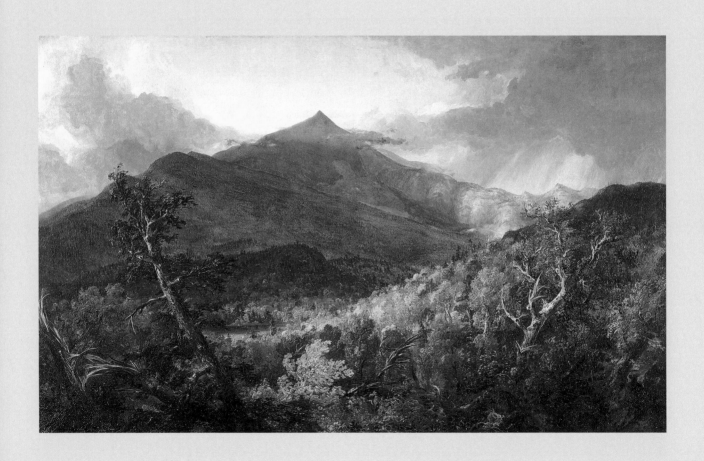

autumn splendor for its own sake, but some also understood the message. As a result, *View of Schroon Mountain* received widespread praise when it was exhibited at the National Academy of Design.

Durand also tried to work up his sketches into an oil painting, but his letters to Cole reveal that he had difficulty completing it. Nonetheless, he had achieved some success in landscape painting, and he wondered whether Cole might have regretted assisting a competitor. "I am still willing to confess myself a trespasser on your ground, tho' I trust, not a poacher," he wrote. Cole considered him neither; he was happy to have a companion on sketching trips and hoped that Durand would return to Catskill "to gather up the flesh" he had "dropped from his bones when last there." Durand began sending landscapes regularly to the National Academy exhibitions. Finding that they sold quickly, he abandoned portraiture altogether and announced humorously, "I leave the human trunk and turn to the trunk of trees."

VIII

VOYAGE OF LIFE

Thomas and Maria Cole settled into the Thomson household at Cedar Grove. Supporting three unmarried nieces, Thomson must have felt relieved to have a man in the family who could contribute to the expenses. Cole felt hard-pressed, however, to meet his financial obligations, which now also included the support of two children, Theddy, born in 1838, and Mary, the following year. Moreover, the use of adequate working space apart from the interruptions of daily life was subject to Thomson's whim. Finally, on December 19, 1839, Cole wrote happily to Durand: "Do you know that I have got into a new painting-room? Mr. Thomson has lately erected a sort of store-house, and has let me have a part of it for a temporary painting-room. It answers pretty well—is somewhat larger than my old one, and being removed from the noise and bustle of the house, is really charming."

From his new studio, Cole continued to send a wide assortment of paintings to the National Academy exhibitions. He made occasional jaunts to New York City, dropping in at Sketch Club meetings and faithfully attending the academy's spring openings. Commissions were coming in for a much broader range of subjects than the wilderness scenes for which he was best known. In 1838 Boston clients commissioned him to paint a number of views of the Arno River in Florence—so many, in fact, that he joked to Durand that he was afraid that the Arno might flood Boston. For Peter Stuyvesant of New York, he painted a literary scene inspired by the popular novels of Sir Walter Scott. He also painted a classical scene which was reviewed so favorably by the press that a businessman from Georgia bought it without having seen it. When Cole had no specific commission to fill, he turned out landscapes that sold easily and quickly in the city. Although he depended heavily on these for income, he began to feel that specific scenes were less worthy of his efforts than allegorical themes.

Cole believed, as did many others of his time, that landscape painting, no matter how brilliant, would not confer upon an artist the highest prestige. Still influential were the eighteenth-century theories of English artist Sir Joshua Reynolds, who proclaimed that the status of an artist was determined by the kind of subject he chose to paint. Historical painting, including biblical and allegorical subjects, held the highest rank because it depicted heroic deeds and universal truths that contributed to the moral improvement of mankind. Pure landscape painting held a lower rank. The possibility that realistic landscape painting could have moral significance did not become widely accepted until the 1850s. Until that time American artists were caught in the dilemma of believing that they were foregoing an enduring reputation by painting landscapes, even though they sold readily.

As Cole grew older, he became increasingly certain that he could achieve immortality as an artist only by depicting scenes that described religious truths. He began to contemplate another series of paintings with a moral lesson. This time it was not to be the empire that traveled the stormy path between birth and death, but man himself.

The Voyage of Life series (see Figs. 16–19) portrays the four stages of a man's life: childhood, youth, manhood, and old age. The first stage (Fig. 16) is set in spring. The

central feature, a boat gliding out of a dark cave, is moved along by the gentle current of a narrow stream, which meanders amid flowering shrubbery and grassy banks. A guardian angel tends the helm, and the cheerful passenger, a baby, sits surrounded by flowers. An hourglass held aloft by the prow's figurehead marks the passage of time.

The second stage (Fig. 17) is set in summer, and the stream, now wider and swifter, represents the broadening experience of youth. Having no further need for the guardian angel, the youth has left the angel on the stream's bank. Fixing his eyes on domed temples in the sky, he confidently takes the helm to steer his own course. In the distance, turbulent waters ahead give the viewer a glimpse of future perils.

The third painting (Fig. 18) shows the voyager confronting the challenges of manhood. He has lost control of the boat, and raging currents push it towards a dangerous drop. The guardian angel has withdrawn to the clouds, where menacing spirits are waiting to tempt a disheartened soul. His eyes cast upward, the voyager chooses to ignore the temptations and beckons to the guardian angel to descend and guide him to safety.

In the concluding painting (Fig. 19), the voyager, now old and humbled by life's adversity, sits in his battered craft in the midst of a dark, boundless sea. A few distant rocks, barely visible through the gloom, suggest his vanishing earthly life. The hourglass has broken off the bow: death is imminent. He looks "upward to an opening in the clouds, from whence a glorious light bursts forth, and angels are seen descending the cloudy steps, as if to welcome him to the kingdom of heaven."

This series had been commissioned by a New York merchant, Samuel Ward, but once again, Cole's patron died before the project could be completed. *The Voyage of Life* became tied up in legalities pending the settlement of Ward's estate. Finally despairing of settlement and hoping to revive his spirits and health, Cole planned another trip to Europe, where he decided to paint the series a second time.

By November of 1841, Cole had settled in a studio in Rome for the winter and started to copy the four paintings in *The Voyage of Life* series, using watercolors of his original paintings as models. Feeling lonely without his family, he wrote to Maria, "But here I am sitting in my studio, warm enough, but confoundedly flea-bitten, a large canvas on

my easel with some chalk marks upon it. … But how can I paint without you to praise, or to criticize, and little Theddy to come for papa to go to dinner, and little Mary with her black eyes to come and kiss the figures in my pictures." In a letter two months later, he seemed more cheerful and wrote: "I am getting on bravely with my pictures. The first and the third are completed, and I am building the castle on the second."

After he finished the last painting, he took a trip to Sicily. With a woolen cap on his head, coarse woolen stockings pulled over his pants, and a pistol in his pocket, he ascended Mount Aetna on muleback. He gazed into the crater, noticing how the smoke hung like wreaths, and made a number of sketches of the volcano before returning to Rome. Then, he traveled on to Milan, through Switzerland, down the Rhine to Rotterdam, and across the channel. From England he booked passage home on the *Great Western*, one of the first steamships to cross the Atlantic.

After an eighteen-day voyage, the ship docked in New York harbor. Cole immediately caught a steamboat up the Hudson, surprising his family by arriving two days earlier than they expected. "For a few weeks after my return," he wrote, "I felt happier, perhaps, than I ever did in my life." But such moments were short-lived.

During the winter of 1843–44, Cole arranged to hold an exhibition of his paintings at the National Academy, still located in rented rooms in Clinton Hall. The second version of *The Voyage of Life* was to be the main feature, but if Mrs. Luman Reed were willing to lend *The Course of Empire*, the two great series could be shown at one time. To Cole's disappointment, she refused. In its place he decided to paint a large scene of Mount Aetna with the ruins of the Greek amphitheater at Taormina in the foreground.

Cole set up his easel in the center of the National Academy gallery surrounded by his own paintings on the walls. When his sister Sarah came to visit, she found him in his shirt sleeves holding a large brush in one hand and a palette piled with colors in the other. "Ah, Sarah," he said, "this is the room to paint in—and this is the way I love to paint." In his enthusiasm, Cole completed the painting in record time. When Daniel Wadsworth bought it for five hundred dollars for his proposed Hartford museum, Cole commented, "Pretty good for five days work."

Fig. 16. The Voyage of Life: Childhood, 1842

Thomas Cole (1801–1848)

Oil on Canvas, 52 7/8 × 76 7/8 in. (1.343 × 1.953 m.)
framed: 64 1/8 × 88 1/2 × 7 in. (1.629 × 2.248 x .178 m.)

Ailsa Mellon Bruce Fund

Image © 2007 Board of Trustees, National Gallery of Art, Washington

1971.16.1 (2550)/PA

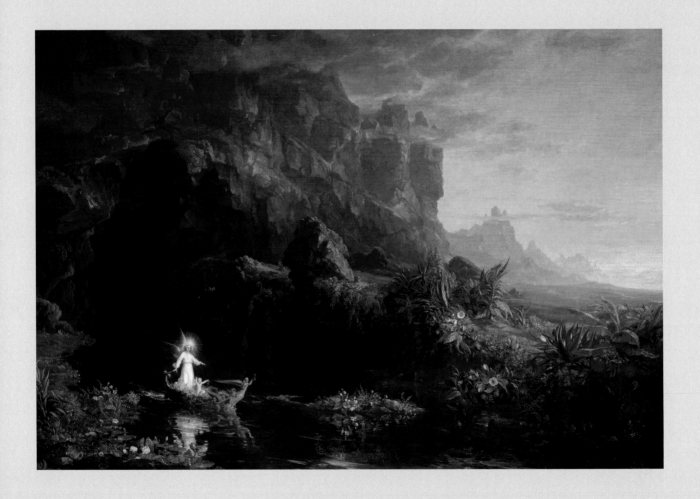

Fig. 17. The Voyage of Life: Youth, 1842

Thomas Cole (1801–1848)

Oil on Canvas, 52 7/8 × 76 3/4 in.

Ailsa Mellon Bruce Fund

Image © 2007 Board of Trustees National Gallery of Art, Washington

1971.16.2

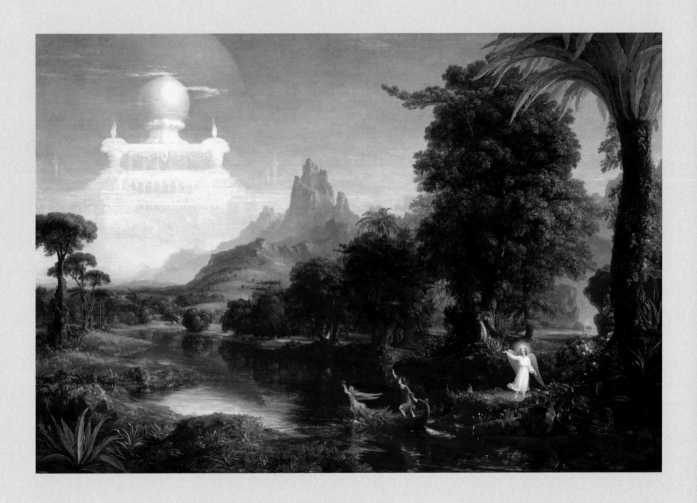

Fig. 18. The Voyage of Life: Manhood, 1842

Thomas Cole (1801–1848)

Oil on Canvas, 52 7/8 × 79 3/4 in. (1.343 × 2.026 m.)
framed: 64 × 91 × 7 in. (1.626 × 2.311 × .178 m.)

Ailsa Mellon Bruce Fund

Image © 2007 Board of Trustees, National Gallery of Art, Washington

1971.16.3 (2552)/PA

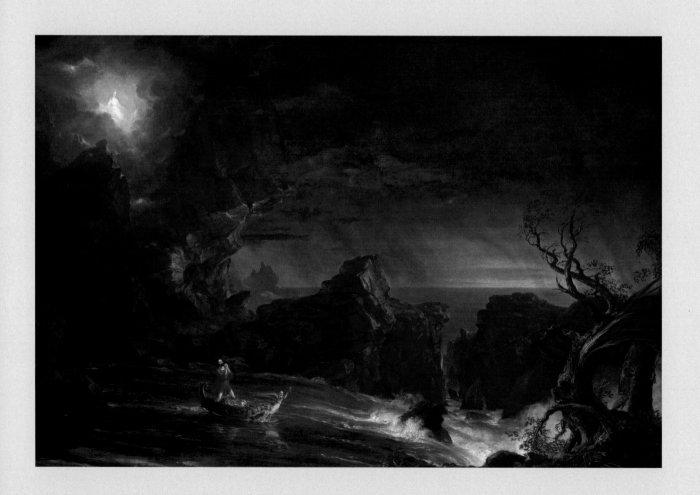

Fig. 19. The Voyage of Life: Old Age, 1842

Thomas Cole (1801–1848)

Oil on Canvas, 52 1/2 × 77 1/4 in. (1.334 × 1.962 m.)
framed: 64 1/8 × 88 7/8 × 7 in. (1.629 × 2.257 × .178 m.)

Ailsa Mellon Bruce Fund

Image © 2007 Board of Trustees, National Gallery of Art, Washington

1971.16.4 (2553)/PA

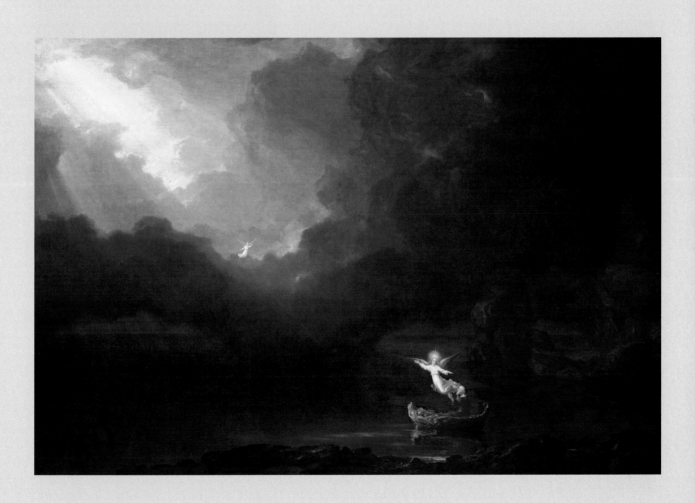

Fig. 20. Thomas Cole, c. 1845.

Image is courtesy of the Macbeth Gallery records, 1838–1968 (bulk 1892–1953), in the Archives of American Art, Smithsonian Institution.

The exhibition itself, however, proved unprofitable. The admission fee seemed high to a public not yet fully recovered from the Panic of 1837. The National Academy exempted Cole from paying the rent, but it also concluded that one-man exhibitions were not worthwhile. Eventually this version of *The Voyage of Life* was sold to George K. Shoenberger of Cincinnati. When his mansion was converted to a home for the aged, the paintings remained hidden away in the house until they were rediscovered in 1962.

Soon after *The Voyage of Life* was exhibited, an incident occurred at a Sketch Club meeting that revealed the gravity with which Cole approached his mission as an artist. The host of each meeting customarily chose a theme for the artists to illustrate. The given subject that evening was "Just in Time." One artist depicted a boy jumping a fence just in time to escape an enraged bull. Another depicted a half-starved man entering a house just in time for a lavish dinner. The humorous genre painter, William Sidney Mount, was looking particularly mischievous that evening. When his turn came to place his drawing on the table, he showed a sketch of an angel lifting an old voyager to heaven by his collar just in time to escape the grasp of the Devil. It was immediately recognized as a caricature of the last painting in Cole's series, *The Voyage of Life*, and

the members enjoyed a good laugh—with the exception of Cole, who appeared to be mortified. One of those attending the meeting said, "It made us all feel sad to see Cole take the joke so seriously."

Cole persisted in his search for patrons who would commission paintings with a moral theme. In an effort to fill the gap left by Reed's death, Cole wrote to Jonathan Sturges, who owned a number of his landscapes, about his idea for a series that would arouse a "holy feeling." Sturges was not interested; he had no room to hang a series of large paintings. Cole then wrote to one of his first patrons, Daniel Wadsworth, whose museum could offer the spacious setting such paintings required. Instead of a commission, Wadsworth replied with a request that Cole take on a young man from Hartford as a pupil. He has "received a good education and has considerable mechanical genius. His personal appearance and manner are prepossessing," Wadsworth assured him.

Cole had never before taken a pupil, but young Frederic Church's father was willing to pay for his son's instruction even though he disapproved of a career in art. The deftness of Frederic's sketches and the seriousness with which he had pursued his studies with local artists had finally convinced the staunch Connecticut Yankee to yield to his son's wishes. Once committed to helping him, Mr. Church enlisted the services of Wadsworth to persuade the best landscape painter in the country to accept him as a pupil.

On June 4, 1844, when the ferry docked at Catskill Landing, a slender young man of eighteen disembarked and climbed the hill to Cedar Grove. A barking dog met him at the gate, and Theddy and Mary scampered down the steep porch steps to catch their first glimpse of the young man coming to study with their father. As soon as Frederic met the older artist and his warmhearted wife, he felt assured that he had taken the right course.

Frederic Church (Fig. 28) had been born in Hartford, Connecticut, on May 4, 1826. His ancestry traced back to Richard Church, who had accompanied Rev. Thomas Hooker's party from Massachusetts Bay Colony to found a new town on the banks of the Connecticut River, which was to become Hartford. Frederic's mother traced her lineage back to William Bradford, the second governor of the Plymouth Colony. His father was a respected and prosperous businessman who owned a variety of enterprises,

from a jewelry and silver shop to half-interest in a paper mill in Lee, Massachusetts. He served on the boards of the Connecticut River Banking Company, Aetna Insurance Company, and as an officer in the Mechanics Society. Like most fathers of that time, he had expected his son to follow in his footsteps.

As a boy, Frederic had accompanied his father on visits to Daniel Wadsworth's home. He had passed long hours gazing at the paintings that hung on his walls—among them one of Cole's earlier paintings, *Kaaterskill Falls*. He had also been allowed a peek at Cole's recently painted *Mt. Aetna from Taormina*, which was in Wadsworth's safekeeping to await the opening of his museum. These paintings had acquainted Frederic with Cole's work from an early age, and by the time he was eighteen, he was bent on becoming an artist.

Thomas Cole was delighted with his young student. He often said, "Church has the finest eye for drawing in the world." They spent summer days rambling through the Catskills, making studies from nature. Church adopted Cole's habit of writing descriptions of color and atmosphere on his pencil sketches. When he began to work in oil, he was quick to pick up techniques that Cole had so laboriously taught himself. After a year, Church was ready to exhibit at the National Academy. In two years, he was ready to strike out on his own.

IX

THE ART-UNION

epression and self-pity began to take hold of Cole after the departure of Church. He realized how isolated he had become from mainstream artistic life in the city. In winter, after the Hudson had frozen over, he did not dare risk the rough and lengthy stagecoach ride over a hundred miles of icy roads to New York City. The thought of the Sketch Club brought back the painful memory of Mount's mockery of his *The Voyage of Life*, and he rarely attended meetings now. With snowdrifts against the window panes and a stove warming the room, he penned forlorn words to a friend in New York, "I have heard of late next to nothing. I am in a remote place. I am forgotten by the great world, if I ever was known."

Cole was saddened by the financial failure of his recent exhibition and his inability to find a patron for another series. He wondered whether his unhappy state was caused by his deficiency as a painter or the times in

which he lived. Whereas years earlier he would have given his left hand to say that he had been born in America, it now appeared that his adopted country was letting him down. The public's apparent lack of sympathy for elevating mankind through art made him unhappy about the state of culture in America. "I am not the painter I should have been had there been a higher taste," he complained.

Popular sentiment was increasingly turning to landscape painting. For years his patrons and friends had been urging him to direct his talent toward painting the scenic beauty of America. Cole had replied angrily to these pleas, insisting that he did not want to be a "mere leaf painter," and stubbornly threw more energy than ever into painting moral allegories for which he had no patrons.

During a visit from Durand, he spoke badly of nearly all of the younger artists. Durand thought that he might be jealous. Cole was now well into his forties. His embitterment was beginning to mark his appearance. His shoulders became stooped and his eyes took on a strange, faraway look. He became preoccupied with work. Many people whom he used to welcome to his studio found him so absorbed in painting that he gave only a quick smile and a gentle "go away."

During these years the local Episcopal minister, Louis Legrand Noble, became Cole's close friend and later his biographer. Together they took long walks in the woods. Noble spoke often of the meaning of Christianity, and Cole began to attend services regularly. He decided to be baptized and to join the church. Finding a religious outlet seemed to push him further into a spiritual mania. Durand was disturbed by the changes in his friend. After a visit, he was convinced that Cole never again would paint a great landscape painting.

The passing of time had served Durand well (Fig. 21). His hair, though now decidedly gray, was long and thick. He wore a beard, and his animated eyes shone brighter than ever. His simplicity, cheerfulness, and humor attracted many friends, while his generosity and sound judgment brought him influence. Younger painters came to him for advice. His work was also causing a stir. He was exhibiting outdoor studies in oil on canvas as finished works of art. Traditionally studies were made only as preparation for large compositions and were not considered suitable for exhibition. In 1841, however, the invention of the tin paint tube

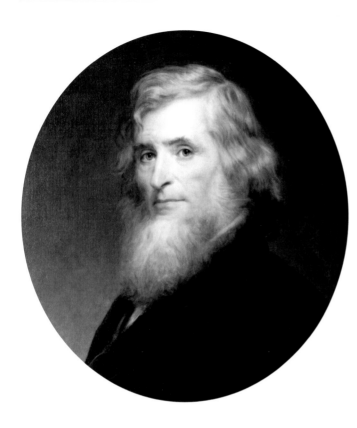

Fig. 21. Asher Brown Durand, 1864

Charles Loring Elliott

Oil on Canvas, 27 × 22 in.

Corcoran Gallery of Art, Washington D.C.

Museum Purchase, Gallery Fund

76.11

allowed artists to carry oil paints into the field rather than having to grind and mix them in the studio. With portable equipment, artists could finish their work on site. Durand produced a series of outdoor studies, such as *Rocky Cliff* (Fig. 22), on which he lavished detail and went so far as to discard conventional modes of composition in order to follow nature's arrangement.

On a trip to Europe in 1840, Durand enjoyed the company of three younger men, one of whom, John Kensett, was to become a major contributor to American landscape painting. Born on March 2, 1816, in Cheshire, Connecticut, Kensett was twenty years younger than Durand but shared a background in engraving with the older man and worked a short while in the shop of Peter Maverick, Durand's former partner. Durand generously offered assistance to Kensett who, like himself years ago, was trying to change his profession from engraver to fine artist. But it was not an easy transition. In Paris Kensett had to continue engraving

to support himself, using his evenings to study art at the École Préparation des Beaux-Arts. As his skill improved, he found a market for his paintings in New York through the National Academy of Design and a new organization called the American Art-Union, but he remained constantly hard-pressed for money. At the age of twenty-eight he had given up the thought of marriage. He confessed to his brother, "I have long set myself down a confirmed old bachelor, beyond the hope of redemption—I am wedded to the arts and they must be my bride, and a more charming mistress I could not hope to win."

Fig. 22. Rocky Cliff, c. 1860

Asher B. Durand (1796–1886)

Oil on Canvas, 16 1/2 × 24 in. (41.9 × 61 cm.)

Reynolda House, Museum of American Art

Winston-Salem, North Carolina

Having no dependents, Kensett stayed abroad six more years, but Durand returned home in 1841. His firsthand knowledge of Old Masters made him a popular teacher at the National Academy's art school. His leadership skills were also appreciated through his service on the council and special committees. When Samuel F. B. Morse resigned as president in 1845 following his successful demonstration of the telegraph, Durand was elected to the office. The following year was the strongest in the National Academy's history. Three hundred and forty-six works of art were exhibited that spring, and admission fees of $5,665 were collected. The National Academy had come a long way since its first exhibition. New Yorkers by the hundreds were now attending its shows and paying to do so.

Although a broader range of people had become interested in art, many of them could not afford to purchase the paintings they admired. To serve this potential market, a group of businessmen organized the American Art-Union (Fig. 23) in 1842. Joining the Art-Union cost five dollars a year, for which each member received an illustrated bulletin, an engraving of an American painting, and a ticket for an annual art raffle. Paintings were submitted to the Art-Union from all over the country and exhibited upon arrival. The union's managers met periodically to decide which ones were to be purchased. The rejected paintings were returned to the artists, and the ones accepted remained on exhibition. This process continued from April to December gradually filling the gallery walls. At the end of the year, the paintings were raffled off to members.

Located at 497 Broadway, the Art-Union contributed considerably to broadening public enthusiasm about art. Running the length of the block, the galleries were used as a major thoroughfare. Since there were no admission fees, people from all walks of life could enjoy the art. In early morning children with satchels could be seen romping through on their way to school. Then came merchants in black frock coats and high hats and later, ladies in flounced skirts and straw hats. In the evenings and especially on Sundays, working-class families joined the throngs.

Since its members came from other cities in the country, offices were also opened in Cincinnati, Philadelphia, Trenton, and Boston. With such wide geographical range, the Art-Union was far more national than the National Academy, whose activities were

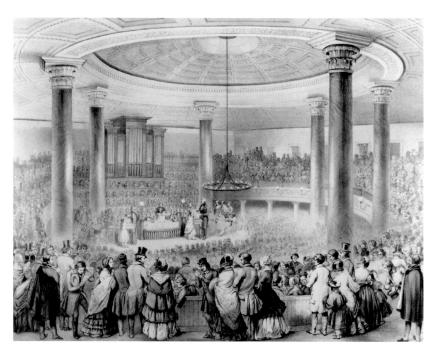

**Fig. 23. Distribution
of American Art-Union
Prizes, 1847**

*Drawn on stone by Davignon
Published by Sarony
and Major, 1847
Museum of the City
of New York
Clarence Davies Collection*

confined to New York. The Art-Union encouraged artists to develop their own style, select native subjects, and paint with freshness. For a limited period, it became the most important patron of the arts in the country. During its best year, the union bought and distributed as many as 460 paintings.

Most members of the National Academy regularly sent paintings to the Art-Union, which also commissioned paintings from them. In 1847 it offered Cole five hundred dollars to paint a landscape of his own choice. Although Cole's work would have been worth twice as much on the marketplace, like most artists he went along with Art-Union prices in expectation of future commissions. Cole selected a White Mountain scene of a log cabin on a quiet lake with the peak of Mount Chocorua in the distance and called it *Home in the Woods.*

The Art-Union, however, became increasingly competitive with the National Academy of Design. Instead of planning exhibitions that would not conflict with the National Academy's spring exhibition, the shrewd union managers capitalized on their rival's audi-

ence by announcing their new acquisitions immediately after the National Academy had set its opening date. As a result, academy receipts dropped drastically. Dependent on admission fees for its survival, the National Academy's exhibitions were no match for the free ones sponsored by the Art-Union. Durand called a special meeting to try to solve the Academy's financial difficulties. The decision was made to close the art school, ask Jonathan Sturges and other wealthy merchants to help financially, and find ways to attract more people to the annual exhibitions.

While Durand in New York City was desperately fighting for the survival of the National Academy, Cole in Catskill was fighting for his own survival. His health had deteriorated to such a degree that he had contracted acute inflammation of the lungs. On February 11, 1848, Cole's friends received word that he had died. The Art-Union offered its galleries for a memorial exhibition, and the largest collection of Cole's paintings ever assembled at one time was shown. The quality of the work astounded even Cole's patrons and friends. Not until after his death did they realize the extent of his genius.

A second event that year brought Cole even greater recognition. The first version of *The Voyage of Life*, which had been collecting dust in Samuel Ward's storeroom for eight years, was released for sale. The Art-Union quickly snatched it up as one of its year-end prizes. Unlike the first exhibition of the series, which had not drawn enough people to pay the gallery rental fee, this one was widely promoted and union subscribers surged from 9,666 to 16,475. Although its subject did not appeal to those who had a stake in the advancement of pure landscape, the series reflected the prevailing religious sentiment held by many at that time.

The Art-Union's success contributed to the National Academy's problems by causing its admission receipts to drop by half, from $5,665 in 1846 to $2,753 in 1848. Debts were piling up, and Durand had to make the humiliating decision to ask members to donate paintings to sell in order to pay creditors.

Nevertheless, as the public began to extol Thomas Cole as the founder of the first American school of landscape painting, a heightened interest in this country's art began to emerge. In 1848 Jonathan Sturges provided an opportunity for Durand to paint the

Fig. 24. Kindred Spirits, 1849

Asher B. Durand (1796–1886)

Oil on Canvas, 44 × 36 in.

Courtesy Crystal Bridges Museum of American Art,
Bentonville, Arkansas

masterpiece of his long career (Fig. 24). He asked him to depict Cole and William Cullen Bryant as pioneers in awakening Americans to the natural beauty of their country. Durand decided to place the artist and the poet standing on a rock ledge with Kaaterskill Falls in the background. Carrying his red sketch book, Cole directs Bryant's attention towards the view. The poet appears to be listening to the artist's discourse, which his friends called his "wood and field talk." A detail bears witness to their friendship as well as to Durand's earlier engraving career; he painted their names to appear as though they had been carved into the bark of a tree.

Durand's former traveling companion, John Kensett (Fig. 43), returned to New York in 1847 after seven years abroad. He quickly met with critical success, good sales, and election to the National Academy. Within two years he was elected to the Century Association, an outgrowth of the Sketch Club, which brought together artists and writers with men who could help advance their careers. The Century held receptions for prominent visitors like the English author, William Makepeace Thackeray, who came to New York in 1852. Kensett had met the novelist in London while he was still a struggling writer; since then, the publication of the novel *Vanity Fair* in 1846 had made him a celebrity. New York's artists and writers, including Bryant, Irving, Morse, and Kensett, crowded into the Unitarian Church on November 19 to hear Thackeray's lecture. Later Kensett invited him to his studio to see his sketches. In a letter to a friend, Thackeray described Kensett's New England woods as "shaggy" and "melancholy." With a touch of humor, he added that Kensett's trees resembled "shriveled matrons." Nonetheless, Thackeray thought him an "excellent artist."

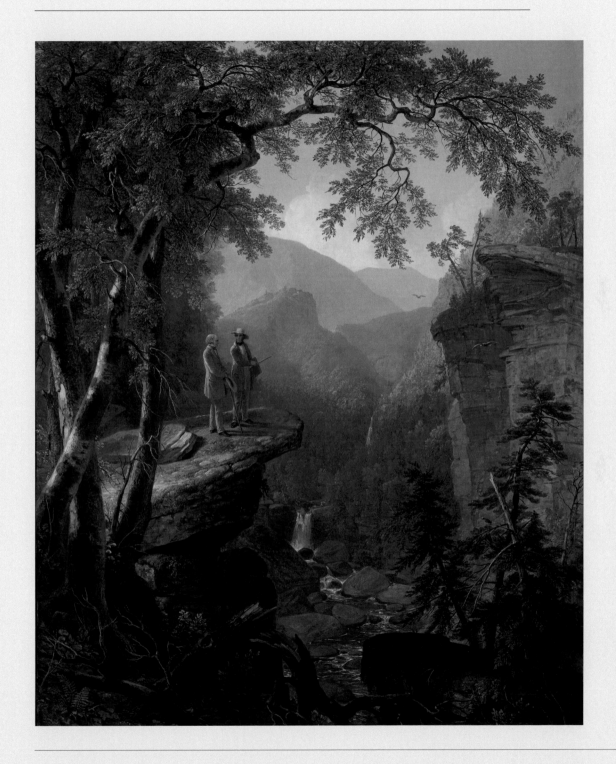

X

DÜSSELDORF

ust as the National Acad-emy of Design was beginning to recover from its financial difficulties, a new gallery opened in New York in 1849 exhibiting a collection from the famous art academy in Düsseldorf. Fifty-six paintings had been shipped to America to protect them from damage during the 1848 revolution in Germany. Showing a degree of technical proficiency that had not been seen in this country, they caused a sensation. The governing body of the Art-Union concluded that American artists would benefit from the kind of professional training offered in Düsseldorf. Their widely read *Bulletin* promoted this opinion, and a number of artists who had found art instruction to be wanting in this country began giving serious consideration to studying abroad.

Worthington Whittredge (Fig. 34) was one among a number of American artists who found their way to Düsseldorf. He was born on

May 22, 1820, in a log cabin on the Little Miami River near Springfield, Ohio, where he worked on his father's 120-acre farm, attending school only a few months of each year. Beaver, muskrat, and otter were so plentiful in Ohio that he moonlighted as a trapper. Leaving his warm bed about midnight, he tramped through snow to inspect his traps, returning to the farm laden with pelts in time to milk the cows. He hoped that his father would use the money made from selling furs for his high-school education, but his father refused. His son was to stay home and work on the farm.

By the time he was seventeen, Whittredge had decided that he wanted to become an artist, but he did not dare tell his father, who believed that any man who spent his life "dabbling with crayons and paint" was a "lost soul." His mother was more sympathetic. Once he had made the decision to leave, she helped him on his way by making him a homespun suit and providing him with a little money. With only two dollars and fifty cents in his pocket, Whittredge went to his sister's home in Cincinnati, where he hoped to find employment in his brother-in-law's painting business. "Of course, there is a gulf of many thousand miles between a house painter and a painter of pictures," Whittredge admitted in his autobiography, "but somehow the gulf did not seem so wide to me at that time." To a boy of seventeen with ambition to be an artist, just the prospect of handling paint and estimating color effects seemed exciting.

After months crouched on the floor painting baseboards, Whittredge began to realize that he needed to advance, so he began to spend his evenings copying letters out of books until he learned how to form them perfectly. He was then promoted from house painter to sign painter. During the 1840 presidential campaign, he made a start at portraiture by painting the face of the Whig candidate, General William Henry Harrison, on hundreds of banners. Since Harrison won by an overwhelming majority, Whittredge thought that he must have made a tolerable likeness.

After a few years he decided to open a daguerreotype studio with a friend in Indianapolis, which was still a frontier town with a population of about four thousand. He soon learned that a dollar in Indianapolis was worth only thirty-five cents in Cincinnati, and even less in Paris, where he had to buy the silver plates. The venture failed, and he found

Fig. 25. The Card Players, c. 1847–50

William Sidney Mount (1807–1868)

Oil on Panel, 19 × 24 3/4 in. (48.3 × 62.9 cm.)

Reynolda House, Museum of American Art

Winston-Salem, North Carolina

himself destitute and seriously ill. He lay in bed in a room above a restaurant for a week. Finally, the minister of the Presbyterian church took him under his care.

The minister was Henry Ward Beecher, who was later to attract a huge following as pastor of Plymouth Church in Brooklyn. Whittredge had met Beecher in Cincinnati at the church of Rev. Lyman Beecher, Henry's father. The Beecher home, on a hill two miles from town, was always open to a stream of visitors. On cold winter nights after choir practice, Whittredge had often ridden in a sleigh up the winding road to enjoy their hospitality.

Soon after Henry Beecher and his wife moved to Indianapolis, they had come down with malaria, which had been rampant there. The length of Whittredge's recovery suggested that he, too, had succumbed to the virulent disease. During his convalescence at the Beecher home, he undoubtedly heard the sermons that Henry Beecher was assembling for a book entitled *Seven Lectures to Young Men*, which came out in 1844. The book was widely read, and its influence reached Stony Brook, Long Island, where artist William Sidney Mount transcribed Beecher's vivid descriptions of the pitfalls of idleness into genre scenes. In a painting entitled *The Card Players* (Fig. 25), begun not long after Beecher's book came out, Mount softened the author's image of drunken gamblers by showing two rural men playing cards in a shack. On close observation, however, a gold coin on the card table indicates that they are, in fact, gambling. Mount magnified the satire by placing a discarded sermon in an overturned barrel, suggesting that one of these men might be the preacher himself.

Whittredge made no comment on Beecher's sermons, but he recalled being privy to monthly readings of a round-robin letter, which circulated to each member of the Beecher

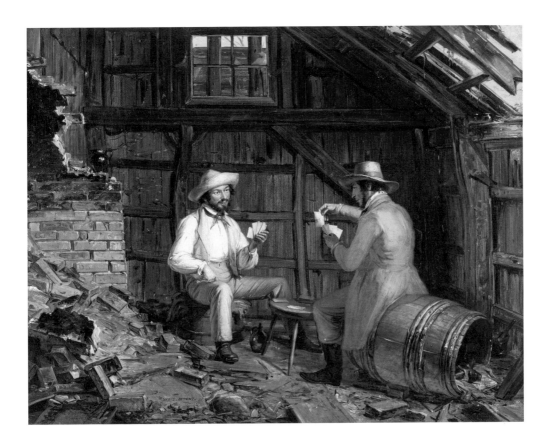

family. Since slavery was often discussed in the letters, he speculated that Henry's sister, Harriet Beecher Stowe, found inspiration in them for her influential novel *Uncle Tom's Cabin*. Slavery, however, was an issue on many minds in the decades before the outbreak of the Civil War.

After a year with the Beechers, Whittredge returned to the family farm. When his father saw how skilled he had become at painting portraits, he grew better disposed toward his son's profession. Whittredge then went to Charleston, West Virginia, in hopes of finding commissions from the wealthy families who owned interests in the salt works. He spent all winter painting the portrait of a senator's wife, who kept him spellbound by her feminine wiles. Finally realizing that he was wasting his time, he ripped apart the canvas in disgust and hopped a boat back to Cincinnati.

Located on a bend of the Ohio River, Cincinnati was a prosperous port town. It also had a lively assortment of cultural institutions, which had hosted the famous English novelist Charles Dickens on a lecture tour in 1842. In Cincinnati Whittredge decided that he would be happier if he looked to the outdoors for subject matter. By 1846 he had gained enough skill to send a landscape called *View on the Kanawha, Morning* to the annual exhibition of the National Academy of Design. Its acceptance brought a complimentary letter from Durand, then in his first term as president. The letter encouraged Whittredge to continue painting landscapes, and from then on he submitted to academy exhibitions each spring.

A prominent Cincinnati lawyer, Nicholas Longworth, had assembled an art collection that included a number of Dutch paintings, a large history painting by Benjamin West, and marble busts by Hiram Powers, a local sculptor working in Florence. Powers's statue *The Greek Slave* was then touring American cities and causing a sensation. Collections in Cincinnati like Longworth's gave Whittredge an opportunity to study a wide range of original art.

Whittredge was exhibiting regularly at agricultural shows and charity fairs where his work was selling well. When he began to consider studying abroad, he sought support from local patrons. William Scarborough, whom he scarcely knew at the time, gave him a letter of credit for one thousand dollars. In return, Whittredge was to send his paintings to Scarborough who would then sell them to other patrons. These transactions supported Whittredge throughout his European stay.

By 1849 he was ready to depart, but before sailing, he spent a week in New York, where he visited the newly opened Düsseldorf Gallery. He was impressed by Carl Friedrich Lessing's *Martyrdom of John Huss*, which was attracting much attention. He was also enthusiastic about works by the gifted landscapist Andreas Achenbach and the genre painter Johann Peter Hasenclever.

When he arrived in Europe, he did not go straight to Düsseldorf, but stopped just outside of Paris to visit a group of landscape painters working in the village of Barbizon. He described them as " 'Kickers,' rebels against all pre-existing art," but neither their defiant

attitude nor their loose handling of paint appealed to him. Like many other American artists, he believed that exacting realism was required to record the newly discovered natural beauty of his country, and Düsseldorf was the place to acquire it.

A quaint old town on the Rhine, Düsseldorf is located in western Germany in the province of Westphalia. Tall, gabled houses with leaded windows and projecting eaves lined its narrow cobblestone streets. Small Gothic chapels and parks brilliant with flowering hawthorns, lilacs, and chestnuts gave the town great charm. Artists from many countries flocked to the famed Düsseldorf Academy of Art. Those who did not want to submit to its academic discipline were nonetheless attracted to the town's lively artistic community. They freely visited studios, learned from one another, and enjoyed lively discussions in tavern gardens. The frequent art exhibitions, the friendly people, and the beauty of the Rhineland made it an ideal place for artists to acquire their training.

Whittredge hoped to avoid the drudgery of drawing from plaster casts in academy classes by gaining acceptance in the studio of Andreas Achenbach, whose work he had admired in New York. Achenbach, however, did not take students, believing that they might copy him rather than develop their own style. Whittredge thought that if he could persuade Mrs. Achenbach to rent him her spare room, he would have the benefit of her husband's critiques of his work. He had had little difficulty becoming acquainted with important Düsseldorf artists, because he was acting as agent for Cincinnati collectors; but placing himself on familiar terms with the Achenbachs was going to require extra ingenuity.

To win the attention of the lady of the house, he studied German harder than ever and sent to the United States for a present that was uniquely American. When the crate arrived, out came a chair "without a scratch, shining and beautiful," Whittredge remembered. The Achenbachs were baffled by its incessant rocking. "Can't the thing stand still?" they inquired. "It is not intended to stand still," Whittredge assured them. "It is intended to sit in at ease and rock gently back and forth." The Achenbachs covered their eyes and refused to sit in it. Merely looking at it made them dizzy.

Nevertheless, Whittredge was allowed to rent the garret room on condition that he agree not to enter Achenbach's studio without an invitation. He later recalled, "I walked

on tiptoe past his studio for an entire year without once going in." When the master finally looked at one of his paintings, he only commented, "*Sehr gut.*"

After giving up on Achenbach, Whittredge turned to Emanuel Leutze, who was known for his encouragement of American artists. Leutze had grown up in Philadelphia as the son of German immigrants, and in 1841 had gone to Düsseldorf, where he gained enough success for local newspapers to report that Carl Friedrich Lessing had accepted him as a student. The paintings that Leutze sent to the National Academy of Design for exhibition received considerable attention, and he became widely known when the American Art-Union selected one of his works to be engraved and distributed to subscribers.

In addition to being the earliest and most promising American artist in Düsseldorf, Leutze had abundant charm and a penchant for showmanship. The day Whittredge appeared at his studio, he wore a long painter's robe and a little cap on his head. His pipe reached nearly to the floor. He was working on a giant-sized canvas on which he had just finished transferring a sketch. Titled *Washington Crossing the Delaware* (Fig. 26), the painting was to bring him enormous fame when it was sent on tour in America. Whittredge's arrival was a godsend, because Leutze wanted only Americans to pose for figures. He had already asked help from an American student, Eastman Johnson, in obtaining an exact copy of the general's uniform. Having painted portraits of numerous political figures, Johnston was able to use his contacts in Washington. Finding someone tall enough to wear it had seemed hopeless, however, until Whittredge walked in. He was recruited immediately and outfitted in full military regalia. He posed for two hours with one hand holding his cloak to his chest and the other on his knee grasping a spyglass. Afterwards, Whittredge reported in his autobiography, Leutze "poured champagne down my throat and I revived."

Whittredge was invited to work with Leutze and six other artists in the large hall that accommodated his twenty-four-foot canvas. As the painting progressed, he was asked to help with the sky. The large area had to be finished in one day so that the gradations would blend smoothly before the paint dried. According to Whittredge, it was Achenbach's idea to paint a single star in the sky to indicate that Washington's landing took place shortly before dawn. Eastman Johnson was assigned a more difficult task. He had to copy

Fig. 26. Washington Crossing the Delaware, 1851

Emanuel Leutze (1816–1868)

Oil on Canvas, 149 × 255 in. (378.5 × 647.7 cm.)

The Metropolitan Museum of Art

Gift of John Stewart Kennedy, 1897

Photograph © 1992 The Metropolitan Museum of Art

97.34

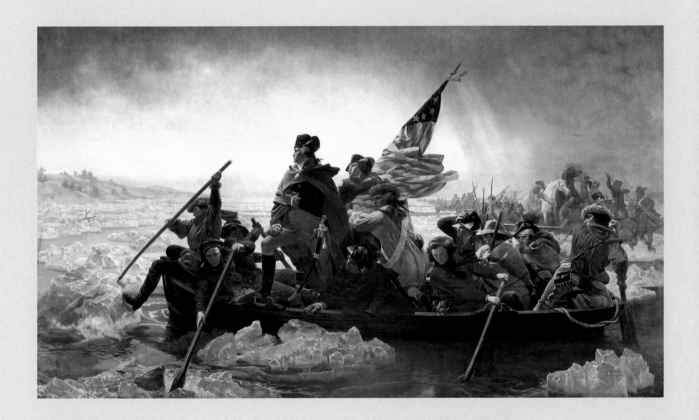

the original painting on a smaller scale so that it could be engraved. In a letter home he wrote that three cannons had been brought into the studio as props, and visitors were received "with three guns."

Whittredge was a full-bearded, handsome man with a dark complexion, prominent nose, and heavy-lidded brown eyes. He looked so much like a Spanish don that Leutze posed him for a portrait in a Spanish nobleman's costume. When younger, Whittredge had been embarrassed about his bald head and wore a toupee. Feeling more self-confident after a few years in Europe, he had decided it was time to reveal the secret that he had concealed from even his most intimate friends. After much wine and fun at a Fourth of July celebration during a summer sketching trip, the opportunity arose. A German girl in the party inquired about the American Indians' practice of scalping their victims. Whittredge abruptly seized a knife, gave a war whoop, climbed a nearby tree, and, hanging from a branch by his knees, to all appearances sliced his hairy scalp from his head and threw it on the ground. Three girls fainted, but Whittredge was rid of his toupee forever.

Complaining that there was nothing to study in Düsseldorf but the work of local artists, Johnson, who wanted to paint scenes of everyday life, left Leutze's studio after six months for The Hague to study seventeenth-century masters Rembrandt and Frans Hals as well as Dutch genre painters. Whittredge stayed in Düsseldorf for another four years and was still working in Leutze's studio when a handsome but despondent young man arrived and introduced himself with a quick bow as Albert Bierstadt (Fig. 47).

He had come to Düsseldorf to visit his cousin, the genre painter Johann Peter Hasenclever, only to find that he had recently died. Bierstadt had been born near Düsseldorf on January 7, 1830, but had grown up in New Bedford, Massachusetts, where his father, a cooper, made barrels in which whale oil was stored and shipped. After school he had helped in a frame maker's shop where he had become interested in painting. Leutze offered to look at the sketches he had brought with him, but he was not favorably impressed. Whittredge took pity on the young artist and invited him to share his studio for the winter. As months went by Whittredge observed that Bierstadt refused all dinner invitations,

especially if it seemed that they had to be reciprocated. He had no money to spend on beer or wine, so he never joined the artists' gatherings at their favorite tavern, Malkasten. He preferred to be thought unsociable rather than poor.

When April came, Bierstadt packed his paint box, stool, and umbrella in a large knapsack and started off to try his skill in the Westphalian countryside. Whittredge heard nothing from him all summer. In late autumn he returned loaded with studies of meadows, lakes, oaks, Westphalian cottages, and one very fine study of sunlight on the steps of an old church. Whittredge thought it a remarkable summer's work for an artist who had had little instruction. As Bierstadt worked his studies into large canvases, even Leutze had to agree that he had talent. Bierstadt's improvement as an artist occurred so rapidly that New Bedford citizens could not believe he had really painted the European scenes which he sent home for sale. It was suggested that he had signed his name to paintings done by Leutze or Whittredge.

When that rumor reached Düsseldorf, Bierstadt's friends were outraged. Leutze and Whittredge immediately wrote a letter to the New Bedford newspaper endorsing the pictures as the genuine work of Bierstadt. Leutze told his friends about the rumor, and Achenbach and Lessing insisted upon adding their signatures to the letter. When it was printed in New Bedford, local citizens read it, rallied around Bierstadt, and began to buy his paintings. He was soon earning enough money to travel around Europe and to enjoy the artists' camaraderie at Malkasten.

In 1856 Whittredge and Bierstadt set off to spend the winter in Rome. On the way they stopped at Lake Lucerne in Switzerland, where they ran into Sanford Gifford (Fig. 55), an American artist whom Whittredge had met some months earlier in Düsseldorf. Just before leaving on his "pilgrimage" to Europe, Gifford had been elected a member of the National Academy of Design. He was a tall, lanky man of thirty-three with curly brown hair and dark, brooding eyes. He had a thin, sharp face and a fast stride that enabled him to walk over thirty miles a day. The son of a prosperous iron refiner, he had grown up in Hudson, New York, just across the river from Catskill, Thomas Cole's home. Gifford had attended Brown College for two years and was the only one of the three who was college educated.

Whittredge tells the story of their visit to the village of Nemi on Lake Albano, southeast of Rome. The village had one, very old inn, which had only one bed, celebrated for its enormous size. Bierstadt, Whittredge, Gifford, and Philadelphia artist William Stanley Haseltine spent the night in the famous bed. Two of them slept with their heads in one direction, two in the other. In the spring, Bierstadt and Gifford took a trip to Naples and Capri, but one winter in Rome was enough for both of them. Leaving Whittredge behind, they returned to the United States in 1857.

The New York City that greeted Bierstadt and Gifford was far different from the New York of the 1830s and '40s. Few single residences remained on the south tip of the island. They had been replaced with five- and six-story structures of marble, stone and cast iron. Fashionable brownstone houses were lining the streets from Washington Square to Thirty-Fourth Street. Anticipating that the city would some day cover the entire island, farsighted men under the leadership of William Cullen Bryant had begun to gather support to preserve undeveloped land, which was to become Central Park.

With thousands of Irish and German immigrants moving into tenements, the population had more than tripled since 1825. Horse-drawn cars on tracks, called omnibuses, thundered up and down Broadway, while wires overhead carried messages from one telegraph office to another. Grand hotels advertised a bathroom and toilet on every floor, and new public buildings boasted steam heat. Roving pigs were no longer the sole garbage collectors; the city had organized a sanitation service as well as a police force.

XI

SOUTH AMERICAN ADVENTURE

Along with the out-ward transformation of New York City, its arts and cultural world also changed. Artists William Dunlap and John Trumbull had been buried many years earlier. The older generation of patrons had followed Luman Reed and Samuel Ward to the grave. The voices of New York's first writers had faded; James Fenimore Cooper had died in 1851, and Washington Irving had lived long enough to grumble about the laying of a railroad track between his house, Sunnyside, and his view of the Hudson River. Public attention had shifted to New England writers like poet Henry Wadsworth Longfellow and novelist Nathaniel Hawthorne.

The interest in nature of transcendentalists Ralph Waldo Emerson and Henry David Thoreau bolstered landscape painting. Having heretofore made up about one out of ten paintings in the National Academy

exhibitions, landscapes now dominated them. The younger landscape painters no longer suffered from the feelings of inferiority that had troubled Thomas Cole. They were reading the famous English art critic, John Ruskin, who had demolished the last trace of Sir Joshua Reynolds's belief that landscape was an inferior branch of art.

Now in his late fifties, Durand continued as the leading spokesman in the country for landscape painting. During summer excursions with other artists to Lake George and the Adirondacks, and at winter gatherings at his Amity Street studio, he had ample opportunity to advance his theories of art. In 1855 he was invited to write for *The Crayon*, an art journal founded by his son John and one of Church's pupils, William James Stillman. Durand's articles were written in the form of letters to young artists and took up John Ruskin's argument that there was no longer a need to impose moral lessons upon nature; its mere imitation was sufficient to produce great art. In fact, the act of painting nature was so "fraught with high and holy meaning" that Durand warned against making any alteration to it lest the "Divine Spirit that created it be offended." The goal of the artist, he believed, was not to create an imaginary world but to reveal "the deep meaning of the real creation around and within us."

Durand added a nationalist twist not found in Ruskin's arguments. He told American artists that by searching for subjects in this country rather than in the well-worn paths of Europe, they had a better chance to fulfill art's highest mission. He believed that this country's unsullied natural scenery provided an "unparalleled means for depicting nature as it might have been at the time of Creation." Opposition to these ideas was negligible in the mid-1850s. Artists appeared to be in perfect harmony with their times. Widespread acceptance of the importance of art coupled with the rising economy created an unprecedented demand for landscape painting.

Before Church left Cole's studio in June 1846, he had completed a major painting of the founding of Hartford with the lengthy title *Hooker and Company Journeying through the Wilderness from Plymouth to Hartford in 1636* (Fig. 27). The painting shows a party of settlers led by Rev. Hooker traveling along a ridge. Far below and in the distance, a river runs through a valley. Although meant to suggest the Connecticut River, it resembles the view of

Fig. 27. Hooker and Company Journeying through the Wilderness from Plymouth to Hartford in 1636
1846

Frederic Edwin Church (1826–1900)

Oil on Canvas, 40 1/4 × 60 3/16 in.

Wadsworth Atheneum Museum of Art, Hartford, Ct. Museum Purchase

1850.9

Fig. 28. Frederic Edwin Church, *carte de visite, photographic negative from Brady's National Portrait Gallery, published by E. Anthony, 501 Broadway, New York, date unknown.*

the Hudson from the Catskill Mountain House. Nonetheless, Church made a shrewd choice of subject. Daniel Wadsworth, who had just opened a public gallery in 1844, could hardly ignore a painting of the founding of his hometown. He purchased it for $130 and hung it in the Wadsworth Atheneum, where it can still be seen today.

Feeling the need to be in the center of artistic activities, Church moved to New York City that autumn and rented a studio in the Art-Union building. Apparently he was hard-pressed for money at this time, because he had to ask his father for help. He received a curt reply: "I have no money to spare in this unprofitable business." Church was rescued, however, as were many other artists, by the Art-Union, which in 1850 purchased three of his paintings for a thousand dollars. In the following three years, it purchased as many as twenty-nine of his paintings, helping pay his rent during his early years as a struggling artist.

Deeply saddened by Cole's premature death, Church painted a memorial called *To the Memory of Cole,* which shows a white cross with a floral garland draped over it. The

view of the Catskills in the distance is taken from Cedar Grove. A pinkish-gray cloud soars high above, suggesting Cole's ascension to heaven.

Cole's death seemed to give Church impetus to fill the void, because the following year he produced a painting called *West Rock, New Haven* (Fig. 29) that showed a considerable advance in his development. He selected a view of a large, flat-topped rock jutting above cultivated fields just outside of New Haven. When it was shown at the 1849 exhibition of the National Academy of Design, one critic praised it for being as "accurate as a daguerreotype." Another announced that the twenty-three-year-old artist "had taken his place, at a single leap, among the great masters of landscape." He was elected to full membership in the National Academy, becoming its youngest member. *West Rock* was purchased by his friend, Cyrus W. Field, who was then making his fortune as owner of the largest wholesale paper business in New York City. Field later became famous as the promoter of the first transatlantic telegraph cable.

Church had first met Field on a business trip with his father to a paper mill in Lee, Massachusetts. Field began to join him on Sunday painting expeditions, fascinated by his artistic talent as much as Church was fascinated by Field's business skill. In 1851 they decided to take a trip to the South, while Field and his wife were awaiting completion of their new home on Gramercy Park in New York. One of the first sites Church chose as a subject was Natural Bridge, Virginia. As he was painting, Field entertained himself by climbing the limestone cliffs to gather rocks, so that Church could duplicate their exact hue. Refusing to use them as models, Church explained that atmosphere and light between the viewer and the rocks altered their color. Nevertheless, the painting turned out to Field's satisfaction and hung in his house for many years.

The first volumes of *Cosmos* by the renowned German naturalist and explorer, Baron Alexander von Humboldt, were published in English in the late 1840s. They represented the culmination of nearly fifty years of scientific study. Humboldt traveled to places all over the world where he could test his knowledge. He was particularly attracted to the region of present-day Ecuador, which exhibited the greatest variety of natural phenomena.

Fig. 29. West Rock, New Haven, 1849

Frederic Edwin Church (1826–1900)

Oil on Canvas, 26 1/2 × 40 in.

John B. Talcott Fund

Photo: Michael Agee from the Collection of the New Britain Museum of Art, New Britain, Connecticut

1950.10

As soon as *Cosmos* was available in English, Church was quick to plunge into the writings of the famous scientist. He read about earthquakes, volcanoes, hot springs, animals, and plants. He learned of the interconnections between these phenomena and how "nature works as one great whole, moved and animated by internal forces." Humboldt even addressed the artistic community, predicting that depictions of landscape would achieve an unrealized brilliancy when artists dared to venture far into the interior of tropical continents. Little did he think an American painter would be the first to take up his challenge.

At the same time that Church was learning of South America's scientific and artistic possibilities, Cyrus Field was considering its commercial potential. Like many at that time, he was influenced by the doctrine of Manifest Destiny, based on the belief that this country was destined to bring liberty and prosperity to the entire New World. The United States was meant to expand, not just to the Pacific, but to Canada and Central and South America. One advocate of Manifest Destiny, Matthew Fontaine Maury, in a series of articles on South America in the *National Intelligencer,* envisioned steamboats on the Amazon, settlers building towns on its banks, and plowed fields replacing the jungle. The vast continent, Maury felt, was wasted unless it could support profitable commercial ventures.

Field, the entrepreneur, and Church, the artist, began to make plans to follow Humboldt's route through Colombia and Ecuador. They set sail from New York City in April 1853. After twenty days on the brig *Viva,* they arrived in Savanilla, Colombia, a seaport on the northern coast of South America. They planned to catch a steamer up the Rio Magdalena from the town of Barranquilla, fifteen miles away, but there were no roads, just trails between one town and another. The only means of transportation they could secure were the skinniest, sharpest-boned horses they had ever seen. Exhausted from the heat and aching from the long ride, they finally arrived in Barranquilla, where their spirits were soon revived with a dinner of roast chicken, boiled beef, beans, ham, fried plantains, rice, and a delicious new fruit—mango.

The next morning they discovered that they had missed the steamer and had to wait ten days in Barranquilla for the next one. The delay gave them the opportunity to explore the old town leisurely. Cacti taller than trees, wasp nests larger than bushel baskets, and tur-

key buzzards strutting around houses like chickens fascinated Church. He sent his mother the cast-off skin of a scorpion, asking her to take notice of the curved sting in the tail. He showed her the size of some huge insects by drawing their outlines on the stationery. He sent home so many dried seeds that he asked his parents to build a greenhouse in which to plant them. Field explored the markets—pinching, tasting, weighing, and pricing the tropical fruits. He visited the rubber forests and gold and silver mines, often asking Church to make sketches of them.

On May 10 they boarded the steamer up the Magdalena River, which would take them four hundred miles into the interior of the country. They ate only rice and chocolate, caught a huge tarantula in their cabin, and fought off mosquitoes and sandflies. The steamer pushed against an eight-knot-per-hour current that grew stronger as the river narrowed. Finally the passengers had to transfer to a canoe, which was poled upstream as far as it could go, and then they were forced to continue their trip on mules.

Neither Church nor Field had ever encountered such awesome scenery as they saw on the four-day trip over the Andes to Bogotá. Paths seemed to wind endlessly upward. The air grew thinner. Sometimes the trail ran along the edge of a precipice, sometimes it turned into zigzag steps cut into rock, sometimes it disappeared altogether. The Indians sprang up the mountain paths, but the two hulking Americans had to rely entirely on the sure-footed mules to avoid the misstep that would plunge them hundreds of feet to certain death. Descent was equally treacherous. The mules' front hoofs slid on loose stones, hind hoofs lurched dangerously off the edge. One evening after their Indian guides had stopped for the night, Church and Field went ahead in hopes of finding more comfortable shelter. Each hut they approached appeared so dingy and foul that they ventured on to the next, until they discovered that they had gone far past the last house.

The night was black, and the mules were struggling down a steep, rocky path. They made a safe descent to a tropical forest. For a while, the mules wove in and out of loose vines and thick foliage until Church and Field realized that the path had disappeared. Leaving Field behind with the mules, Church pushed his way on foot through the dense growth in hopes of recovering the path. Having no success, he climbed to the top of a tree and gazed

into the black night looking for a light. The only flicker he could see was that of the stars. He decided to try his Spanish, shouting out that he would give "*cinco pesos*" to anyone who would help him. No answer. Losing his sense of Yankee thrift, he raised his price to ten, then twenty pesos. The only reply came from hooting birds and howling beasts.

He climbed down from the tree and tried to grope his way back to Field. Suddenly the ground seemed to give way. When he recovered, he found himself sitting on the sandy bottom of a stream. Before long the night sounds brought him back to reality, and he tried to climb out of the water. The banks were too high and slippery, and he slid back at each attempt. Finding a thick root, he finally managed to pull himself up from the bank and, "hallooing" all the way, he proceeded in the direction in which he had left Field. At last he heard a faint reply, and in a few moments, found Field lying on the ground hardly able to speak. He was too ill to move. Church made a bed of saddles and blankets for him, but in the dark he placed it on top of a nest of ants, and Field was nearly eaten alive.

In the morning Field was still too sick to travel, so Church left him behind to go for help. Meeting some Indians on the path, he asked the distance to Bogotá.

"Is it two leagues?" he asked.

"*Si, señor.*"

To be certain that they understood, he asked, "Is it five leagues?"

"*Si, señor.*"

"Is it eight leagues?"

"*Si, señor.*"

At long last, Church arrived in Bogotá, where he found the home of an American to whom he had a letter of introduction. Before the day was over, Field had been retrieved and put to bed, while Church entertained his host with stories of their adventures.

The highlight of their stay in Bogotá was a side trip to the Falls of Tequendama, which later became the subject of a painting. They had hired Indians to hack away the thick foliage with machetes so that Church could sketch a view as near as the spray would allow. While he sketched, colorful macaws sailed in the air and bright rainbows appeared in the mist.

Church and Field spent the next six weeks riding four hundred miles on muleback through the Andes from Bogotá to Quito, Ecuador. On the way they stopped to drink from the Vinegar River, which flowed from a volcano near Popayan. They tried making lemonade from its sour waters by adding sugar. "It was delicious," wrote Church, "with a fine flavor sufficiently charged with just enough acid to be agreeable."

After crossing a cold and windy plateau, they came to an eminence overlooking the Chota Valley. "A view of such unparalleled magnificence presented itself," Church wrote, that he "must pronounce it one of the great wonders of Nature." At last his "ideal of the *cordilleras*" had been "realized." That evening he made sketches that would later be used for the showpiece of his first trip to South America, *The Andes of Ecuador* (Fig. 30). As they proceeded south, the jagged peak of Cotacachi appeared and, farther on, loomed the white, rounded form of Cayambe. Their excitement mounted as they approached the capital city of Quito and, in the distance, caught their first glimpse of the conical peak of the 19,344-foot Cotopaxi, the highest active volcano in the world. Already familiar with Humboldt's scientific observations and vivid description, they were nonetheless overwhelmed by the sight of such majesty rising from the earth.

In Quito, Field and Church were invited to stay at the grand house of Modesto Larrea, who introduced them to Rafael Salas, a local artist. They visited churches, convents, and haciendas and climbed Pichincha, a volcano on the outskirts of town. After two weeks, they again headed south and stopped at La Cienega, a hacienda offering a splendid view of Cotopaxi. Church reported that the mountain was hidden in clouds until late in the day, when suddenly they dispersed to reveal the snowcapped peak reflecting the rosy light of the setting sun.

Further south near Riobamba, the travelers passed another mountain made famous by Humboldt—the 20,577-foot Chimborazo, one of the world's highest peaks. Although hoping to sketch it from every possible angle, Church had time to make only a few hasty drawings. It was the end of August. The journey had taken longer than they had planned, and Field was due home for his parents' golden wedding anniversary in October. The two adventurers hurried down the Rio Guayas to the coastal town of Guayaquil, where they

Fig. 30. The Andes of Ecuador, 1855

Frederic Edwin Church (1826–1900)

Oil on Canvas, 48 × 75 in. (121.9 × 190.5 cm.)

Original purchase fund from the Mary Reynolds Babcock Foundation,
Z. Smith Reynolds Foundation, Arca Foundation, and Anne Cannon Forsyth

Reynolda House, Museum of American Art

Winston-Salem, North Carolina

caught the steamer to Panama. After crossing the isthmus by railroad, they took another steamer to New York City.

Still dressed in straw hats and ponchos, Church and Field returned exactly six months and twenty-three days after their departure. Parakeets screeched from cages as their baggage was unloaded. Church's arms were full of branches of dried palms and exotic plants. Field walked down the gangplank with a jaguar on a leash and an Indian boy at his side.

Back in his Broadway studio, Church began painting with such fervor that for the next three years he worked ten hours a day and rarely left New York, even to escape the summer heat. Finding that his small South American views met with enthusiasm at the National Academy, he began a large painting, which was to include many of the features he had sketched on his trip.

Church's method of arranging compositions was to lay his sketches out on a large table, then move them about like pieces of a jigsaw puzzle to see how they could best be combined into a full-sized painting. He worked slowly during this conceptual stage, but once he had decided upon the arrangement and had drawn the compositions on the canvas, he quickened his pace. Beginning to paint from the upper left-hand corner, working downward and across, he was able to complete his painting with a rapidity and precision that utterly astounded those who saw him at work.

The Andes of Ecuador was his largest and most spectacular work to date. On a canvas six feet wide, Church had succeeded in creating a sense of infinite, light-filled space. The view, although not taken from a single spot, is unmistakably based on his sketches of the Chota Valley. Furthermore, the painting illustrates Humboldt's account of the different climates, one ranging above another, which could be seen in Ecuador at a single glance: "The eye surveys majestic palms, humid forests …," he wrote, "then above these forms of tropical vegetation appear oaks and sweetbrier, and above this, the barren snowcapped peaks."

Church, like Humboldt, attempted to encompass all aspects of natural phenomena in *The Andes of Ecuador*. For example, the complex arrangement of the flow of water suggests his desire to capture all the variations in water's form as it makes its long journey down from the mountain ranges to the chasm in the foreground. Along the way, Church

depicts falls, rapids, and serene lakes to indicate water's various ways and speeds of descent. Echoing Humboldt's theories of diversity and unity, the numerous streams finally consolidate in a single current. At this point, colorful birds frolic among the fronds of palm trees as though heralding a bright new day. In the center of the painting, hovering in the sky, is a glowing cross formed by the intersection of the sunbeam with the shiny surface of a plateau.

Church considered his paintings as much a scientific effort as an artistic one. Fortunately, he was gifted with an acute visual memory, which enabled him to record nature with great accuracy. A critic asserted that Church wanted his viewers to be able to rely "on each plant as a veritable transcript ... for no matter how subtle the treatment of a picture, or how artistic its composition, if it had not this basis of truth, we are only polishing pebbles."

When *The Andes of Ecuador* was exhibited in 1857 at the National Academy, the reviewers felt that it "caught and conveyed a new feeling to the mind." Church had composed nature in such a way as to reveal the internal processes that had created it. He had become "the artistic Humboldt of the new world."

The South American trip satisfied Church's loftiest dreams, but it discouraged those of Field, who concluded that the lack of communication among towns, hostility between countries, and the formidable mountains and tropical forests made commerce impossible. On the other hand, Church was inspired to new brilliance. His South American landscapes would bring him widespread recognition and make him the most famous American artist of the mid-nineteenth century.

XII

CHURCH'S FAME SPREADS

After the success of his South American scenes, Church decided to look to North America for a new challenge. Many landscape painters had tried to capture Niagara Falls, but none had succeeded in conveying its true immensity and grandeur. In the spring and summer of 1856, Church paid two visits to Niagara where he made pencil and oil studies from every conceivable vantage point. Recalling how effective the aerial view had been in *The Andes of Ecuador,* he even climbed a tree, hacked away obstructive foliage, and sketched as he balanced precariously on a limb.

Back in his New York studio, he decided to give the scale of the falls greater impact by emphasizing their breadth rather than their height, so he selected an unusual format that was seven feet long and only three feet high. Despite the width of the canvas, he still had to compress the perspec-

tive to bring into view both the American and Canadian shores. Unlike earlier artists who had painted views of the falls from a safe distance, he zoomed in on them, generating in the viewer an uneasy sense of vertigo. Undoubtedly his ability to evoke peril played a key role in the public's charged reaction to the painting.

Church orchestrated the various manifestations of water so meticulously that the eye was fooled into believing them to be real. But he conveyed more than Niagara's visual effect; he captured "its immensity, its duration, its impetuosity, and uncontrollable power." These were the words Thomas Cole had used to describe his own encounter with the spectacle years earlier. Now his pupil had succeeded in evoking those same sensations through a work of art.

The New York press had already identified Church as an artist to watch, and those who had visited his studio spread the word that a masterpiece was in progress. Williams, Stevens, Williams & Company, a new commercial gallery, made an offer of twenty-five hundred dollars for the painting and two thousand dollars for reproduction rights. The gallery exhibited it as a sole attraction for an admission fee of twenty-five cents. *Niagara* (Fig. 31) caused an immediate sensation and was described in the press as "incontestably the finest oil painting ever painted on this side of the Atlantic."

The publicity brought hundreds to see the painting. One of these was itinerant artist Martin J. Heade from Lumberville, Pennsylvania, who would later figure prominently in Church's life. Heade had learned painting from the well-known Quaker preacher and sign painter Edward Hicks, who lived fifteen miles away. Heade also knew Edward's cousin, Thomas Hicks, who painted an oil portrait of him.

In the summer of 1857, *Niagara* was sent to London, where John Ruskin, the famous art critic, declared publicly that he saw "an effect of light upon water" which he had long waited to see in a painting. He also mistook the picture's rainbow for a real one that he thought was reflected by the gallery window, later realizing that it was a part of the painting. Ruskin's error became widely known and enhanced Church's reputation for incontestable accuracy.

Church's fame attracted young artists who wanted to learn his methods, but he had trouble explaining the technique that came so easily to him. His manner was stuffy and

Fig. 31. Niagara, 1857

Frederic Edwin Church (1826–1900)

Oil on Canvas, 42 ¼ × 90 ½ in.

In the Collection of the Corcoran Gallery of Art, Washington, D.C.,
Museum Purchase, 76.15

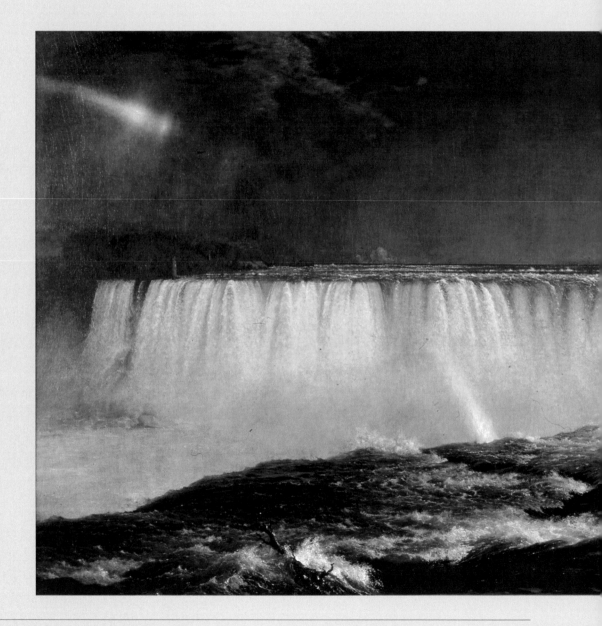

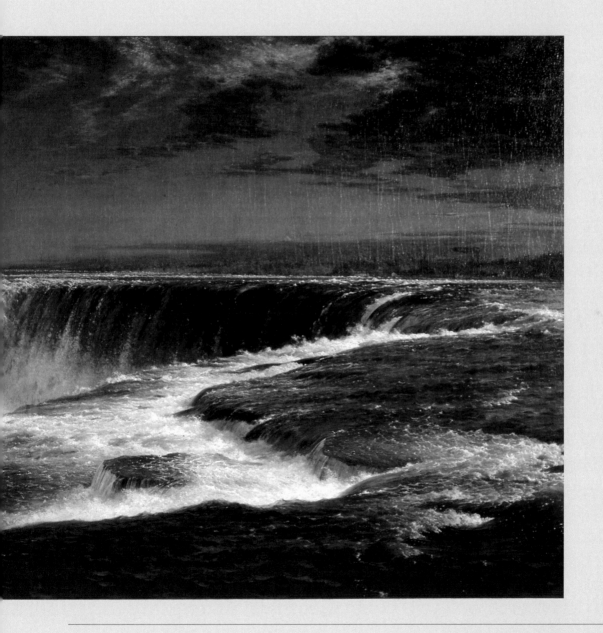

restrained, and his attitude toward art often exasperatingly flippant. His curt responses to his young admirers, however, may have come less from arrogance than tongue-in-cheek humor. When they asked him to comment on his method, he was known to have replied, "Grasp nature in one hand and do what you like with the other."

The exhibition of *Niagara* as a single attraction in a commercial gallery heralded a new era in the New York art world. Older institutions like the Art-Union, which had been a leading factor in the early development of American art, had begun to falter. The year after its enormous success with the raffle of Cole's *The Voyage of Life*, subscriptions fell so drastically that the Art-Union had to postpone its year-end lottery. Subscribers holding tickets for which there were no prizes, and artists submitting work for which there was inadequate remuneration became enraged. Finally, in 1853, the New York district attorney filed a suit declaring the lottery illegal, and the Art-Union was forced to close.

Although its demise left a vacuum, it had created a number of collectors who now turned to commercial galleries, which had begun to play an important role. The Paris firm Goupil, Vibert & Co., which later became Knoedler's, established a branch in New York in the late 1840s. Among the estimated five other private dealers in the city, Goupil's became the leader in promoting European and American art.

The 1850s brought increasing prosperity, and with it, the National Academy saw its receipts rising. Still having no permanent home, the academy held receptions in rented galleries at Fourth Avenue and Tenth Street, where the rooms were attractively carpeted and brilliantly lit with gas jets. As women became increasingly influential in the art world, the traditional all-male dinners preceding the annual exhibition were replaced by formal receptions to which both men and women were invited.

By the end of the decade, a new building designed especially for artists brought attention and status to the art community. It was the brainchild of entrepreneur James Boorman Johnston, who selected Richard Morris Hunt as its architect. Hunt's first commission after returning from his studies at the École des Beaux-Arts was to design a house and studio for artist Thomas R. Rossiter at 17 West Thirty-Eighth Street. The Artists' Studio Building was located at 15 West Tenth Street, and it was to contain twenty-five

studios. Each was to be heated by a coal stove, which was a far cry from the unheated garrets that had previously served as painting rooms. They were to be spacious and attractively appointed, but the rent was to be kept at an affordable $200 a year. Large windows, skylights, and transoms supplied light and air circulation. On the first floor a large gallery space would permit its occupants to exhibit their work to the public.

Construction of the Studio Building was well underway when Church boarded a steamer for a second trip to South America. He was accompanied by Louis R. Mignot, who grew up in Charleston, South Carolina, but was then living in New York. Mignot was also interested in finding new material for his landscapes. This time the direction of Church's first trip was reversed. They sailed down the west coast of Colombia and Ecuador and up the Rio Guayas to Guayaquil, and then took a boat inland towards the village of Guaranda. Church had a definite goal in mind. During his earlier trip, he and Field had passed through this region hurriedly, and he had had too little time to sketch Chimborazo. Only eighteen miles southwest of this great mountain peak, Guaranda was the perfect location for studying it at close range. Even in June when clear weather was anticipated, the mountain was often hidden in clouds. Church was, nevertheless, able to make twenty drawings and four oil studies in the next ten days.

On June 14, Church and Mignot left Guaranda for Quito, traveling north by mule. After a week in Quito, they were on the road again, heading south toward Hacienda Chillo near the village of Machachi. Humboldt had been a guest there for several months in 1802. Church left a record of his stay in two extant oil sketches, which he identified as "Near Haciendo Chillo."

From Riobamba, where they were guests of Governor Pablo Bustamente, they made a four-day excursion southeast to one of the most unpredictable Ecuadorian volcanoes, Sangay, which towers 17,455 feet above the rain forest. The first part of the journey was relatively easy, since they followed a road that ran alongside a river, but the road eventually vanished and they had to make their way through tall river grasses. The occasional hut, green field, and flock of sheep gradually disappeared as they reached higher altitudes and the air grew thin. At length all signs of human and animal life were gone.

As they approached the summit, Quipo, the Indian guide, indicated that they should stop and prepare camp for the night. It was only three o'clock, but Quipo, who spoke no English, conveyed in sign language that there would be no other place with water. Church decided he would continue the climb on his own in hopes of catching a glimpse of the crater. Making his way through the thick grass was difficult, and low clouds limited visibility. Each eminence he gained revealed a higher one above.

Church wrote in his diary that "the regular, impressive shaking of the earth and the tremendous peals, which marked each explosion" warned him that the crater was near, but he could not yet see it through the clouds. When he had finished sketching a view to the southwest, where the clouds had dispersed, he turned around and there was Sangay in front of him with its rising plume of smoke: "Above a serrated, black, rugged group of peaks which form the crater, the columns arose, one creamy white against an opening of exquisitely blue sky," he wrote. "The other, black and somber, piled up in huge, rounded forms cut sharply against the dazzling white column of vapor." As the sun began to set, it "crested the black smoke with burnished copper and the white cumulus cloud with gold."

Church sketched the awesome crater until it was nearly dark and then made his way back to the camp. Mignot and the four guides were waiting, but there was no supper. At such a high altitude water would not boil, so they ate bread and chocolate and slept on grass, which the Indians had bent over and flattened for a bed. The following day they began the descent. When they finally reached the village of Ysapan, they dined on roasted guinea pigs and potatoes they peeled with "the shoulder blades of the guinea pigs." Church's only regret was that Mignot had not seen the crater.

They arrived home at the end of August 1857. Early the following year, Church rented a studio in the new Tenth Street Studio Building. He needed enough space to accommodate a ten-foot-wide canvas, on which he intended to paint his most ambitious work to date. His presence and reputation added luster to the building. Even solitary Martin Heade rented space there, undoubtedly to follow Church's progress on his next South American masterpiece—a view of the colossal white dome of Chimborazo soaring above the Ecuadorian tropics.

By spring of the following year, *Heart of the Andes* (Fig. 32) was finished, but this time Church did not turn over his painting to a commercial gallery. He rented the exhibition hall in the Tenth Street Studio Building, where he had full control over its presentation. For its display, he designed a freestanding, black walnut casement fourteen feet wide and thirteen feet high. Instead of framing the painting, he set it into an opening in the structure. A heavily carved wood cornice with swags of green silk draped several times over a rod surmounted the ensemble. In order for the only light in the hall to fall on the painting, black cloth was hung over the walls, and the skylight was screened in a manner that directed the light onto the painting. These stage effects conspired to give the illusion that the painting was, in fact, a window looking out to the equatorial wilderness. Further blurring the distinction between painting and theater, Church invited viewers to sit on benches so they could examine each detail at leisure.

A glistening cascade first catches their eye, which then follows the bend of a river gorge upstream and into the middle ground, where a distant settlement rises at the water's edge. Farther on, a flat, elevated plain stretches beneath a broad, desolate mountain, which reaches across almost the width of the canvas. Its bleakness is broken only by a wisp of smoke. Finally the eye meets the snow-capped dome of Chimborazo looming above the tropical scene. Despite its commanding presence, dark clouds hover above suggesting that its appearance will be brief. Its shiny, white surface connects visually with the cascade in the immediate foreground. Here nature's apparent serenity is countered by the dangerously exposed tree roots, which attest to the mercurial character of the tropical climate.

Newspapers were quick to cover this extraordinary exhibition. The *Christian Intelligencer* found that, within this "single focus of magnificence," there was a "complete condensation of South America—its gigantic vegetation, its splendid Flora, its sapphire waters, its verdant pampas and its colossal mountains." Other newspapers were filled with column after column of description. The accolades drew many well-known people to see it. The aging Washington Irving marveled at its "grandeur of general effect with such minuteness of detail." Ralph Waldo Emerson described it as "a fairer creation than we know."

The exotic subject, the scale, the precise detail, and uncanny realism electrified admirers. Cole's biographer and Church's friend, Rev. Louis Legrand Noble, wrote a twenty-four-page description of the painting, which was printed as a booklet and sold at the door. Another friend, the writer Theodore Winthrop, composed an essay twice as long. These booklets served as guides for people scanning the painting through opera glasses or tubes made of paper and tin.

Heart of the Andes was on view in New York for only three weeks, but more than 20,000 people came to see it, each paying a twenty-five-cent admission fee. On the last day, crowds grew so large they blocked the street, and police had to be called to keep order. Before the exhibition closed, the painting was sold for $10,000 to William T. Blodgett, a New York manufacturer, and $6,000 worth of subscriptions for an engraving had been collected.

Fig. 32. Heart of the Andes, 1859

Frederic Edwin Church
(1826–1900)

Oil on Canvas,
66 1/8 × 119 1/4 in.
(168 × 302.9 cm.)

The Metropolitan Museum of Art

Bequest of Margaret E. Dows, 1909

Photograph © 1979
The Metropolitan Museum of Art

09.95

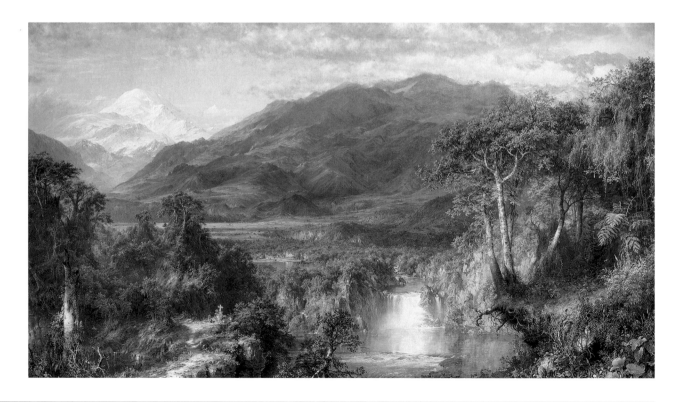

Soon after the May 23 closing in New York, *Heart of the Andes* was on its way to London to be exhibited at the German Gallery on New Bond Street. After its opening on July 4, the English response was immediate. The *Daily News* wrote, "Turner, himself, in wildest imagination, never painted a scene of greater magnificence." After closing in London, Church was particularly eager to make arrangements for it to be shown in Berlin, the home of Baron von Humboldt, but the aging scientist died that very year. Church's plans did not materialize, and the painting was never exhibited on the continent.

After its return to the United States, however, it was sent on tour to cities as far west as St. Louis, where it was seen by young Samuel L. Clemens, later known as Mark Twain. Clemens observed: "I have seen it several times, but it is always a new picture—totally new—you seem to see nothing the second time which you saw the first." Through his opera glasses he examined the forest flowers and counted the leaves on the trees. Even the tiniest leaf had a distinct personality. By his third visit, he found his "brain gasping and straining with futile efforts to take all the wonder in—and understand how such a miracle could have been conceived and executed by human brain and human hands."

Church had painted another symbol of his age. He had interpreted the famed mountain peak—already regarded as sacred by Humboldt's readers—and its tropical valley as a Garden of Eden. He seemed to have fulfilled what Durand had defined as the artist's mission: "to depict nature as it might have been at the time of Creation." *Heart of the Andes* had become the most celebrated American painting of the entire nineteenth century.

Just as Church reached the pinnacle of success, he became distracted by personal matters. While *Heart of the Andes* was being shown in the Tenth Street Studio Building, Church often hid behind the black curtain to listen to comments and peek out at viewers. One day he noticed among the crowd a beautiful young woman accompanied by her mother. His shyness forgotten, he rushed out in his gray smock to meet her. She introduced herself in a beguiling accent as Isabel Carnes. Although living in Dayton, Ohio, she had in fact been brought up in France where her father managed the Paris office of his importing firm. The thirty-three-year-old artist was immediately smitten. Before *Heart of the Andes* returned from London, they were engaged, and the following year, married.

XIII

BIERSTADT DISCOVERS THE ROCKIES

 orthington Whittredge was still in Rome when he heard the news of Church's huge success. He was breakfasting at an artists' gathering spot, Café Greco, when someone brought in a copy of the *New York Herald* reporting that *Heart of the Andes* was bringing in six hundred dollars a day, and crowds were so dense that many could not even find standing room. The news, according to Whittredge, resounded "like a bombshell in Camp."

Two years had passed since Albert Bierstadt and Sanford Gifford had returned home. Whittredge's European paintings had been selling so well in Cincinnati that he had been able to remain abroad much longer than most artists. He had become caught up in the leisurely Roman life, taking dancing lessons so he could enjoy the balls given by the American ambassador, and paying five scudi to attend the annual reception at the Palazzo Doria, where men flashed their gold medals and women their diamond brooches.

He had passed many hours at the Café Greco drinking *caffe latte* and watching for celebrities in the long, narrow room called "the omnibus." Occasionally a celebrity actually appeared. Whittredge remembered the excitement aroused by the entrance of the Victorian painter, Frederick Leighton. Once he recognized Nathaniel Hawthorne, who was writing his novel *The Marble Faun;* and occasionally at parties, he met English poets Robert and Elizabeth Browning, who were both shy but "very great."

Rome had provided many happy moments; but after hearing the news of Church's success, Whittredge regretfully acknowledged that Church had become the rage of New York City while he—Church's elder by six years—was still lingering in Europe. He immediately booked passage on the *Vanderbilt,* the fastest steamship of the time, and reached New York in eleven days.

Fig. 33. Receptions at the Tenth St. Studio, 1869, *from Frank Leslie's Illustrated Newspaper, January 29, 1869. Museum of the City of New York.*

Fig. 34. Worthington Whittredge, c. 1864. *Image originally photographed by George Gardner Rockwood and is courtesy of the Miscellaneous Photograph Collection in the Archives of American Art, Smithsonian Institution.*

Forty years old when he returned to New York, Whittredge retained few traits of the farm-boy-turned-artist who had left Cincinnati ten years earlier. He stood tall and handsome, his thick black beard contrasting with his shiny bald pate. His courtly manner was well suited to the lively social scene that had become so much a part of an artist's life in New York. Eager to catch up with his former traveling companion, Sanford Gifford, he stopped at the Tenth Street Studio Building and climbed the wide staircase to his studio on the top floor. It contained only a few chairs, an easel, a bookcase, and a mahogany table holding a vase with a single rose, but it had a large window and a skylight, which were essential for producing the subtle tonalities that made Gifford's work distinctive.

A large canvas of a mountain scene looking towards the setting sun was placed on the easel. It was composed from sketches he had made the previous summer from the top of Mount Mansfield in Vermont. Gifford was much too modest to mention that critics had singled it out for praise when it was shown at the National Academy of Design. Only later, when Whittredge had caught up with reviews, did he learn that Gifford's painting had been celebrated for achieving the most subtle "gradation of color and aerial perspective." Another reviewer called attention to the "immense difficulty" of painting the sun itself and wondered how it could be "within the province of Art."

After the visit, Whittredge felt an urgency to renew his ties to the founders of American landscape. Knowing that Luman Reed's collection of American art had been donated to the New-York Historical Society, he went immediately to its new building on Second Avenue and Eleventh Street. He entered a large room with two tiers of upper galleries supported by pairs of Corinthian columns. He walked over the patterned green carpet and up the wide iron staircase to the galleries where works by Thomas Cole and Asher Durand were hanging. He thought that Cole's rugged brushwork surpassed that of any master, and Durand's faithful reproductions of American hills and valleys brought tears to his eyes. These paintings made him realize that, if he were going to succeed in this country, he would have to produce landscapes that were "new and inspired by home surroundings."

The same conclusion had been reached by Albert Bierstadt after his return from Europe. He had worked for a while in New Bedford, trying out a variety of subjects—landscapes of Westphalia, a historical scene of the founding of New Bedford, and a genre scene of a fish market in Rome. These had sold quickly, but had not attracted the attention of critics. Bierstadt, like Whittredge, had realized that, if he was to gain fame at home, he would have to give up European subjects and historical scenes and turn to America's natural scenery. At first he looked to the White Mountains, but found too many artists at their easels under white umbrellas. He wanted to find scenery that had never been seen by the public. Tales of the spectacular beauty of the West were appearing in expedition reports and newspapers, but the actual sights had not been captured by an artist of his skill. He decided to be the first.

Looking for a way to attach himself to a government expedition to the West, Bierstadt found Colonel Frederick W. Lander, an explorer and civil engineer who had already been west a number of times to survey alternative routes for the Overland Trail. After the Mountain Meadows Massacre of 1857, when Mormons had killed over one hundred Arkansas emigrants, the trail had been rerouted. In the spring of 1859, Lander was employed to make improvements to the new route. Bierstadt arranged to meet with President Buchanan's secretary of war to ask for help in securing a place with the expedition.

On April 15, 1859, he and Boston artist F. S. Frost boarded a westbound train. Twelve days later they stepped off at the river town of St. Joseph, Missouri, where the railroad

tracks ended. Across the Missouri river lay the Great Plains and the Rocky Mountains. St. Joseph was a busy frontier town full of land sharks, miners, and prospectors bound for the Pikes Peak gold fields. Brick and wooden stores lined the main street, and signs identified a land office, printing shop, bank, gambling house, and saloons. Advertisements for cheap land were pasted to store fronts. Men with hard faces and guns in holsters gathered in the saloons. Clerks tilted wooden chairs against the outside walls of their stores as they watched the wagons, carts, and horses go past.

The only hotel in town charged two dollars a night for a few square feet of floor space. Bierstadt and Frost spent several nights rolled up in blankets on a hard floor along with frontier ruffians. The artists discovered that as many as fifty to a hundred men each day were applying to Lander's expedition. By May 5, Lander had picked up enough men and supplies to begin his journey. Outfitted with blue flannel shirts, heavy pants tucked into their boots, slouch hats, and revolvers, Bierstadt and Frost mounted their own horses. Their paints, paper, and photographic equipment had been stored in one of the wagons. They followed the south bank of the Platte River across what is now the state of Nebraska until it divided into north and south forks. At the crossing they met hundreds of destitute and disillusioned gold-seekers returning home.

While waiting to cross the river, Bierstadt brought out his pad and pencil. Seated on a wagon tongue with his pad propped against a vinegar keg, he made sketches that were later published in *Harper's Weekly*. Both banks of the river were lined with emigrants' wagons and animals—some had safely crossed the rushing river, others still had to prove their mettle. As the wagons rolled into the river, water rushed over the hubs of the wheels, mules began to kick and plunge, teamsters shouted and cursed. Crossings were dangerous; horses and mules could be lost and goods swept downstream. Sometimes people drowned in the torrents. A band of Sioux Indians with Dog Belly, their chief, smoking a pipe, was sitting in a circle watching the activity.

After fording safely, the expedition followed the North Platte River into Wyoming and picked up the Sweetwater River until it came to the South Pass. Many emigrants had made their way over this pass to seek a better life in California and Oregon. The road was

lined with ox skulls, broken wagons, stoves, and other household equipment discarded to lighten the wagon loads. Noonday stops as they crossed the mountains provided Bierstadt with time to make sketches, which he later used in a painting called *Oregon Trail*.

Lander's expedition settled for the summer just beyond South Pass in a valley between the Wind River and Wyoming ranges. The site lay at the headwaters of the Green River and within sight of the 13,730-foot Fremont Peak. Wagons were formed into a corral with earth embankments piled up as bulwarks against Indian attack. Lander's men cleared trees and rocks and built reservoirs to hold water from springs. The artists were not allowed to venture very far alone. Bierstadt reported that although the Indians had been kindly disposed to them, it was risky "because being very superstitious and naturally distrustful, their friendship may turn to hate at any moment."

The Crayon kept New Yorkers posted on Bierstadt's travels by publishing a lengthy letter from him. "I am delighted with the scenery," he wrote. "These mountains are very fine; as seen from the plains they resemble very much the Bernese Alps. They are of granite formation, the same as the Swiss mountains, and their jagged summits covered with snow and mingling with the clouds present a scene which every lover of landscape would gaze upon with unqualified delight."

Bierstadt had not relied entirely on pencil and paints to capture the grandeur of the West. He also carried a stereoscopic camera and wrote, "We have a great many Indian subjects. We were quite fortunate in getting them, the natives not being very willing to have the brass tube of the camera pointed at them. Of course, they were astonished when we showed them pictures they did not sit for; and the best we have taken have been obtained without the knowledge of the parties. When I am making studies in color, the Indians seem much pleased to look on and see me work; they have an idea that I am some strange medicine-man."

At the end of the summer, Bierstadt, Frost, and a man in charge of the animals left the expedition, which was to continue on to California. Bierstadt appeared to enjoy the dangerous journey homeward. He wrote, "... we go wherever fancy leads us. I spend most of my time in making journeys in the saddle or on the bare back of an Indian pony. We have plenty of game to eat, such as antelope, mountain grouse, rabbit, sage hens, wild ducks, and the like. We

have also tea, coffee, dried fruits, beans, a few other luxuries, and a good appetite. ... I enjoy camp life exceedingly. This living out-of-doors, night and day, I find of great benefit. I never felt better in my life. I do not know what some of your Eastern folks would say, who call night air injurious, if they could see us wake up in the morning with dew on our faces!"

Soon after Bierstadt returned, he decided to move to New York and secured space on the ground floor of the Tenth Street Studio Building. There he worked up his western sketches into oil paintings and exhibited them at the National Academy the following spring. They won him membership in the academy but attracted no notice from critics, who seemed to have eyes only for the work of Frederic Church. At that time, Church's painting of a flaming sunset, *Twilight in the Wilderness,* was attracting rave reviews.

After producing a number of paintings of the Wind River country, Bierstadt was ready to attempt a grandiose view that he hoped would equal the best of Church's work. After stretching a huge canvas ten feet wide and six feet high, he sketched in the same natural elements that Church had employed in *Heart of the Andes:* a snow-capped mountain, reflecting water, and a sparkling cascade. The towering peaks in the background reach nearly to the top of the canvas, and the valley is dotted with aspen, fir, and pine. The cliffs converge from both sides on a waterfall that glitters in the sun. In contrast to the light-filled background, Bierstadt painted the entire foreground in shadow. On the lake shore, a bustling Shoshone village is precisely depicted from the hundreds of stereographs he had taken. Braves are returning to the village with carcasses of elk and mule deer flung over their ponies. Papooses are propped against the teepees, while the women hurry to meet the hunters. Game lie on the grass ready to be skinned. Fish are smoking over fires. As if all the activities demanded a spectator, at the left, a tiny prairie dog in front of its burrow observes the scene attentively.

As Bierstadt was finishing his painting, he learned that Col. Lander had been killed in the Civil War. He decided to commemorate his expedition leader by naming the painting *The Rocky Mountains, Lander's Peak* (Fig. 35), although the peak was officially named after John C. Fremont, an explorer and political figure who, in 1842, became the first person to reach the summit.

Fig. 35. The Rocky Mountains, Lander's Peak, 1863

Albert Bierstadt (1830–1902)

Oil on Canvas, 73 1/2 × 120 3/4 in. (186.7 × 306.7 cm.)

The Metropolitan Museum of Art

Rogers Fund, 1907

Photograph © 1979 The Metropolitan Museum of Art

07.123

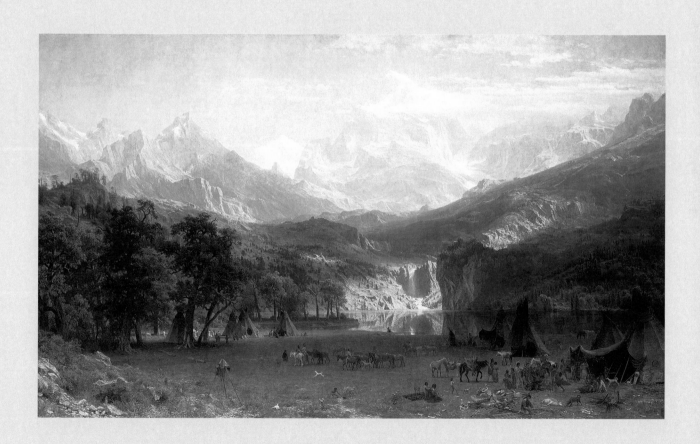

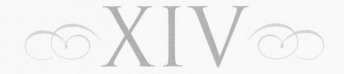

XIV

THE CIVIL WAR BEGINS

t looked like a gray-blue cloud floating down Broadway. As it drew closer, the sound of drums and trumpets was heard. Worthington Whittredge and Albert Bierstadt stood on the corner scanning the passing faces. Suddenly, they cheered and waved. Sanford Gifford turned his head and smiled proudly as he marched by with the Seventh Regiment of the New York City National Guard—the first troops to leave New York for Washington. Whittredge claimed that he had also tried to enlist, but volunteers were required to supply their own uniforms and equipment. He had been turned down for lack of a knapsack.

After the first shots were fired in April 1861 at Fort Sumter, South Carolina, New Yorkers had united in their efforts to preserve the Union. Volunteer regiments were hastily organized and drilled. Committees were set up to sew, knit, roll bandages, and collect funds for relief work. Whit-

tredge was one of the few men sufficiently adept with a needle to join a sewing society—which always concluded with a game of charades. Accompanied by Emanuel Leutze, who had given up his Düsseldorf studio for the congenial atmosphere of the Tenth Street Studio Building, Bierstadt made an excursion to Washington to photograph the army camps.

Church did not follow his fellow artists to the army camps. As soon as the exhibition of *Heart of the Andes* closed in 1859, he was ready for another adventure. He wanted to sketch in a region that might offer even greater spectacles of nature than the snow-capped mountains of the Andes and the roaring cataracts of Niagara. He persuaded Rev. Louis Legrand Noble to accompany him to the southern Arctic. In June 1859 they took a steamship from Halifax, Nova Scotia, to St. John's, Newfoundland, and then chartered a schooner to take them closer to the icebergs. Most of Church's sketches, however, had to be made from a rowboat, which lurched about in the rough, frigid sea. In spite of his unsteady seat and nausea he managed to make nearly one hundred pencil and oil sketches, which would provide material for another large painting. The completed work, however, did not appear for two years.

Church had been in no hurry to finish; the exhibition opening was planned to coincide with the publication of *After Icebergs with a Painter,* the book Noble wrote about the journey. In 1861 the painting (Fig. 36) was finally presented to the public at Goupil's Gallery. Once again Church used the window effect in its presentation. He inserted the ten-foot-wide canvas into a massive dark frame "carved like a cabinet and draped with crimson," to convince the public that they were in the actual presence of the ice floes.

The master showman had also prepared a broadside to help the public understand this unfamiliar sight. It explains that the viewer is standing on the ice looking out at a bay created by a single iceberg connected beneath the sea. On the left the edges of recently broken ice are cut like "porcelain or glass." A blue ribbon-like vein that runs through it is formed by "clear, transparent ice" lodged in a crack. On the right the upper surface of the iceberg has risen "out of the waves" and has lifted the reddish-brown boulder with it.

In daylight there is practically no color in the icebergs, Church explains. They are "purely white—an opaque, dead white." In late afternoon, however, the "lights and

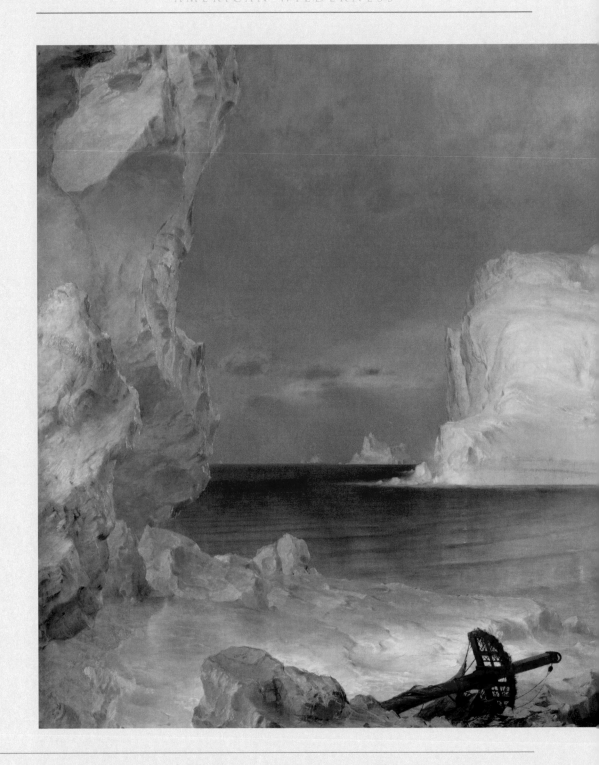

Fig. 36. The Icebergs, 1861

Frederic Edwin Church (1826–1900)

Oil on Canvas, 64 ½ × 112 ½ in. (1 m. 63.83 cm. × 2 m. 85.751 cm.)

Dallas Museum of Art, anonymous gift

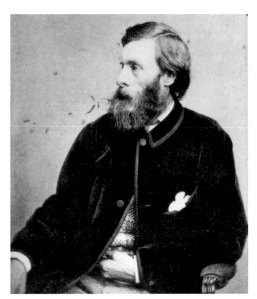

Fig. 37. Jasper Francis Cropsey, c. 1865, *carte de visite, photograph by George G. Rockwood, New York City. The Metropolitan Museum of Art, The Albert Ten Eyck Gardner Collection, gift of the Centennial Committee, 1970. 1970.659.175*

shadows, hues and tints, shower the scene." To bring out the brightness of the central iceberg, the color of the sea changes to a dark violet. He concludes, "The flight of the mist is noiseless. The swells come gently rolling in, in glassy circles, breaking with low murmur on the icy foreground."

In 1861 when *The Icebergs* was exhibited, viewers were astonished by the resplendent Arctic seascape. They remarked frequently that it showed no sign of human life and only the boulder hinted at the presence of solid ground. No artist had ever brought before the public the magnificence and splendor of such a sight. Some reviewers were inspired to compare the ice formations to temples and cathedrals. One critic responded in more secular terms: "If visits to the constituent members of the solar system were practical, we are not certain but that Mr. Church would undertake to delineate Mars and Jupiter with their attendant satellites."

The painting was exhibited in New York and Boston, but its mood of exaltation no longer fit the times. The country had plunged into civil war. There were no American buyers, so in June 1862 Church arranged to send the painting to London. Before it left, he painted a ship's mast protruding from the ice, which an English audience would have

recognized as a reference to the lost Arctic explorer, Sir John Franklin. The painting met with success there, and a member of Parliament, Sir Edward Watkin, purchased it.

Another American artist who had found favor in England was Jasper Francis Cropsey (Fig. 37). While working as an apprentice in a New York architectural firm, Cropsey had learned to paint landscapes as settings for architectural renderings. After taking up painting exclusively, he began to exhibit at the National Academy. In 1856 he went to London, where he showed a large-scale painting, *Autumn—On the Hudson River* (Fig. 38), which portrayed American maples, elms, and birches in blazing scarlets and yellows. Such autumnal splendor was unknown in England, and critics accused him of exaggeration. In response to their disbelief, Cropsey sent home for some red and yellow maple leaves, which he pinned to a board near his painting.

Fig. 38. Autumn—On the Hudson River, 1860

Jasper Francis Cropsey (1823–1900)

Oil on Canvas, 59 3/4 × 108 3/4 in.

Gift of the Avalon Foundation

Photograph © 2000 Board of Trustees, National Gallery of Art, Washington

1963.9.1 (1906)/PA

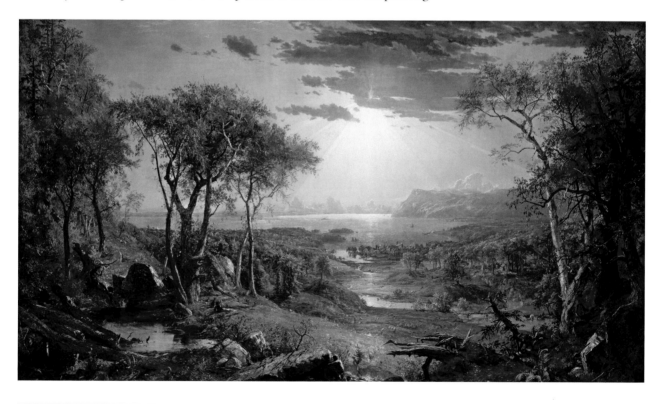

The critics then had to admit that they were wrong. The controversy brought the press to the exhibition, and Cropsey's work was mentioned in fourteen reviews.

After spending seven years in England, Cropsey sailed home, entering New York harbor on July 4, 1863—a terrifying time in this war-torn country. The North had just won the battle of Gettysburg, but a few days later, violent mobs rampaged through New York City burning, killing, and destroying in protest against unfair draft laws.

The severity of the situation brought Sanford Gifford and his Seventh Regiment back from Baltimore to New York to help restore order. His National Guard regiment usually spent part of every spring and summer protecting Baltimore and Washington. Between tours of duty, he had time to seek out the quiet of the Catskills, painting nearly fifty scenes of the region from 1861 to 1863. Whittredge often accompanied him on these excursions.

The 1860s were crucial to Whittredge's career. He was struggling to eradicate his memory of orderly German forests, which had furnished the subject for many of his European paintings. In those forests peasants collected fallen sticks to burn as firewood, but in American forests the debris decomposed on the forest floor, leaving a tangled mass of rotting logs and thick underbrush. The unruly character of the American wilderness seemed incompatible with the arrangement of form essential to a successful composition. He demonstrated, however, that he was able to overcome this obstacle with the success of *The Old Hunting Grounds* (Fig. 39) when it was shown at the National Academy.

In *The Old Hunting Grounds* Whittredge showed that he had surpassed the kind of artist Cole had called "a mere leaf painter" by fusing a realistic forest interior with symbolic associations. For example, the tall trees, bent like the gothic arch of a cathedral, suggest the forest as a fitting place of worship. He selected clusters of trees at various stages of growth ranging from young birches to an old stump to show the ravages of time. An abandoned Indian canoe conveys a similar message, evoking a sense of nostalgia by recalling the forest's earlier inhabitants.

Another artist who found his mature style during the Civil War years was Martin J. Heade (Fig. 40). In 1863 he produced a large number of marshland and coastal scenes in a very distinct and personal style. Then, because of the disruptions of wartime, he went to

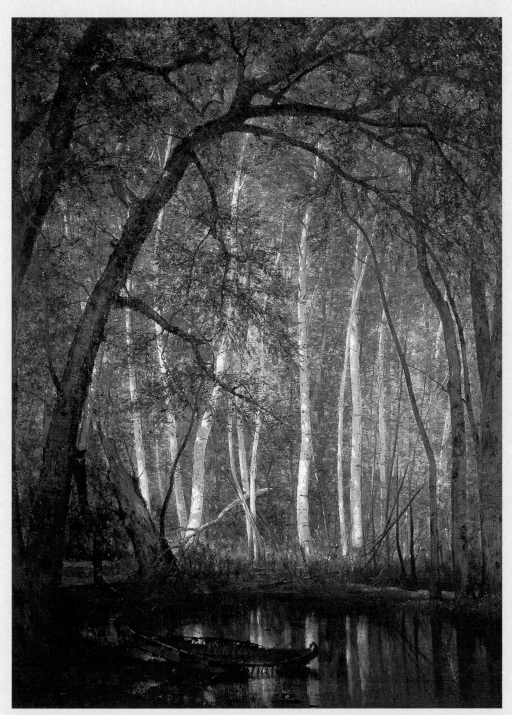

Fig. 39. The Old Hunting Grounds, 1864

Worthington Whittredge
(1820–1910)

Oil on Canvas, 36 × 27 in.
(91.4 × 68.6 cm.)

Reynolda House,
Museum of American Art

Winston-Salem,
North Carolina

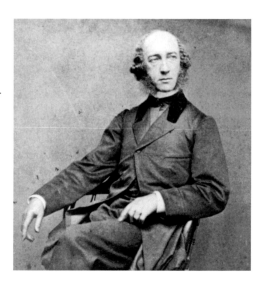

Fig. 40. Martin Johnson Heade, 1860.

*Image is courtesy of the Miscellaneous
Photograph Collection in the Archives of
American Art, Smithsonian Institution.*

Brazil to paint "those winged jewels, the
hummingbirds." On February 14, 1864, he
exhibited twelve paintings of humming-
birds at the Universal Exposition of Fine
Arts in Rio de Janeiro and dedicated his
work to the Imperial Majesty Dom Pedro II, who responded by naming Heade a Knight
of the Order of the Rose. Heade sailed for England, where he intended to have his paint-
ings chromolithographed. The project never materialized, and he returned home.

Although Heade's personal style was appealing, and remains so today, in his own
time his work was hardly noticed. He was the only skilled landscape painter in New York
who did not become a member of the National Academy, even though he exhibited
there frequently. His paintings sold for sixty dollars or less, while those of his colleagues
were bringing much higher prices. He was uncomfortable in social situations, and once
he announced that he would never "be placed in the ranks of the bootlickers to the rich."
He did, however, maintain a lifelong relationship—sometimes one-sided—with Frederic
Church, who was both wealthy and celebrated.

After two years at the Tenth Street Studio Building, Heade moved to Boston, return-
ing occasionally to use Church's studio when he was away. Heade's canvases could often
be found stored there. A story was told that one day Church picked up one of Heade's
marsh scenes with the lower portion of the canvas unfinished. Mischief-loving Church
could not resist filling it in. First, he painted two sawhorses that appeared to be supporting
the marshland; then he painted falling driblets of water to suggest that the marsh itself was
leaking. In the center he added a dancing, grinning goblin.

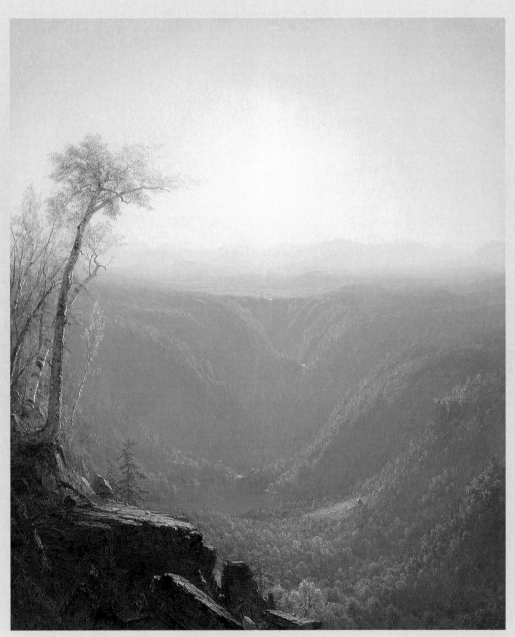

Fig. 41. A Gorge in the Mountains (Kauterskill Clove), 1862

Sanford Robinson Gifford (1823–1880)

Oil on Canvas, 48 × 39 7/8 in. (121.9 × 101.3 cm.)

The Metropolitan Museum of Art

Bequest of Maria Dewitt Jesup, from the collection of her husband, Morris K. Jesup, 1914

Photograph © 1987 The Metropolitan Museum of Art

15.30.62

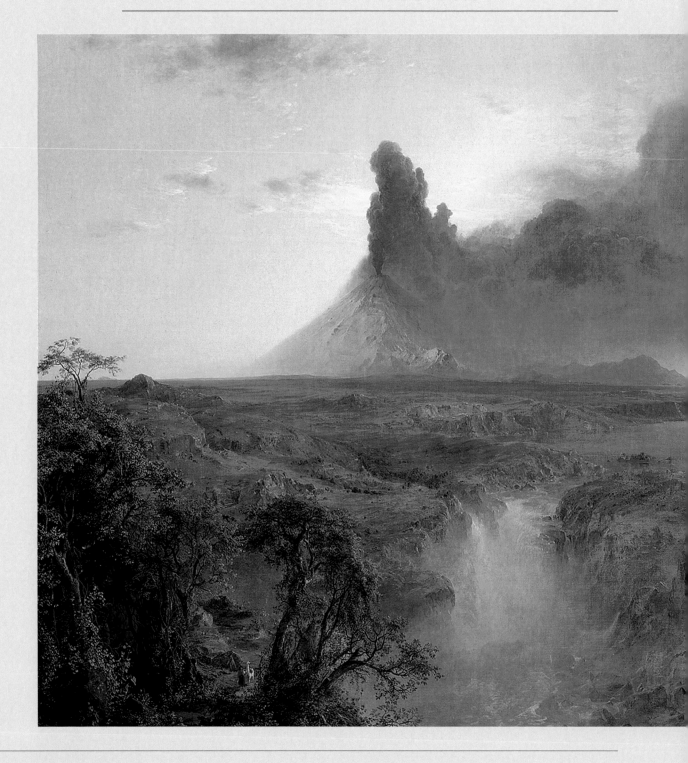

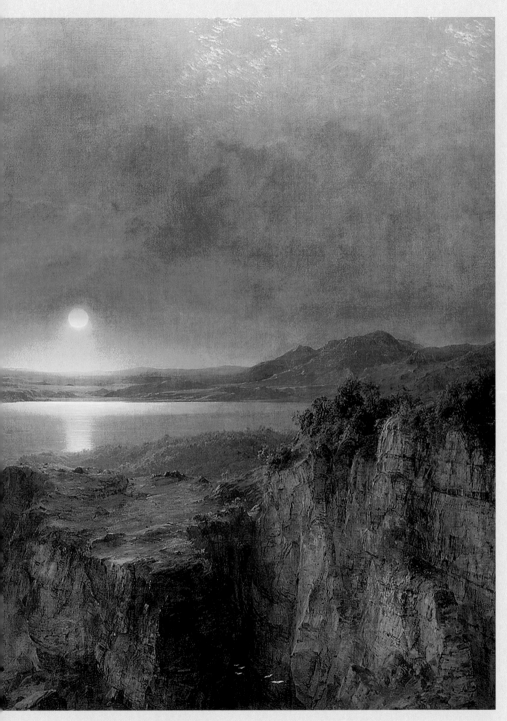

Fig. 42. Cotopaxi, 1862

Frederic Edwin Church
(1826–1900)

Oil on Canvas, 48 x 85 in.
(121.9 × 215.9 cm.)
framed: 66 5/8 x 103 × 6 in.

Founders Society Purchase,
Robert H. Tannahill Foundation
Fund, Gibbs-Williams Fund,
Dexter M. Ferry Jr. Fund, Merrill
Fund, Beatrice W. Rogers Fund
and Richard A. Manoogian Fund

Photograph © 1985
The Detroit Institute of Arts

76.89

Many of Heade's landscapes demonstrate his skill in capturing a special quality of light. John Kensett and Sanford Gifford also placed the importance of light and atmosphere over form, often simplifying their work to quiet bodies of water or marshland accented with a sailboat or just a rock. Although their primary interest was in natural light, they never broke up surfaces into myriad dabs like the French Impressionists, who were beginning to paint in Europe at the time. American artists preferred to convey light through carefully rendered modulations of color and value and to apply the paint so smoothly that the brushwork remained invisible.

When Gifford returned to New York after several months in the Union army, he painted one of his finest works, *A Gorge in the Mountains (Kauterskill Clove)* (Fig. 41). Although this subject had been painted by nearly every Hudson River School artist, Gifford interpreted it in an original way. His aim was not to catch each leaf, twig, and branch, but to paint the rosy haze that lay between the golden birch in the foreground and the barely visible falls in the distance. Gifford described his efforts as "air painting."

As war raged on, Church began to look for natural phenomena that reflected the country's upheaval. He studied his sketches of erupting volcanoes made during his last trip to South America and worked them up into a painting seven feet wide entitled *Cotopaxi* (Fig. 42). It shows the volcano across a rocky plain, spewing black ashes that obscure the morning sun. When Goupil's exhibited the painting in the spring of 1863, critics called it another masterpiece. The *New York Times* described it as "throbbing with fire and tremulous with life." Once again, Church had captured through his portrayal of nature the exact temper of the times.

While viewers were admiring *Cotopaxi* (Fig. 42), the distant drums of regiments drilling on the outskirts of the city echoed through the streets of New York. Newspaper boys crying, "Extra, extra!" announced the outcome of fierce and bloody battles. Behind Church's painting of the erupting volcano lay the specter of rifle flashes, exploding shells, the acrid smoke of battlefields and, doubtless, the tragic death of his friend, Theodore Winthrop, who was killed by a musket ball at the battle of Great Bethel, Virginia.

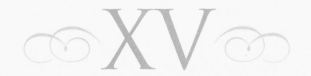

XV

CROSSING THE CONTINENT

n 1863 Goupil's was the site of an exhibition of photographs of California's recently discovered Yosemite Valley taken by the photographer-explorer C. W. Watkins. They showed enormous granite cliffs rising some four thousand feet above a valley with the Merced River winding through it and Yosemite Falls showering the valley thousands of feet below with spray.

Albert Bierstadt studied the exhibition intently. The falls must have been at least half a mile high; it was hard to believe that nature had created such a spectacle. When he returned to his studio, his recently finished *The Rocky Mountains, Lander's Peak* was on the easel, elaborately framed and ready for exhibition. He had painted the Wyoming peaks as though they were impassable barriers to the far West, and yet, beyond them, as he had just seen, lay more dazzling falls and beautiful valleys than he had ever imagined. He wondered if he could again survive the rigors of the trail and the added danger of traveling through Indian territory.

One of the first critics to notice Bierstadt's work was Fitz Hugh Ludlow of the *New York Evening Post* who, along with his beautiful wife Rosalie, frequently dined with the artist. Ludlow, who had commented favorably on Bierstadt's paintings in the 1862 and 1863 National Academy exhibitions, had become a celebrity because of his best-selling book, *The Hasheesh Eater*. As a boy in Poughkeepsie, New York, Ludlow had passed his spare time hanging around the local drugstore. One day he had found some hashish and began to experiment with it. By the time he entered Princeton College, he had become an addict, and his book recounted his efforts to overcome addiction. Now looking for adventures to fill a new book, the brilliant writer agreed to accompany Bierstadt on a trip across the continent.

The artist and the writer went by train to the frontier town of Atchison, Missouri, where they took the Overland Coach to Denver, Colorado. There they attended a buffalo hunt and visited Pikes Peak and the Garden of the Gods. Bierstadt made such a good impression on the people of Colorado that they named one of the highest mountains in his honor. From the streets of Denver today, the 14,060-foot peak of Mount Bierstadt can be seen near the somewhat higher Mount Evans.

Ludlow began his account of the journey soon after he and Bierstadt left Denver by stagecoach for Salt Lake City, more than 380 miles further west. After days of lurching and swaying over winding mountain roads, Ludlow realized that the Rocky Mountains were not a single chain as most Easterners thought, but a series of mountain ranges. To the fanciful young writer, they seemed like "a giant ocean caught by petrification at the moment of the maddest tempest."

They passed the strange sandstone formations of Church Buttes, where erosion had molded the reddish-brown bluffs into weird shapes that reminded Ludlow of Gothic cathedrals. He imagined some of the rocks taking the shape of niches containing grotesque statues. Others looked like flying buttresses. Enraptured by the sight, he exclaimed, "Oh that the master-builders of the world could come here even for a single day! The result would be an entirely new style of architecture—an American school, as distinct from all the rest ..."

Finally they arrived in Salt Lake City, populated entirely by the Mormons and ruled with an iron hand by Brigham Young. They were amazed to discover an opera house that seated twenty-five hundred people and orchards abounding with apples, apricots, and plums. They attended a Fourth of July ball, but Young scolded them for arriving late—it had started at four o'clock in the afternoon. As they talked with him about the Civil War, they found that he believed that it would create such chaos in the East that survivors would be forced to find refuge with the Mormons in Utah. "When your country has become a desolation," he pronounced, "we will forget all your sins against us, and give you a name." With New York City in the midst of its bloody Draft Riots—in which more than one thousand people were killed or wounded—Young's position seemed credible.

Swimming in the Great Salt Lake fascinated the travelers. The water's salinity buoyed them up so much that they could not sink below their armpits. "I swam out into it for a considerable distance," Ludlow reported, "then lay upon my back *on*, rather than *in*, the water, and suffered the breeze to waft me landward again. I was blown to a spot where the lake was only four inches deep, without grazing my back, and did not know I had got within my depth again until I depressed my hand a trifle and touched the bottom." A painting by Bierstadt shows the two of them floating in the briny lake.

Soon after the Fourth of July, Ludlow and Bierstadt left Salt Lake City and began their four-hundred-mile journey to Virginia City, Nevada. The road lay through a forbidding desert with sand of powdered alkali, white as snow, stretching for ninety miles in one uninterrupted sheet. There was no vegetation, and the water was so bad that travelers described it as "hell-broth." Day and night the stagecoach jolted through the deep, powdery sand. Sleep was impossible.

On the second day out, they stopped at a station where they learned that the Goshoots were on the warpath. By noon they had spotted moccasin tracks in the dust and a Goshoot scout on a distant ledge. With the horses struggling to drag the coach, sunk up to its hubs in sand, there was no chance of outrunning the Indians. They thrust rifles out of the coach windows, five on each side. Six-shooters lay across the passengers' laps and bowie knives at their sides. Cartridge boxes hung open on their breast straps. They

sat with tightly clenched teeth, muttering now and then in a glum undertone, "Don't get nervous—don't throw a single shot away, take aim—remember it's for home!" Sometimes a silent squeeze of a hand was all that passed among them.

The passengers' main hope was to intimidate the Indians with the military appearance of the stagecoach until they could reach the next overland station. At last they approached it, but all they saw was thick smoke curling into the sky. The barn, stables, and station house were a smoldering pile of rafters, and a dozen horses were roasting on the embers. Six men with their brains dashed out, their faces mutilated beyond recognition, and limbs hacked off were sprawled among the carcasses of animals. They fled the scene and pushed on. After another hundred miles, they arrived in Ruby Valley, Nevada, at the foot of the Humboldt Mountains, leaving the last Goshoot behind them.

They still had to cross what is now the state of Nevada before reaching the silver-mining town of Virginia City near the California border. The morning before they arrived, a stout, young Illinois farmer, who was regarded as the staunchest of all their fellow passengers, became delirious and had to be held in the stagecoach by force. When they were changing horses near Carson City, another traveler became deranged and blew his brains out. Once safe in Virginia City, Ludlow fainted as he entered a warm bath. How Bierstadt reacted is not known, but he had to have possessed an iron constitution to have survived the traumatic journey. Ludlow later confessed, "I look back on the desert as the most frightful nightmare of my existence."

When they had recovered from their ordeal, the two men took a stagecoach over the Sierra Nevada and down to San Francisco bay. Ludlow reported, "San Francisco has the interest of a new planet. It ignores the meteorological laws which govern the rest of the world. There is no snow there. There are no summer showers. … The thin woolen suit made in April is comfortably worn until April again." They found the elegance, service, and food of the Occidental Hotel better than any in New York. For two weeks, they enjoyed friends, the casinos, and fresh strawberries for breakfast every morning.

But the enjoyment of these luxuries was to last only until they could complete preparations for their anticipated trip to Yosemite Valley. Their party consisted of two other

artists, two scientists, a few friends, a camp cook, and an Indian boy. For the first part of their journey, the road was wide enough for a wagon to carry their supplies. When the trail narrowed, they roped their supplies to the backs of the pack mules and climbed in single file. Suddenly they emerged from thick foliage to find their horses standing on the verge of a precipice more than three thousand feet high. Facing them stood another wall, but how far off it was they could only guess. The distance was so great that it baffled any effort to calculate it. Their eyes were caught by a tremendous dome which, Ludlow imagined, stood smiling "in all the serene radiance of a snow-white granite Buddha." Not a living creature, neither man nor beast, broke the silence.

Before them lay the glorious Yosemite Valley, which made them feel that they looked not so much upon "a new scene on the old familiar globe as a new earth into which the creative spirit had just been breathed." They wound their way down the face of the precipice and by twilight had reached the meadows on the banks of the Merced River, where they pitched tents. They unsaddled the horses, put them out to graze, and gathered dead wood for the fire. A nearby brook furnished the hungry men with enough frogs for an unexpected and delicious main course. After dinner they smoked their pipes around the fire, then pushed together some evergreen strewings and slept soundly on the soft, fragrant mattresses.

For seven weeks the little group of explorers remained in the valley. Rising at dawn each morning, they enjoyed a hearty breakfast of flapjacks and coffee. Then each followed his own pursuit: the artists rode off with paint boxes and camp stools, the naturalists with botany boxes and bug holders, and the sportsmen with fishing rods and guns. The artists often worked so steadily that they did not return to camp for lunch; an Indian boy carried out a pail containing a bit of grouse, quail, or pigeon fricassee with dumplings. The boy and his pony were so thin that the artists nicknamed them "Death on the Pail-Horse," a pun on Benjamin West's famous painting, *Death on a Pale Horse*. In the evening, the artists showed their sketches, and the naturalists, their insects. Occasionally Bierstadt, who could catch trout by tickling them on their stomachs, would provide the camp with a special treat for dinner.

Ludlow recounted how the artists, each day a little after sunrise, "began labor in that only method which can ever make a true painter or a living landscape, color studies on

the spot." He summed up their experience in the valley: "They learned more and gained greater material for future triumphs than they had gotten in all their lives before at the feet of the greatest masters."

Autumn was approaching. Most of the group returned to San Francisco, but Bierstadt was eager to sketch the famed mountain peaks of the northwest. Bidding farewell to the others, he and Ludlow continued unaccompanied on horseback to northern California, Oregon, and Washington. Having sent their luggage ahead by California Express, they could ride forty miles a day. Western horses could lope all day, and they loved the comfort of the western saddle, never tiring in it as they would in the "slippery little pad" that easterners used. But the long, fast rides through boundless plains of wild grass and thick groves of California oak lasted only as far as the termination point of the California Express, where they had to pick up Bierstadt's heavy paint box. They struggled, in turn, to balance it on the pommel of their saddles, until at last they ran into a wagoner who was willing to carry it in exchange for cheap watches.

Staying mostly at ranches, Bierstadt and Ludlow sometimes found good accommodations, sometimes bad. At one rancher's, they had to eat a dinner of hen stew that was one-third feathers, and sleep in a flea-infested room with children who were sick with colds. Near Mount Shasta they found the attractive Sisson family living in a two-story house that spread out in all directions. Mr. Sisson, who had given up teaching in Illinois, was an excellent woodsman and the best rifle shot they had ever seen. Since Mrs. Sisson was a first-class cook, they dined on roast venison, potatoes in cream sauce, and pears baked in syrup—a treat for men who for weeks had eaten only camp fare of pork and biscuits.

No mountain that Ludlow and Bierstadt had seen in their travels compared with the 14,162-foot Mount Shasta. "When we first saw the whole of it distinctly," Ludlow wrote, "it seemed to make no compromise with surrounding plains or ridges, but rose in naked majesty, alone and simple, from the grass of our valley to its own topmost iridescent ice." When they departed, they were loaded down with a paint box full of Shasta studies. They also carried plenty of venison and a journal of adventures.

By November Bierstadt had sketched Oregon's 11,245-foot Mount Hood and Washington's 14,410-foot Mount Rainier. The two travelers were now ready to return to New York. Rather than make the risky trip across the continent again, they booked passage on a steamship from Portland to San Francisco, and then south to the Isthmus of Panama. They crossed the isthmus, caught another steamship north to New York, and arrived there just in time to spend Christmas at home.

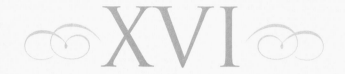

XVI

THE WAR YEARS

Great **fortunes were** gained and lost in the North during the Civil War. Many merchants with business connections in the South went bankrupt, while industrialists who owned woolen mills, shoe factories, munitions plants, and steel foundries made huge profits. Inflation was rampant, but New York City on the whole prospered as never before. Its cultural life was booming; the wealthy came out in full force to attend concerts, lectures, theater benefits, and art exhibitions to raise money for war relief. Tickets for artists' receptions were especially difficult to obtain because, as Worthington Whittredge explained, "so many fine people were desirous of attending them" (Fig. 33).

One of the most important volunteer organizations was called the Sanitary Commission. It was created to improve conditions in the Union army camps and to provide better care for the wounded—a mission later undertaken by the Red Cross. In the winter of 1864, plans for the most

extravagant fund-raising event of the war years were underway. Hundreds of committees were meeting in homes all over the city to organize for the commission's huge Sanitary Fair.

Nearly every trade and profession as well as literary and artistic societies participated in the event. Auxiliary committees were set up in London, Paris, and Rome. Two new exhibition buildings were constructed: one on Fourteenth Street and the other, a temporary building, on Union Square. Days before the opening, the fair buildings bustled with activity as men in frock coats and women in hoop skirts unpacked parcels from all over the world and distributed them to the correct booth.

Eleven thousand soldiers carrying tattered flags ripped by Confederate bullets turned out to march in the opening-day parade. Entertainment ranged from plays enacted by prominent members of New York society to Indian war dances organized by Bierstadt. Exhibition galleries (Fig. 44) held more than six hundred works of art. Some had been donated for sale by artists; others had been selected by the art committee's chairman, John Kensett. Paintings from the Düsseldorf School and French Academy occupied nearly half the space. The

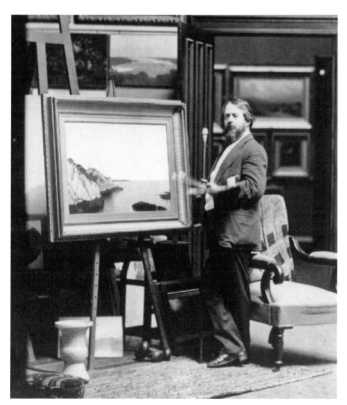

Fig. 43. Portrait of John Frederick Kensett in his Studio, c. 1866. *Image is courtesy of the Miscellaneous Photographs Collection in the Archives of American Art, Smithsonian Institution.*

rest was taken by works of American artists. Leutze's *Washington Crossing the Delaware* and Church's *Heart of the Andes* were shown, but the crowds were gathering around another painting, *The Rocky Mountains, Lander's Peak*. Bierstadt had first exhibited this large-scale painting in 1863 soon after it was completed, but it did not gain wide public exposure until the fair. It was an immediate hit.

Newspapers and magazines were filled with reviews of the painting. One art critic wrote, "There are certain passages of it which indicate an acquaintance with artistic means unsurpassed in any painting of our age and country ... the handling of these particulars is of a perfection which would entitle Bierstadt to the name of a great workman, did he not deserve that of a great artist more justly still." Critics agreed that *The Rocky Mountains*

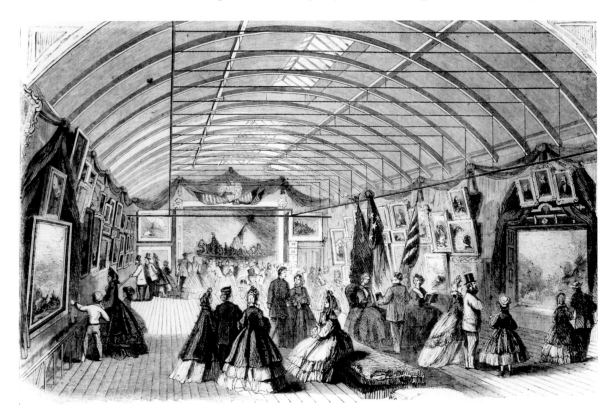

Fig. 44. Metropolitan Sanitary Fair, the Art Gallery, *from Frank Leslie's Illustrated Newspaper, April 23, 1864. © Collection of The New-York Historical Society. 70974*

placed Bierstadt "in the first rank of American genius." He became famous overnight, and Church, four years his senior, found himself with a rival.

As Bierstadt was joining the leading rank of American artists, Kensett was attracting attention for his skill as an organizer. After his success as chairman of the art committee for the Sanitary Fair, which raised more than one million dollars in three weeks, he continued to be sought after as a volunteer for charitable events. In appreciation for his efforts, the Century Association commissioned a painting from him. Like Thomas Cole twenty years earlier, Kensett selected Mount Chocorua as his subject. This time the mountain was no longer the backdrop for a home in the wilderness; it was the backdrop for a pastoral scene of wheat fields, farmhouses, and people. The painting was sold for $5,000, the highest price his work had ever commanded.

The first evidence of a spectacularly rising art market had occurred just before war broke out, when William T. Blodgett paid $10,000 for *Heart of the Andes*. Just as wartime fortunes quickly changed hands, so too were art collections being feverishly bought and sold. Auction galleries were packed, and fabulous prices were the rule. What appears to have made the greatest impact on the market, however, was the sale in London of a collection of paintings owned by a merchant, Elhanan Bicknell. By buying directly from artists at low prices, he had built an important collection of paintings, including a number of works by Turner. When his collection was sold, it brought the equivalent of $300,000—an extraordinary rise in market value in one man's lifetime. After the sale of the Bicknell collection, it was apparent to many that buying art was not just a worthy cause, but an investment that could increase greatly in value. In 1865 James McHenry, an American living in London, bought Bierstadt's *The Rocky Mountains, Lander's Peak* for $25,000—the highest price ever paid for an American painting.

The National Academy also benefited from the rising art market. From time to time in its vagabond history, its members had made fruitless attempts to acquire a permanent home. Before the war, a plot of land had been purchased and designs submitted, but as the artists quibbled over the style of architecture, the outbreak of the war brought the project to a halt. Exhausted after sixteen years as president, Asher Durand resigned at sixty-five

Fig. 45. National Academy of Design, opened 1865. *Photograph, Peter Bonnett Wight (1838–1925). National Academy Museum Archive, New York.*

years of age. Unprepared for succession, the academy summoned the seventy-year-old former president, Samuel F. B. Morse.

A year later, however, a newly elected president, portrait painter Daniel Huntington, decided to proceed with the building despite the war. Before construction could begin, the academy's council had to agree on whether to erect a plain brick building or to raise enough money to build an example of the finest architecture of the times. For three years the academy remained in deadlock. Finally a member of the council proposed starting a Fellowship Fund of one-thousand-dollar memberships. John Kensett, still a bachelor with a reputation of appearing nightly at the finest dinner tables in the city, became one of the prime fundraisers. He and his committee so persistently pursued the rich from their Wall Street offices to their Fifth Avenue drawing rooms that by May 1863 they met their goal of $100,000.

The following October, a ceremony was organized for the lowering of the cornerstone. Members of the academy and guests assembled at the Century Association at East Fifteenth Street. In their silk hats and black coats, they marched to the academy plot on

Twenty-Third Street and Fourth Avenue. The procession was led by the janitor, who carried the copper box to be placed in the cornerstone. Speeches began with an invocation proclaiming the building's dedication to the honor of God, the benefit of his creatures, and to the beautiful in nature. "Nature is the art of God," said the clergyman. "Thou, Lord, hast made all things beautiful."

William Cullen Bryant's speech related the events that had led to the National Academy's founding forty years earlier. "I lent its founders such an aid as a daily press could give," he told the audience. In those days he could count "the eminent artists of the country on his fingers," while today no one could enumerate all the men who had "devoted their genius to the Fine Arts." Between speeches the band played, and at the end, Peter B. Wight, the architect, gave Daniel Huntington a silver trowel to lay the cornerstone.

In the spring of 1865, the new National Academy of Design building (Fig. 45) was opened to the public. The artists' allegiance to John Ruskin had succeeded in uniting them on the style of architecture. They selected Venetian Gothic—a style Ruskin praised highly in his influential book, *The Stones of Venice*. Modeled after the Doge's Palace in Venice, the building had a polychrome facade decorated with horizontal bands. Gothic-arched windows ran along the second story, and roundels filled with tracery pierced the upper walls. The impressive entryway was approached by a double staircase, beneath which a drinking fountain offered an opportunity for passersby to quench their thirsts.

For the grand opening, ladies and gentlemen arrived in formal attire. An orchestra played, and paintings were shown celebrating the scenic regions of the country from the Atlantic to the Pacific. Celebration was in the air that spring. On April 10, New Yorkers received news that General Robert E. Lee had surrendered. Four years of the bloodiest war in the history of the country had come to an end.

XVII

POSTWAR EXUBERANCE

One **prominent member** of the National Academy was noticeably absent from the New York art scene in the spring of 1865. Frederic Church had made a hasty departure to Jamaica. In March his three-year-old son and one-year-old daughter had died of diphtheria within eight days of each other. Heartbroken, he and Isabel packed their trunks and sailed to the West Indies. For five months Church traveled about the tropical islands sketching with the fervor of a man trying to recover from a tragic loss.

Revived by his trip, Church arrived home to complete one of the most glorious masterpieces of his career, *Rainy Season in the Tropics* (Fig. 46), a misty landscape bathed in golden light with a perfectly arched rainbow reaching from a tropical mountainside to glowing cliffs. The world was hopeful again—his country was at peace, and his wife was expecting another baby.

At the same time, Bierstadt was enjoying his most productive years, working on large paintings of Yosemite Valley and other scenic regions he had sketched on his trip across the continent. One of these, *Storm in the Rocky Mountains: Mount Rosalie* was first shown at a benefit for the Nursery and Children's Hospital in February 1866. The painting's central mountain soared so high that one critic estimated that if proportions were rendered correctly, it would have to be ten thousand miles high. Bierstadt named the fantastic peak Mount Rosalie, reflecting his elation at the time; he had fallen in love with the beautiful, brown-eyed Rosalie Osborne Ludlow, who had divorced Fitz Hugh Ludlow. She and Albert Bierstadt were married on November 21, 1866.

Fig. 46. Rainy Season in the Tropics, 1866

Frederic Edwin Church
(1826–1900)

Oil on Canvas,
56 1/4 × 84 1/4 in.
(142.9 × 214 cm.)

Fine Arts Museums
of San Francisco

Museum purchase,
Mildred Anna Williams Collection

1970.9

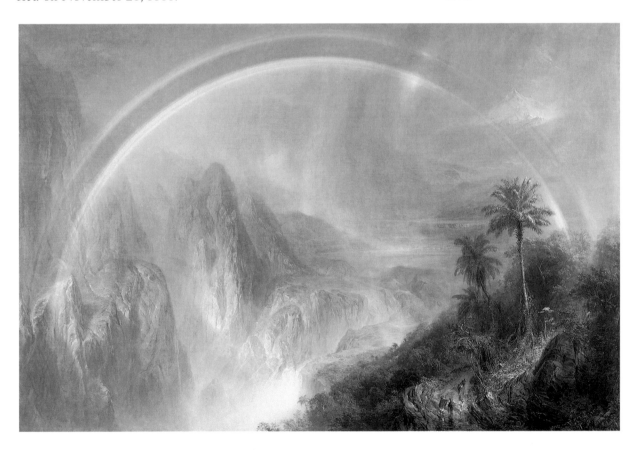

Fig. 47. Albert Bierstadt, c. 1875.

Image originally photographed by Bierstadt Brothers and is courtesy of the Miscellaneous Photograph Collection in the Archives of American Art, Smithsonian Institution.

Ludlow was furious. In his book, *Heart of the Continent,* about his western trip with Bierstadt, he did not once mention the man whom he had formerly described as his best friend. Ludlow had become increasingly unstable, returning to hashish and also beginning to drink heavily. His friends lost all patience with him. With his health deteriorating, he went to Switzerland in hopes of finding a cure, but he died there four years later.

From his bachelor days, Bierstadt had been a popular member of New York's social circles. He possessed charm, warmth, and a wealth of adventure stories that delighted his dinner partners. His good looks, distinguished bearing, and polished manners made him acceptable to the rich, whom he cultivated with great success. One New York matron confided to her diary that Mr. Bierstadt, the artist, was the most charming man attending the New York balls. Rosalie was a perfect wife, for she, too, moved among the most cultivated people of New York. She was admired for her beauty, outspokenness, and wit. The thirty-six-year-old groom was so ecstatic about his marriage, he wrote to a friend, "My only regret is that I did not know my wife when I was thirteen years old, and could have married her then. I am the happiest man living."

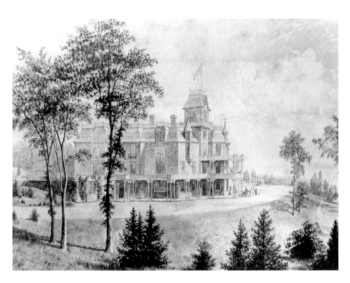

Fig. 48. Malkasten, the Victorian mansion built by Albert and Rosalie Bierstadt, Irvington, New York. *Stereograph, The Brooklyn Museum of Art, Library Collections, Bierstadt Collection. 1996.169.2*

The high prices that Bierstadt's paintings continued to command brought him a small fortune, which was quickly consumed by an elaborate project begun soon after his wedding. He and Rosalie had decided to build a mansion on a hillside overlooking the Hudson River in Irvington, New York, just above Washington Irving's house, Sunnyside.

The Bierstadts' thirty-five-room Victorian mansion (Fig. 48) was crowned with towers, adorned with balconies, and surrounded by verandas. A three-story-high studio (Fig. 49) with a floor-to-ceiling window occupied the central portion, providing ample space for his large-scale paintings as well as his collection of Indian costumes, war implements, and animal trophies. From hundreds of sketches, displayed even in the bathrooms, clients could choose the mountain, lake, waterfall, grove of trees, and wild animal they liked best. Bierstadt would then combine those elements into a large oil painting tagged with the name of a specific geographical location. A balcony just off the master bedroom overlooked the studio, permitting the artist to slip out at any time to view a work on the easel.

The ground floor contained a billiard room, dining room, butler's pantry, and kitchen. Outside there were stables, a carriage house, icehouse, gardens, and a lawn that led down toward the river. Bierstadt named this imposing structure Malkasten after the artists' club in Düsseldorf.

Fig. 49. Bierstadt's Studio at Malkasten.
Stereograph by Charles Bierstadt. The Brooklyn Museum of Art, Library Collections, Bierstadt Collection. 1996.169.5

His spacious studio was perfectly suited for the largest work he had ever been commissioned to paint—the nine-by-fifteen-foot *Domes of the Yosemite* (Fig. 50). Exhibiting as much boldness in his art as he had in his travels, Bierstadt depicted the immense valley with the shining Merced River winding through it. The painting was to be hung in the front hall of the Norwalk, Connecticut, mansion of the banker and railroad vice-president, Legrand Lockwood. When the painting was exhibited in 1867, some critics were offended by its size. "Mr. Bierstadt," wrote one, "seems to be under the delusion that the bigger the picture is, the finer it is."

Many eastern critics, who had never seen the West, thought that Bierstadt exaggerated the proportions of the scenery. He had tried to explain the differences in scale in a

Fig. 50. Domes of the Yosemite, 1867

Albert Bierstadt (1830–1902)

Oil on Canvas, 116 × 180 in.

Collection of St. Johnsbury Athenaeum, St. Johnsbury, Vermont

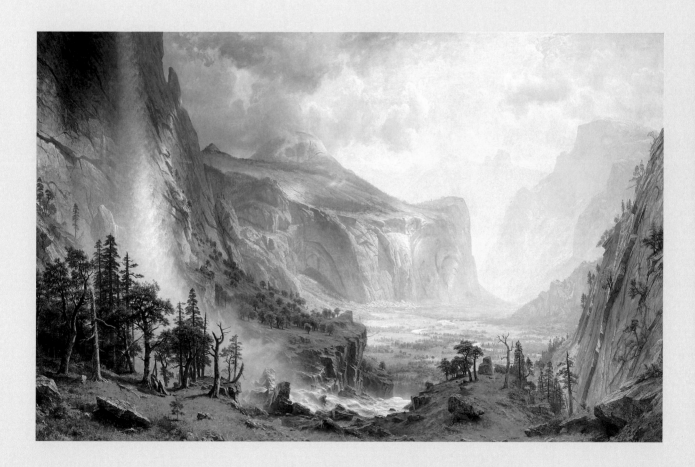

letter published in *The Crayon* in 1859: "We see many spots in the scenery that remind us of our New Hampshire and Catskill hills, but when we look up and measure the mighty perpendicular cliffs that rise hundreds of feet aloft—we realize that we are among a different class of mountains."

Other critics understood that Bierstadt was a master at creating the illusion of space: "The idea of space or distance, from the foreground to the extreme point where the rocks blend with the vapoury films ... strikes the mind of the spectator. In rendering the illusion here, the artist has, we think, achieved his greatest success."

Bierstadt's trip west inspired other artists. At the conclusion of the war, Worthington Whittredge decided to accompany an expedition to the Southwest led by General John Pope, who had commanded Union troops during the second battle at Bull Run in 1862. Whittredge rode over two thousand miles on horseback that summer, usually traveling between daybreak and one o'clock in the afternoon, at which time he would pull his sketch box from under the piles of camp furniture heaped in the wagons and sketch until sundown. He carried a revolver on these excursions, for the Ute Indians were on the warpath. Sometimes the artist grew annoyed when General Pope, upon seeing his white umbrella perched on a hillock in an innocent-looking landscape, ordered him back to camp for safety.

In Santa Fe Whittredge shared the barracks with the famous frontiersman Kit Carson. "I was the subject of the most profound interest to him," Whittredge wrote. "He said nothing about it, but I could see I was an enigma to him which he was all the time trying to solve. He looked at my sketching apparatus and then at my pictures, until finally one day he asked if he might not go with me a little way up the mountain side where I expected to make a sketch."

Whittredge was glad for his company and reported, "He stood over my shoulder a long time in silence; when finally he seemed very uneasy and asked if I would not stop painting and go a short distance and sit down on a stone with him; he had something he wanted to tell me. I went with him. He began by describing a sunrise he had once seen high up in the Sangre de Cristo mountains. He told how the sun rose behind their dark tops and how it began little by little to gild the snow on their heads and finally

how the full blaze of light came upon them and the mists began to rise from out the deep canyons, and he wanted to know if I couldn't paint it for him." Whether Whittredge complied with Carson's request he does not say, but he concluded, "Nature had made a deep impression on this man's mind, and I could not but think of him standing alone on the top of a great mountain far away from all human contact, worshipping in his way a grand effect of nature until it entered into his soul and made him a silent but thoughtful human being."

On returning to New York, Whittredge began to court a young woman he had known for a long time. Her father, Judge Samuel A. Foot, was a member of the Supreme Court of New York State. On October 16, 1867, the forty-seven-year-old artist married Harriet Euphemia Foot in Geneva, New York. Some years later he used their large porticoed house as the subject of a painting. He showed a horse and carriage waiting in the driveway, his father-in-law reading on the front porch, and his daughters, Euphemia and Olive, playing in the sunshine.

After the war Jasper Francis Cropsey was selling enough paintings to be able to build an elaborate summer home in Warwick, New York. The site looked out to twin mountains called Mounts Adam and Eve, which he painted a number of times. One small painting of this view (Fig. 51) appears to be a beautiful autumn scene, but the flow of water through the landscape brings to mind Thomas Cole's allegory, *The Voyage of Life*. At the right corner a flurry of gray strokes suggests a rill running through the forest, across the road, and down the hill. It surfaces again in the distance as a stream gliding through a green meadow. Even at this stage, its progress hints at man's journey from infancy to youth, but the painter's symbolic intent is verified further when the watercourse gains momentum and turns to rapids, representing the challenges of manhood. After it vanishes into the forest, a distant mountain cleft testifies to its passage into another realm. A nearby church offers a final opportunity for redemption.

The Paris Universal Exposition of 1867 offered American landscapists their first opportunity to be judged as a group by a European audience. Fear that their work would not hold up in Europe had been dismissed years ago. Before he left for Paris, Church wrote

Fig. 51. Mounts Adam and Eve, 1872

Jasper Francis Cropsey (1823–1900)

Oil on Canvas, 12 1/8 × 20 1/8 in. (30.8 × 51.1 cm.)

Reynolda House, Museum of American Art

Winston-Salem, North Carolina

to Bierstadt to ask for the use of his large easel to put some finishing touches on *Niagara* before it was sent to France. He also asked Bierstadt to "brush up" his intellect and be ready to find all the fault that he could.

Bierstadt's *The Rocky Mountains, Lander's Peak* was also sent to the exposition, leaving a bare wall in James McHenry's house in the heart of London. Church's *Niagara*, Gifford's *Hunter Mountain, Twilight,* Whittredge's *The Old Hunting Grounds*, Kensett's *Autumn Afternoon on Lake George*, and Cropsey's *Mount Jefferson, New Hampshire* were all shown to European viewers. Both *Niagara* and *The Rocky Mountains, Lander's Peak* won awards. One foreign critic wrote: "Every nation thinks that it can paint landscape better than its neighbor; but it is not every nation that goes about the task in a way peculiar to itself. No one is likely to mistake an American landscape for the landscape of any other country. It bears its nationality on its face smilingly."

Church, Bierstadt, and Kensett sailed off to Paris to attend the Exposition. In England the Bierstadts were introduced to Queen Victoria and attended a private concert by the Hungarian composer, Franz Liszt. Bierstadt hosted a lavish dinner at the Langham Hotel in London for Henry Wadsworth Longfellow, who was receiving an honorary degree from Cambridge. Notables attending included the poet Robert Browning, artist Edwin Landseer, and British Prime Minister William Gladstone. Cyrus Field, who had laid the first successful transatlantic telegraph cable two years earlier, was also present. Guests enjoyed a dinner of fish, game, veal, chicken, artichokes, and corn. A George IV pudding was served for dessert. After the men had eaten, the ladies were presented and music began.

While the Bierstadts enjoyed life among the European elite, the Churches left Paris to explore the Middle East (Fig. 52). Church cared little for Europe; his passion leaned toward the Biblical sites and ancient ruins of the Holy Land. He made arrangements for his wife, mother-in-law, and one-year-old son Freddie Josie to stay in Beirut while he made short excursions to Jerusalem and the hidden city of Petra, which had only recently been discovered. Since the trip over the desert was dangerous, Church took precautions by traveling in a caravan. Nevertheless, Isabel was relieved when he returned. Meanwhile, she had discovered her own favorite means of transportation—the white Syrian donkeys.

Fig. 52. Frederic Church and his son Frederic Joseph in Beirut, date unknown. *Attributed to Felix Bonfils. Olana State Historic Site, New York State Office of Parks, Recreation and Historic Preservation.*
OL 1984.446

With the absence of these two celebrated artists, the Tenth Street Studio Building became a quieter place. Martin J. Heade took advantage of the lull, leaving Boston and moving into Church's vacant studio. At the National Academy exhibition of 1868, he exhibited one of his most startling paintings, *Thunder Storm on Narragansett Bay* (Fig. 53). The dark, brooding coastal scene was unlike anything done at the time, but the critics did not respond well to it. One of them wrote, "It is to be regretted that so hard and chilling a painting as this should have been allowed to leave his studio." *Thunder Storm on Narragansett Bay* is considered today to be one of the more significant paintings in nineteenth-century American art.

Nearby in his Broadway studio, John Kensett was also working on one of the more important paintings of his career. Taking leave of Bierstadt and Church, he had

sailed home soon after the closing of the Paris Exposition. He returned immediately to work, selecting a view of Lake George. A subdued palette of carefully orchestrated warm and cool grays with occasional broad areas of dark green conveys the tranquility of the lake on an overcast day. He had no trouble finding a buyer. Morris K. Jesup, a banker and manufacturer, purchased it for $3,000, the second-highest price Kensett had received.

Lake George (Fig. 54) confirmed the new direction in which Kensett had started to move. Unlike Church and Bierstadt, he drew inspiration from places that conveyed peace and serenity, and within these confines he worked towards the elimination of detail. Many of his works from this period were inspired by views across the placid waters of Long Island Sound, where he found the quietude that inspired him.

Sanford Gifford had been fidgety all winter. Finding the diminished activity in the Studio Building uncongenial for work, he decided to travel again. One day in June he walked into Whittredge's studio with a satchel on his shoulder and bade him good-bye as if he were going to Coney Island. He left his studio door open with a finished painting on the easel and a card indicating where it was to be delivered. He visited Egypt, Jerusalem, Lebanon, Syria, Greece, and Turkey, catching up with Church in Rome in the winter of 1869. Eighteen months later, he returned with the same satchel on his shoulder. He ordered breakfast from the janitor, asked if all were well, and started to work in his studio as if he had never been away.

New York art devotees were still waiting eagerly to see Church's canvases from the Middle East. Expectations rose to such heights that one critic wrote: "A new picture by Church is a considerable event in the art world, like a new novel by Victor Hugo or a poem by Tennyson." But this time it was not a picture of nature's wonders, but of mankind's. It was a view of Jerusalem. When it was exhibited at Goupil's in 1871 to great acclaim from the press, a diagram identifying twenty-four places of interest in the Holy City was made available to spectators.

During eighteen months of living and working in rented houses and studios, Church was dreaming of building a new home. Middle Eastern architecture had given him a new

Fig. 53. Thunder Storm on Narragansett Bay, 1868

Martin Johnson Heade
(1819–1904)

Oil on Canvas, 32 1/8 x 54 3/4 in.

Amon Carter Museum,
Fort Worth, Texas

1977.17

Fig. 54. Lake George, 1869

John Frederick Kensett (1816–1872)

Oil on Canvas, 48 1/8 × 66 3/8 in. (112.1 × 168.6 cm.)

The Metropolitan Museum of Art

Bequest of Maria Dewitt Jesup, from the collection of her husband, Morris K. Jesup, 1914

Photograph © 1992 The Metropolitan Museum of Art

14.30.61

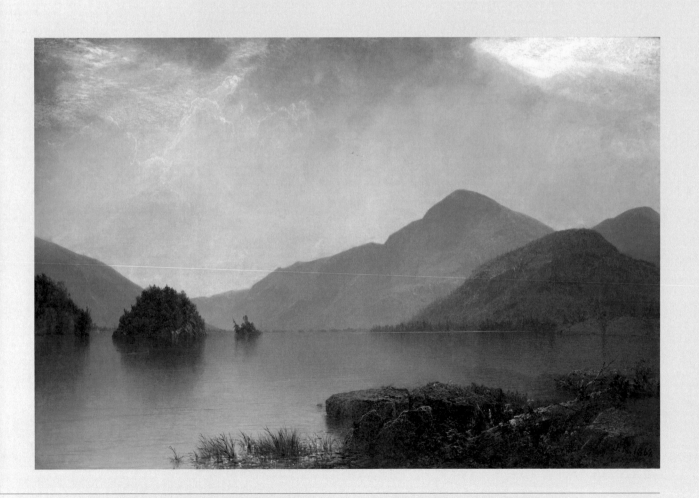

Fig. 55. Sanford R. Gifford, 1868, *carte de visite from Mrs. Vincent Coyler's Album. Photographer unknown. The Metropolitan Museum of Art, David Hunter McAlpin Fund, 1952 (52.605).*

perspective on house planning. Before he left, he had asked Richard Morris Hunt, the Tenth Street Studio architect, to work up some drawings, but after he returned, he felt that he needed an architect sympathetic to Middle Eastern styles. He also wanted someone willing to take on the basic construction so he could concentrate on the design. His friend Calvert Vaux, a landscape designer and architect then working with Frederick Law Olmsted on Central Park, was willing to accept the job.

The new house was to be located on Church's farm in Hudson, New York, where he had a summer cottage. It was to be built on a hilltop from which he could see the course of the Hudson River for miles. He could also look across it to Cedar Grove, where Cole's son

Theddy still lived. Hundreds of architectural sketches document the enormous amount of work that Church put into the design and decoration of his house, which he called Olana (Fig. 56), a variation of the Persian word *olane* meaning fortress treasure-house.

Its position on a hilltop, its stone facade, and its square tower give Olana the fortress-like appearance reflected in its name. Bricks in colors of yellow, red, and black decorate the stone facade at the upper level. Embellishment increases toward the roof and, in fact, turns playful with ceramic teapots adorning the tower. The interior incorporates Middle Eastern domestic architecture in its court hall and elaborate wall decoration painted in variations of pale orange, gray, mauve, and moss green.

The Churches had shipped home fifteen crates filled with exotic objects from many countries. They liked to call them their "treasures," but they were in fact inexpensive objects found in Middle Eastern and Roman markets. They unpacked Turkish and Persian rugs, bronzes, ancient weapons, armor, brass trays, Chinese porcelain vases, religious relics, and statuary. These were carefully arranged to give the interior a cosmopolitan ambiance anticipating the Aesthetic Movement of the late 1870s and '80s. In this period it was fashionable to use stained glass in fine homes, but it was very expensive, so Church and Isabel cut sheets of black paper into delicate patterns and slipped them between two large plates of amber glass. The result was a perfect imitation of a leaded glass window.

Church intended to have "one old room" in his house "with old furniture and old pictures—everything toned down to 400 years back." For this room, which became the dining room, he put together a collection of paintings that he referred to as "old masters." He bragged that the highest price he paid for a painting was thirty dollars; the lowest, one dollar. He liked to pretend that he owned masterpieces and joked about opening his collection to the public. "Of course great names must be attached to the pictures—for faith works miracles ...," he wrote. A visitor today will find that Church did indeed attach a plaque bearing a famous artist's name to each frame.

By the time Church began to spend summers at Olana with Isabel and their young children, the Bierstadts, some seventy miles downriver, had already forsaken Malkasten.

The childless couple preferred to be on the move. The Churches, on the other hand, socialized mainly with family and close friends. Church took pride in his new home. "About one hour this side of Albany," he wrote, "is the center of the world—I own it."

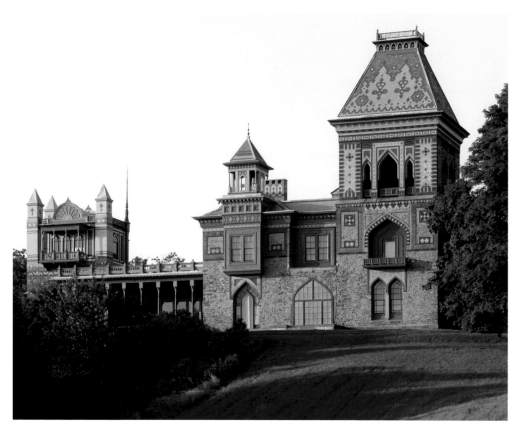

Fig. 56. South façade of Olana, Frederic E. Church's house, Hudson, New York.
Photograph by Stan Ries. Courtesy of Olana State Historic Site, New York State Office of Parks, Recreation and Historic Preservation.

XVIII

THE RAILROAD WEST

ince 1863 thousands of Chinese laborers had been working at backbreaking speed in the California mountains, blasting tunnels through rock, constructing trestles over ravines, and laying rails on new roadbed. Many people had doubted whether the railroad could penetrate the snow-clogged passes and bridge the deep canyons of the Sierra Nevada, but the colossal task had been at last completed. Now the Central Pacific crews worked fast and furiously to span the flatlands of the Nevada desert. They were racing to meet the Union Pacific, which was laying its rails westward at a top speed of five miles per day. The gap between the two sets of tracks was closing fast.

In May 1869 the link-up ceremony was set to take place in Promontory, Utah, north of the desert that Albert Bierstadt had crossed at such peril by stagecoach six years earlier. Railroad presidents Leland Stanford

and Thomas Durant waited among construction crews, soldiers, and other railroad officials for the great moment when they were to drive the gold and silver spikes into the ties. The spikes were wired to set off a telegraph signal to inform the world that the east and west coasts of the continent were now linked by its first transcontinental railroad. It was a day to stir the entire nation. The railroad brought the Atlantic and Pacific coasts within a six-day journey of each other.

Legrand Lockwood, who could enjoy a painted view of Yosemite Valley each time he stepped into the rotunda of his mansion, had been considering how others might thrill to the reality of the country's scenic wonders without foregoing the comforts of home. He came up with the idea of a specially designed palace railroad car with dining service and plush seats that converted into sleeping berths. In 1871 Bierstadt took his wife across the country in one of these new palace cars.

Bierstadt was not only looking for new subjects, he was also looking for new patrons. After the first rush of enthusiasm for his *The Rocky Mountains, Lander's Peak*, New York critics had decided that his paintings "astound but do not elevate" and emit "no depth of feeling." In an effort to maintain his stylish life with income earned entirely from his work, Bierstadt sometimes dashed off commissions. Moreover, he composed much of his work according to a few formulas, using certain elements. He was unable to imbue natural scenery with the rich metaphorical associations evoked by Church's landscapes. Nonetheless, Bierstadt remained popular with the people. Americans wanted to know what their country looked like, and no other artist could arouse such pride in national scenic wonders.

The year that Bierstadt arrived in California, Clarence King, a leading geologist and member of the Josiah Dwight Whitney surveying group, claimed to be first to reach the top of the 14,495-foot Mount Whitney, then believed to be the highest mountain in the United States. After writing a book about his feat, he discovered that he had mistakenly climbed a lower peak, while Mount Whitney had remained hidden in clouds. The persistent King set out again to conquer Mount Whitney, but upon reaching the top, he discovered names carved in the granite indicating that someone else had reached the summit first.

While the controversy raged as to who had first conquered the elusive mountain, Bierstadt, capitalizing on the publicity, turned out numerous Mount Whitney paintings (Fig. 57) for an eager public. With his customary knack for flattery, he named his best-known painting of the mountain after Col. William Corcoran, even though no Mount Corcoran existed. He hoped that the colonel would purchase the painting for his museum. He did, and it can be seen today in the Corcoran Gallery in Washington, D.C.

Some of Bierstadt's most enthusiastic patrons were men who had amassed fortunes in the West. Leland Stanford's Central Pacific Railroad was taking hundreds of passengers through the regions Bierstadt made famous with his brush. Stanford's partner, Collis P. Huntington, took Bierstadt on a trip into the High Sierra soon after his arrival in San Francisco, and for $25,000 commissioned him to paint a view of the highest point over which the railroad passed. Called *Donner Lake from the Summit*, the huge painting, over twelve feet wide, was exhibited in San Francisco and was described as the "art-sensation of the city." A critic on the *San Francisco Chronicle* rephrased Mark Twain's reaction to Church's *Heart of the Andes* years earlier: "If you take your lorgnette with you and look with an intelligent eye, you can discover new beauties every moment; and the oftener you see it, the more impressed you will be."

When Bierstadt was not off on a sketching trip, he worked in a studio on Clay Street overlooking San Francisco Bay and the Golden Gate. He painted a number of California scenes including seals prancing among the rocks on the Farallon Islands, some twenty miles off the coast. This painting found its way to the New York mansion of A.T. Stewart, the department store magnate. In October 1873 Bierstadt and Rosalie returned to New York, where he continued to work up his West Coast sketches into full-sized paintings.

Meanwhile, Kensett and Gifford had taken their first trip to the foot of the Rocky Mountains. Whittredge, who accompanied them, left his impressions in his autobiography. He found that the vastness and serenity of the prairie inspired him more than the height and grandeur of the Rockies. With perhaps a touch of envy over the enormous prices that Bierstadt's works were bringing, Whittredge questioned why the public made such a

fuss over paintings of mountain scenery. He said that he had never measured "all grandeur in a perpendicular line."

Kensett and Gifford were also attracted to subjects with horizontal rather than vertical lines and rarely attempted the dramatic views that appealed to Bierstadt and Church. They preferred to paint medium-sized canvases that were more appropriate to drawing-room walls than exhibition galleries. They continued to depend on the National Academy as their primary place to exhibit, along with hundreds of other artists. Their paintings were loved by the people, welcomed by the critics, and brought prices high enough to permit them to live comfortably.

As firm supporters of the National Academy, Whittredge, Gifford, and Kensett maintained a close friendship with its former president, Asher B. Durand, who had decided to sell his house in New York City and move back to the family farm in Maplewood, New Jersey. At age seventy-four, he was continuing to paint directly from nature and was still exhibiting annually at the academy. His son and biographer, John Durand, recounted an interview with a reporter from a health journal. He was eager to learn Durand's secret for such a long and productive life:

"Mr. Durand, I suppose that you have never used tobacco," the reporter queried.

Picking up his pipe, Durand answered, "Yes, sir, I have always used it; I smoke now, and when a young man, I chewed."

"Ah! But you did not drink ardent spirits. How is that?"

"Yes, sir, I have, and do so now. My daughter has just given me an egg-nog with brandy in it."

The interviewer pursued another possibility: "Well, during your long life you have done a great deal of work?"

"That is true," Durand chuckled. "I have spoiled a great many canvases."

In 1872 Kensett, Gifford, Daniel Huntington, and another artist, Jervis McEntee—all grateful to Durand for the encouragement he had offered in their youth—invited friends to a party in honor of the aging artist. Bringing food and champagne from the city, they organized a surprise picnic in the woods near Maplewood. William Cullen Bryant toasted

Fig. 57. Sierra Nevada, c. 1871–1873

Albert Bierstadt (1830–1902)

Oil on Canvas, 38 1/2 × 56 1/2 in. (97.8 × 143.5 cm.)

Original purchase fund from the Mary Reynolds Babcock Foundation,
Z. Smith Reynolds Foundation, Arca Foundation, and Anne Cannon Forsyth

Reynolda House, Museum of American Art

Winston-Salem, North Carolina

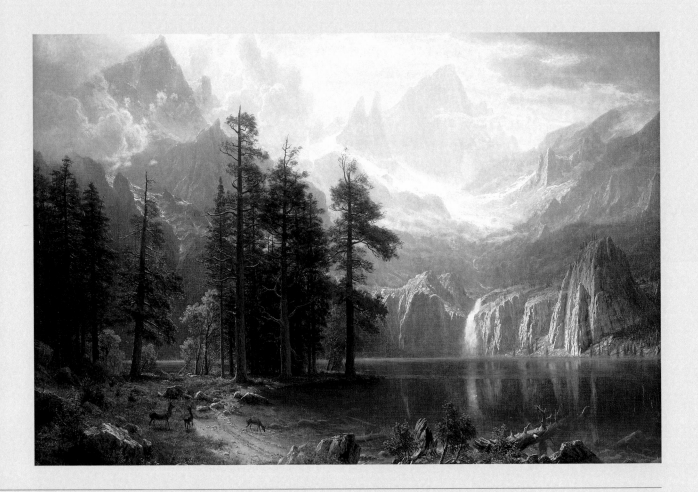

Durand as the pioneer "of our pathways which have now become highways." Music followed, after which groups took walks in the woods. When evening came, four-horse teams took the New Yorkers off to the railroad station, cheering and calling farewell.

Durand could not have known that he would never again see his friend John Kensett. The next winter, Kensett tried to rescue the drowning wife of a friend in Darien, Connecticut, and caught pneumonia. He died just before Christmas at the age of fifty-six. The following spring the contents of his studio were auctioned off for a total of $136,312. His friends were surprised at the value of his unsold paintings and other possessions.

A huge Centennial Exposition was organized in 1876 to celebrate one hundred years of American independence. One hundred and sixty-seven buildings were erected on a 236-acre site in Philadelphia to house exhibitions from as many as fifty nations. A half-size railroad transported visitors past four and a half miles of pavilions, villas, gardens, lakes, and colossal statues. On display were products of all kinds—a hair regenerator from Switzerland, sugar-coated pills from Pennsylvania, dog soap from Britain, artificial manure from Argentina, and salted reindeer tongues from Russia. One of the highlights was a bust of a girl carved in butter by a woman from Arkansas.

The glass-domed Memorial Hall displayed the largest art exhibition ever held in the United States. Fifteen of its thirty galleries were devoted to American art. Paintings by the deceased landscapists Thomas Cole and John Kensett were obtained for the occasion. History paintings, portraits, still lifes, and genre paintings were represented, but landscapes dominated—and won half of the medals.

Whittredge, who was then president of the National Academy, was in charge of assembling paintings from New York State. Church sent *The Parthenon*, a depiction of the Greek temple, and *Chimborazo*, painted twelve years earlier from the sketches he had made in Ecuador. He, Cropsey, Whittredge, and Bierstadt were praised for their work, but Sanford Gifford, who had sent the largest number of paintings, walked away with most of the awards. In spite of the recognition, however, he appeared depressed. The following spring he married secretly, but died soon after at the age of fifty-seven.

None of the paintings in the exhibition acknowledged the industrial expansion then revolutionizing the country. The era of exploration represented by picturesque landscapes and stunning views was coming to a close. America's future lay in the clattering, chugging, roaring galleries of Machinery Hall. As far as the eye could see, machines of all kinds were run by one giant steam engine. Each day at one o'clock the engine would stop for an hour, and crowds would gather to watch it start up again. As the giant flywheel began to turn and all the shafts, pulleys, and belts went into action, the hall was filled with the cheers of the crowd heard above the deafening roar.

During the Centennial year Americans had begun to visualize another world. Faith in nature was giving way to faith in the machine. Hope for mankind shifted to technology and industry. The locomotive had pierced the wilderness. A new era had begun.

XIX

THE FALL FROM FAVOR

In the late 1870s a new generation of American artists was returning to New York from art studies abroad. Düsseldorf no longer attracted them; they studied at more progressive centers such as Munich and Paris. When they arrived home, some of them settled into the Tenth Street Studio Building where Church, Bierstadt, Whittredge, and Heade were still painting natural scenery. The old-timers were shocked and bewildered by the radical ideas of the young. Many of them cared nothing for scenery and would just as soon paint a backyard, a vase, a figure, or even dead fish. They avoided the subdued brushwork that gave priority to subject matter and favored flashy brushwork that often seemed to obscure it. They scoffed at the suggestion that their art had to be characteristic of their country. The hopes and dreams of the older generation for the continuation of a truly American style were collapsing.

During Whittredge's term as president of the National Academy, which was still this country's major art showcase, conflicts erupted between young and old artists. Because there was not enough gallery space to exhibit all of the work submitted, a selection committee had been established. The first year the committee selected mostly younger artists, outraging the older members. The following year, the committee tried to compensate by giving preference to the old guard. This set off a revolt among the younger artists, who accused the National Academy of being ruled by a clique of stodgy old men who favored social position over genius. George Inness (Fig. 58), an older but largely unrecognized artist, complained bitterly that an artist who kept "his nose clean and his shoes well-brushed" carried more weight than one with talent. In a move recalling the founding of the National Academy fifty years earlier, the new generation banded together and, by the fall of 1878, had organized its own association, the Society of American Artists, where their work could be exhibited without having to undergo the scrutiny of older artists.

In the midst of the dissension, Church reaffirmed the beauty of the equatorial wilderness in his last masterpiece, entitled *Morning in the Tropics*, showing a broad river flowing through a tropical forest. Between 1878 and 1880, the painting was widely exhibited, first at the Paris Exposition, then in New York at the Century Association and the Metropolitan Museum of Art. Church's brushwork, although delineating the usual full range of fascinating botanical detail, had become more richly textured. This stylistic shift suggested that Church might have adapted to the new aesthetic, but for the young generation in the aftermath of the Civil War, the divine spirit in nature embodied in Church's subjects had lost its meaning. When Henry James, a brilliant young novelist, saw the painting, he remarked condescendingly, "Why not accept this lovely tropic scene as a very pretty picture, and have done with it?"

When Bierstadt returned to New York from California, he found a different city. The population had soared to over one million, and thousands of immigrants continued to pour in. Mansions were spreading up Fifth Avenue overlooking the ponds, fountains, and meadows of the newly completed Central Park. At Eighty-Second Street, people were crowding into the Metropolitan Museum of Art, which had opened its new building in a

Fig. 58. George Inness seated in his studio with *Sundown* **(1884) in the background, c. 1890.** *Image originally photographed by E. S. Bennett and is courtesy of the Macbeth Gallery records, 1838–1968 (bulk 1892–1953), in the Archives of American Art, Smithsonian Institution.*

ceremony led by President Rutherford B. Hayes. Downtown, the first masonry skyscraper was on the drawing board, a project of Church's old friend Cyrus Field. Electric arc lights had been installed on lower Broadway, and two years later, Thomas Edison's giant dynamo would be supplying electricity to homes and shops. The overhead wires of New York's first telephone exchange already cluttered the sky.

Among the rapid changes, a shift in taste towards French landscapes had affected the market for Bierstadt's American scenery. Waning interest took a bite out of the twenty-five thousand dollars he had been accustomed to receiving for his large-scale western scenes. To make up for reduced income, he and Rosalie moved into her family's house in Waterville, New York, and rented out Malkasten in the summertime. Still, whenever an opportunity arose to associate with the rich and powerful, the Bierstadts were certain to be there. They had made such a favorable impression on Lord Dufferin, the governor-general of Canada, on his visit to New York that he invited them to be his houseguests for the most important social event of the season, the Ottawa masquerade ball. Rosalie went dressed as Mary, Queen of Scots, in a costume of white puffed satin and silver-

Fig. 59. Orchid with Two Hummingbirds, 1871

Martin Johnson Heade (1819–1904)

Oil on prepared panel with Winsor & Newton label, 13 3/4 × 18 in. (34.9 × 45.7 cm.)

Reynolda House, Museum of American Art

Winston-Salem, North Carolina

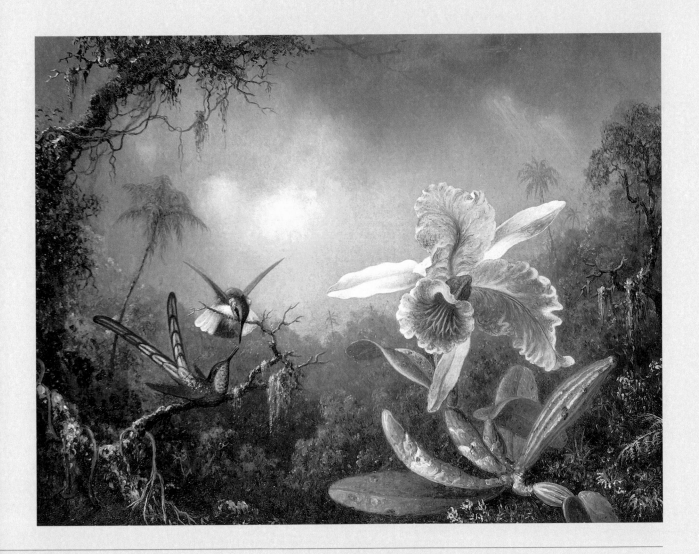

embroidered velvet. Albert was outfitted as Charles I in knee breeches, a velvet cape, and fringed hat. A sleigh carried them over the snow to a candlelit hall where they danced until five o'clock in the morning.

When the Earl of Dunraven, an author, traveler, and sportsman, visited New York, Bierstadt entertained him lavishly at the Brevoort Hotel. A newspaper reported that the distinction of the gentlemen and the extravagance of the menu had "seldom if ever been excelled." Bierstadt was hoping to obtain a commission to paint a view of Estes Park, Colorado, where the earl had just acquired ten thousand acres of land. Bierstadt accompanied him there in 1876 and made many studies in the region. They reached agreement on a price of fifteen thousand dollars for a painting that was only slightly smaller in scale than *The Rocky Mountains, Lander's Peak*. Although his prices had fallen, the quality of the finished painting, *The Rocky Mountains, Long's Peak*, 1877, was as fine as any of his western views.

Fading interest in the Hudson River School affected other artists as well. Jasper Francis Cropsey returned to his earlier profession and busied himself with architectural plans for the Sixth Avenue elevated railroad stations. He also designed a colorful interior for the Seventh Regiment Armory on Sixty-Sixth Street and Park Avenue. (No trace of either remains.) He continued to produce paintings of autumn scenery, but his prices had declined so much that he was forced to sell Aladdin, the twenty-nine-room Victorian mansion he had built many years earlier in Warwick, New York.

Frederic Church's artistic production slowed down after the exhibition of *Morning in the Tropics*. Although he continued to paint sporadically, he never again created a masterpiece. Fortunately he did not need to make adjustments to his living style, since he had inherited considerable wealth. He took comfort in spending longer periods of time with his family at Olana, where he often reflected on the changes taking place around him. Sitting on his veranda one day, looking across the Hudson to the Catskills, he remarked, "I wish science would take a holiday for ten years so I could catch up." The days of Baron von Humboldt had passed—no single person could possibly keep abreast of such vast quantities of new knowledge. Moreover, Darwin's theories of evolution

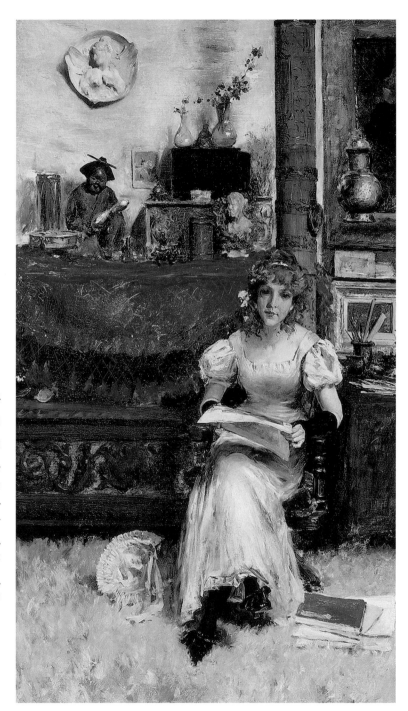

Fig. 60. In the Studio, c. 1884

William Merritt Chase (1849–1916)

Oil on Canvas, 39 × 22 in. (99.1 × 55.9 cm.)

Original purchase fund from the Mary Reynolds Babcock Foundation, Z. Smith Reynolds Foundation, Arca Foundation, and Anne Cannon Forsyth.

Reynolda House, Museum of American Art

Winston-Salem, North Carolina

and survival of the fittest were undermining the concept of a divinely created universe, which had fueled Church's artistic vision.

During this period, Church continued to carry on a lively correspondence with Martin Heade who, in 1871, had again taken up the subject of hummingbirds (Fig. 59), combining them with orchids in tropical settings. At the age of sixty-four, he finally found financial security in the patronage of the Standard Oil vice president, Henry M. Flagler, who was then developing the east coast of Florida. Church was surprised to hear that Heade had bought a house in St. Augustine. He wrote, "That surprise gives way to the greater one of your engagement—not that extraordinary ... but I hadn't heard you were

Fig. 61. William Merritt Chase's Tenth Street studio in New York, N.Y., c. 1880. *Image originally photographed by George Collins Cox and is courtesy of the Miscellaneous Photographs Collection in the Archives of American Art, Smithsonian Institution.*

Fig. 62. The Storm, 1885

George Inness (1825–1894)

Oil on Canvas, 20 × 30 in.
(50.8 × 76.2 cm.)

Reynolda House,
Museum of American Art

Winston-Salem, North Carolina

interested in any particular lady." The bride was forty-year-old Elizabeth V. Smith from Southampton, Long Island, and they married October 9, 1883.

Whittredge had moved to Summit, New Jersey, in 1880, but he held on to his studio in the Tenth Street Building for twenty more years. He must have been astounded by the changes brought about by William Merritt Chase, the dapper twenty-eight-year-old artist, who caused a sensation when he set up his studio in "the city's chief artistic citadel"—the large sky-lighted room in the Tenth Street Building where Church had held his legendary exhibition of *Heart of the Andes* twenty years earlier.

Chase transformed the thirty-by-forty-foot hall into a lavishly decorated studio (Fig. 61) in the new Aesthetic taste, which was prevalent in Europe, but had been seen by few people in this country. Not an inch of space was left bare. He covered the walls with luxurious textiles, gold-framed paintings, Japanese prints, armor, classical tondos, and other relics of world cultures. Brass incense burners hung from the ceiling. Elaborately carved Renaissance furniture provided surfaces on which to display carved Asian figures, pewter tankards, glass vases, glazed pots, and various tools of his trade. The objects were arranged in compositions that displayed a sensitivity to color, line, texture, and form, indicating that Chase considered the entire space a work of art.

His studio became the subject for his most inspired paintings of the 1880s (Fig. 60). Its opulence seemed to arouse Chase's muse as readily as natural beauty had inspired Church and Bierstadt. Subject matter aside, however, Chase's revolutionary contribution was his bold brushwork—the sign of a new era that valued exciting surfaces and dashing strokes as much as the subject they depicted.

When visitors entered Chase's studio, they were greeted by Daniel, a black man costumed as a Turk. He identified so closely with his employer that he would announce Chase's progress by saying: "*We* have just finished a portrait." The artist himself was always dressed to perfection in spats and a cutaway with a carnation in his buttonhole and a different scarf pin for each day of the month. His dandified attire was enhanced by his exotic pets, especially the Russian wolfhounds that were often seen at the end of his leash.

Before his arrival in New York, Chase had accepted a teaching position at the Art Students League, an institution like the Society of American Artists, founded by artists who had broken away from the National Academy. The League welcomed Chase's cosmopolitanism. His firsthand knowledge of the latest art theories, his personal charm, and his dedication to his students made his classes immensely popular. Undoubtedly his affected mannerisms contributed to his notoriety. One of his students reported that he nibbled on his fingertips, jiggled trinkets in his pockets, and told them, "Take plenty of time for your picture—take two hours if you need it." He would not tolerate the laborious execution of detail; to him, it was a sign of bad art.

During Church's rise to fame, his contemporary, George Inness, harbored doubts whether the elaborate detail that the public craved added meaning to art. After struggling unsuccessfully to gain recognition by painting in the prevailing Hudson River School style, he traveled to France where he fell under the spell of the Barbizon School, the same group of artists whom Whittredge had visited and rejected years earlier. Now their style had caught on, and many American collectors bought Barbizon paintings when traveling in France. Inness began to develop a new style based on Barbizon precepts. He abandoned detail in the foreground, suggesting the presence of foliage with dabs of paint and dashing brush strokes. He painted in broad masses and often used variations on a single hue to unify the scene. Instead of exciting wonder and awe, his paintings evoked a gentle, contemplative mood (Fig. 62).

As a follower of Swedish mystic Emanuel Swedenborg, Inness believed that every object had a spiritual counterpart, which he suggested in his landscapes by his use of filmy surfaces, soft edges, and murky light. The spiritual fervor expressed in his work attracted Henry Ward Beecher, the popular Brooklyn preacher, who had taken the ailing Whittredge under his wing many years before. Beecher became one of his early admirers, often asserting that Inness was "the best American painter of Nature in her moods." Unfortunately, the public lagged behind the preacher in its estimation of his work.

His reputation finally took a turn for the better in 1884 when the American Art Galleries in New York held a retrospective of fifty-seven of his paintings. About the same time,

Thomas B. Clarke became his agent and successfully promoted his work to collectors. During most of his life, Inness had been under financial pressure to support a wife and six children. Now he was able to purchase property in Montclair, New Jersey, where he could be found painting in a frenzied manner, splattering paint over the canvas, his studio walls, and even himself.

Nearby, in Maplewood, the patriarch of this country's first generation of landscapists still continued to paint the scenery he knew so well. Asher B. Durand was completing a painting of a sunset in the Adirondacks when he laid down his brush and remarked sadly to his son, "My hand will no longer do what I want it to do." He had painted his last painting. He died in 1886 at the age of ninety.

Bierstadt was the most persistent of his generation in trying to exhibit and sell his western scenes long after the public had lost interest. When the Paris Exposition of 1889 offered American artists another opportunity to exhibit their work to an international audience, Bierstadt looked desperately for material. Thumbing through his sketches, he came across some studies of buffaloes from his western trip in 1863. The plains had been covered with herds as far as the horizon. Unique to this country, the sight was a natural wonder in itself. Now buffaloes were being slaughtered so fast that the spectacle was soon destined to vanish. His drawings had yellowed with age, but the quick sketches of a wounded bull—its tail erect and its eyes glaring—drawn just before the marksman fired his final shot, were still vivid and fresh. He decided to use them in a large composition, which he hoped would be the crowning achievement of his western themes.

Seventeen American artists sat on the selection committee for the Paris Exposition. When *The Last of the Buffalo* (Fig. 63) came before them, they voted unanimously to reject it. The public had grown tired of paintings of the West, and the realistic technique looked old-fashioned. Bierstadt had to face a cruel fact—his paintings had fallen out of favor.

Conversely, after years of working in Church's and Bierstadt's shadow, Inness had gained prominence as a landscape painter. His work was in such demand that the commissioner of the selection committee for the Paris Exposition sent him an invitation to submit a painting. Although Inness refused, the commissioner was not deterred. He con-

tacted Inness's gallery, which, over the artist's vehement protests, selected a painting to send. It won a gold medal.

That same year, Church had just completed a new studio wing at Olana. The effort he put into the project suggests that he intended to create another masterpiece, but, in fact, only a few half-hearted paintings came out of his new workplace. His right hand, severely crippled by rheumatoid arthritis, no longer functioned effectively. He continued his interest in landscape, however, by serving on the board of commissioners of the New York Department of Parks and designing the grounds around Olana. He was also a founder and trustee of the Metropolitan Museum. He wrote to his friend, the sculptor Erastus Palmer, "I have made about one and three quarter miles of road this

Fig. 63. The Last of the Buffalo, c. 1888

Albert Bierstadt (1830–1902)

Oil on Canvas, 71 1/4 × 119 1/4 in.

In the Collection of the Corcoran Gallery of Art, Washington, D.C.

Gift of Mrs. Albert Bierstadt

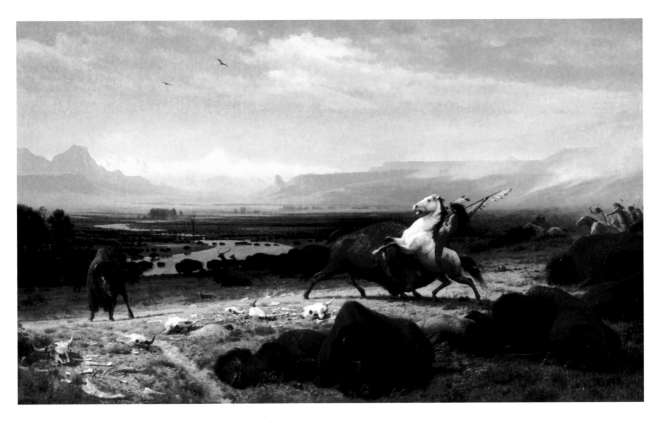

season, opening entirely new and beautiful views—I can make more and better land-scapes in this way than by tampering with canvas and paint in the studio."

In 1882 Bierstadt's life began to crumble. Malkasten burned to the ground, taking with it many of his possessions and countless sketches. The once beautiful, vivacious Rosalie was slowly dying of tuberculosis. With his enjoyment of elaborate entertaining and the accumulation of doctors' bills, Bierstadt fell into debt. In 1893 Rosalie died. Bierstadt was quick to secure the hand of a wealthy widow, Mary Hicks Stewart, stepmother of the Boston art collector, Isabella Stewart Gardner. Rather than ask that his new wife pay his debts, Bierstadt declared bankruptcy, and the couple spent their time traveling to fashionable resorts in America and Europe, where he occasionally met patrons who still appreciated the western scenes he continued to paint.

After Henry Flagler opened the Ponce de Leon Hotel in 1888 with its four hundred and fifty rooms, people began to flock to St. Augustine in winter. Heade occupied one of the hotel's seven artists' studios and found a ready source of purchasers. Flagler bought two of his largest and best Florida marsh scenes for two thousand dollars each. Ironically Heade, always scornful of society, acquired considerable social distinction in St. Augustine; an 1893 newspaper placed his wife and him "among the most prominent" in attendance at a local charity ball.

During the last two decades of his life, Church spent spring, summer, and autumn at Olana and wintered in Mexico, where the warm weather helped soothe his rheumatism. In 1893 Whittredge visited him there. Among other things, the two aging artists discussed the recent popularity of still another French style of art, Impressionism, which to them seemed frivolous. In his journal Whittredge expressed the concern that the Impressionists' colorful paintings were making people think that "all works of art must be pretty instead of serious."

After Church's death in 1900 at the age of seventy-four, the Metropolitan Museum of Art organized a memorial exhibition of his work, but the public viewed it primarily as a tribute to a founder of the museum. The major role that he had played in shaping American landscape painting would not be recognized for another half century. Crop-

sey also died in 1900, followed two years later by Bierstadt and, in 1904, by Heade. With
the passing of his colleagues, Whittredge decided to write his memoirs, leaving a valuable
record of his times. The fame of his generation of landscape painters now seemed distant
to him. In hindsight he thought that they had erred by leaning too heavily on scenery.

Only the reputation of George Inness, who had abandoned wild and remote scenery
in favor of familiar countryside, continued to soar. His adoption of the Barbizon School's
tenets tinged with his own mystical beliefs brought him fame in the last years of his life.
By the 1890s, he had assumed Church's mantle as the most highly acclaimed landscape
painter in the country.

By the turn of the century, few understood what the excitement over the Hudson
River School had been all about. At Church's memorial exhibition, his great scenic
views of volcanic eruptions became targets of belittlement. The ashes and vapor spout-
ing from craters, having once conjured up feelings of the sublime, now looked to one
critic like "steam from a tea kettle." Whittredge responded sadly to the change in public
attitudes. At ninety years of age, just before he died, he did not believe that his work
or that of any of his colleagues would have lasting impact. Fortunately, time has proved
that he was mistaken.

LIST OF ILLUSTRATIONS

Frontispiece. *Worthington Whittredge in his Tenth St. Studio,* 1865, Emanuel Leutze (1816–1868), oil on canvas, 15 × 12 in. (38.1 × 30.5 cm.) Reynolda House, Museum of American Art, Winston-Salem, North Carolina.

Fig. 1. *Kaaterskill Falls,* 1826, Thomas Cole (1801–1848), oil on canvas, 25 × 35 ¾ in. Wadsworth Atheneum Museum of Art, Hartford, Ct. Bequest of Daniel Wadsworth. 1848.15

Fig. 2. *Lake with Dead Trees (Catskill),* 1825, Thomas Cole (1801–1848), oil on canvas, 27 × 33 ¾ in. (68.6 × 85.8 cm.) Gift of Charles F. Olney, 1904. Allen Memorial Art Museum, Oberlin College, Ohio. AMAM 1904.1183

Fig. 3. *Landscape, Scene from "The Last of the Mohicans",* 1827, Thomas Cole (1801–1848), oil on canvas, 25 × 31 in. Fenimore Art Museum, New York State Historical Association, Cooperstown, New York. Photo: Richard Walker.

Fig. 4. *The Garden of Eden,* 1828, Thomas Cole (1801–1848), oil on canvas, 38 ½ × 52 ¾ in. Amon Carter Museum, Fort Worth, Texas. 1990.10

Fig. 5. *Expulsion from the Garden of Eden,* 1828, Thomas Cole (1801–1848), oil on canvas, 39 ¾ × 54 ½ in. (100.96 × 138.43 cm.) Museum of Fine Arts, Boston. Gift of Martha C. Karolik for the M. & M. Karolik Collection of American Paintings, 1815–1865. Photograph © 2007 Museum of Fine Arts Boston. 47.1188

Fig. 6. *Clinton Hall.* The National Academy of Design rented space in this building on Nassau Street.

Fig. 7. *The Titan's Goblet,* 1833, Thomas Cole (1801–1848), oil on canvas, 19 ⅜ × 16 ⅛ in. (49.2 × 41 cm.) The Metropolitan Museum of Art. Gift of Samuel P. Avery Jr., 1904. Photograph © 1992 The Metropolitan Museum of Art. 04.29.2

Fig. 8. *View from Mt. Holyoke, Northampton, Massachusetts after a Thunderstorm—The Oxbow,* 1836, Thomas Cole (1801–1848), oil on canvas, 51 ½ × 76 in. (130.8 × 193 cm.) The Metropolitan Museum of Art. Gift of Mrs. Russell Sage, 1908. Photograph © 1995 The Metropolitan Museum of Art. 08.228

Fig. 9. *The Course of Empire: Savage State,* 1833–36, Thomas Cole (1801–1848), oil on canvas, 39 ¼ × 63 ¼ in. Collection of the New-York Historical Society. 1858.1

Fig. 10. *The Course of Empire: Arcadian or Pastoral State,* 1833–36, Thomas Cole (1801–1848), oil on canvas, 39 ¼ × 63 ¼ in. Collection of the New-York Historical Society. 1858.2

Fig. 11. *The Course of Empire: Consummation of Empire,* 1836, Thomas Cole (1801–1848), oil on canvas, 51 ¼ × 76 in. Collection of the New-York Historical Society. 1858.3

Fig. 12. *The Course of Empire: Destruction,* 1836, Thomas Cole (1801–1848), oil on canvas, 39 ¼ × 63 ¼ in. Collection of the New-York Historical Society. 1858.4

Fig. 13. *The Course of Empire: Desolation,* 1836, Thomas Cole (1801–1848), oil on canvas, 39 ¼ × 63 ¼ in. Collection of the New-York Historical Society. 1858.5

Fig. 14. *The Mountain House.* Title Block from Thomas Nast's "Sketches among the Catskills", *Harper's Weekly,* July 21, 1866.

Fig. 15. *View of Schroon Mountain, Essex, New York, After a Storm,* 1838, Thomas Cole (1801–1848), oil on canvas, 99.8 × 160.6 cm. © The Cleveland Museum of Art. Hinman B. Hurlbut Collection. 1335.1917

Fig. 16. *The Voyage of Life: Childhood*, 1842, Thomas Cole (1801–1848), oil on canvas, 52 ⅞ × 76 ⅞ in. (1.343 × 1.953 m.); framed: 64 ⅛ × 88 ½ × 7 in. (1.629 × 2.248 × .178 m.) Ailsa Mellon Bruce Fund. Image © 2007 Board of Trustees, National Gallery of Art, Washington. 1971.16.1 (2550)/PA

Fig. 17. *The Voyage of Life: Youth*, 1842, Thomas Cole (1801–1848), oil on canvas, 52 ⅞ × 76 ¾ in. Ailsa Mellon Bruce Fund. Image © 2007 Board of Trustees, National Gallery of Art, Washington. 1971.16.2

Fig. 18. *The Voyage of Life: Manhood*, 1842, Thomas Cole (1801–1848), oil on canvas, 52 ⅞ × 79 ¾ in. (1.343 × 2.026 m.); framed: 64 × 91 × 7 in. (1.626 × 2.311 × .178 m.) Ailsa Mellon Bruce Fund. Image © 2007 Board of Trustees, National Gallery of Art, Washington. 1971.16.3 (2552)/PA

Fig. 19. *The Voyage of Life: Old Age*, 1842, Thomas Cole (1801–1848), oil on canvas, 52 ½ × 77 ¼ in. (1.334 × 1.962 m.); framed: 64 ⅛ × 88 ⅞ × 7 in. (1.629 × 2.257 × .178 m.) Ailsa Mellon Bruce Fund. Image © 2007 Board of Trustees, National Gallery of Art, Washington. 1971.16.4 (2553)/PA

Fig. 20. *Thomas Cole,* c. 1845. Image is courtesy of the Macbeth Gallery records, 1838–1968 (bulk 1892–1953), in the Archives of American Art, Smithsonian Institution.

Fig. 21. *Asher Brown Durand*, 1864, Charles Loring Elliott, oil on canvas, 27 × 22 in. Corcoran Gallery of Art, Washington, D.C. Museum Purchase, Gallery Fund. 76.11

Fig. 22. *Rocky Cliff*, c. 1860, Asher B. Durand (1796–1886), oil on canvas, 16 ½ × 24 in. (41.9 × 61 cm.) Reynolda House, Museum of American Art, Winston-Salem, North Carolina.

Fig. 23. *Distribution of American Art-Union Prizes*, 1847, drawn on stone by Davignon, published by Sarony and Major, 1847. Museum of the City of New York. Clarence Davies Collection.

Fig. 24. *Kindred Spirits*, 1849, Asher B. Durand (1796–1886), oil on canvas, 44 × 36 in. Courtesy Crystal Bridges Museum of American Art, Bentonville, Arkansas.

Fig. 25. *The Card Players*, c. 1847–50, William Sidney Mount (1807–1868), oil on panel, 19 × 24 ¾ in. (48.3 × 62.9 cm.) Reynolda House, Museum of American Art, Winston-Salem, North Carolina.

Fig. 26. *Washington Crossing the Delaware*, 1851, Emanuel Leutze (1816–1868), oil on canvas, 149 × 255 in. (378.5 × 647.7 cm.) The Metropolitan Museum of Art. Gift of John Stewart Kennedy, 1897. Photograph © 1992 The Metropolitan Museum of Art. 97.34

Fig. 27. *Hooker and Company Journeying through the Wilderness from Plymouth to Hartford in 1636*, 1846, Frederic Edwin Church (1826–1900), oil on canvas, 40 ¼ × 60 ³⁄₁₆ in. Wadsworth Atheneum Museum of Art, Hartford, Ct. Museum Purchase. 1850.9

Fig. 28. Frederic Edwin Church, *carte de visite*, photographic negative from Brady's National Portrait Gallery, published by E. Anthony, 501 Broadway, New York, date unknown.

Fig. 29. *West Rock, New Haven*, 1849, Frederic Edwin Church (1826–1900), oil on canvas, 26 ½ × 40 in. John B. Talcott Fund. Photo: Michael Agee from the Collection of the New Britain Museum of Art, New Britain, Connecticut. 1950.10

Fig. 30. *The Andes of Ecuador*, 1855, Frederic Edwin Church (1826–1900), oil on canvas, 48 × 75 in. (121.9 × 190.5 cm.) Original purchase fund from the Mary Reynolds Babcock Foundation, Z. Smith Reynolds Foundation, Arca Foundation, and Anne Cannon Forsyth. Reynolda House, Museum of American Art, Winston-Salem, North Carolina.

Fig. 31. *Niagara*, 1857, Frederic Edwin Church (1826–1900), oil on canvas, 42 ¼ × 90 ½ in. In the Collection of the Corcoran Gallery of Art, Washington, D.C. Museum Purchase. 76.15

Fig. 32. *Heart of the Andes*, 1859, Frederic Edwin Church (1826–1900), oil on canvas, 66 ⅛ × 119 ¼ in. (168 × 302.9 cm.) The Metropolitan Museum of Art. Bequest of Margaret E. Dows, 1909. Photograph © 1979 The Metropolitan Museum of Art. 09.95

Fig. 33. *Receptions at the Tenth St. Studio*, 1869, from *Frank Leslie's Illustrated Newspaper*, January 29, 1869. Museum of the City of New York.

Fig. 34. *Worthington Whittredge*, c. 1864. Image originally photographed by George Gardner Rockwood and is courtesy of the Miscellaneous Photographs Collection in the Archives of American Art, Smithsonian Institution.

Fig. 35. *The Rocky Mountains, Lander's Peak*, 1863, Albert Bierstadt (1830–1902), oil on canvas, 73 ½ × 120 ¾ in. (186.7 x 306.7 cm.) The Metropolitan Museum of Art. Rogers Fund, 1907. Photograph © 1979 The Metropolitan Museum of Art. 07.123

Fig. 36. *The Icebergs*, 1861, Frederic Edwin Church (1826–1900), oil on canvas, 64 ½ × 112 ½ in. (1 m. 63.83 cm. × 2 m. 85.751 cm.) Dallas Museum of Art, anonymous gift.

Fig. 37. *Jasper Francis Cropsey*, c. 1865, *carte de visite*, photograph by George G. Rockwood, New York City. The Metropolitan Museum of Art, The Albert Ten Eyck Gardner Collection, gift of the Centennial Committee, 1970. 1970.659.175

Fig. 38. *Autumn—On the Hudson River*, 1860, Jasper Francis Cropsey (1823–1900), oil on canvas, 59 ¾ × 108 ¾ in. Gift of the Avalon Foundation. Photograph © 2000 Board of Trustees, National Gallery of Art, Washington. 1963.9.1 (1906)/PA

Fig. 39. *The Old Hunting Grounds*, 1864, Worthington Whittredge (1820–1910), oil on canvas, 36 × 27 in. (91.4 × 68.6 cm.) Reynolda House, Museum of American Art, Winston-Salem, North Carolina.

Fig. 40. *Martin Johnson Heade,* 1860. Image is courtesy of the Miscellaneous Photographs Collection in the Archives of American Art, Smithsonian Institution.

Fig. 41. *A Gorge in the Mountains (Kauterskill Clove)*, 1862, Sanford Robinson Gifford (1823–1880), oil on canvas, 48 × 39 ⅞ in. (121.9 × 101.3 cm.) The Metropolitan Museum of Art. Bequest of Maria Dewitt Jesup, from the collection of her husband, Morris K. Jesup, 1914. Photograph © 1987 The Metropolitan Museum of Art. 15.30.62

Fig. 42. *Cotopaxi*, 1862, Frederic Edwin Church (1826–1900), oil on canvas, 48 × 85 in. (121.9 × 215.9 cm.); framed: 66 ⅝ × 103 × 6 in. Founders Society Purchase, Robert H. Tannahill Foundation Fund, Gibbs-Williams Fund, Dexter M. Ferry Jr. Fund, Merrill Fund, Beatrice W. Rogers Fund and Richard A. Manoogian Fund. Photograph © 1985 The Detroit Institute of Arts. 76.89

Fig. 43. *Portrait of John Frederick Kensett in his Studio*, c. 1866. Image is courtesy of the Miscellaneous Photographs Collection in the Archives of American Art, Smithsonian Institution.

Fig. 44. *Metropolitan Sanitary Fair, the Art Gallery*, from *Frank Leslie's Illustrated Newspaper*, April 23, 1864. © Collection of The New-York Historical Society. 70974

Fig. 45. *National Academy of Design*, opened 1865. Photograph, Peter Bonnett Wight (1838–1925). National Academy Museum Archive, New York.

Fig. 46. *Rainy Season in the Tropics*, 1866, Frederic Edwin Church (1826–1900), oil on canvas, 56 ¼ × 84 ¼ in. (142.9 × 214 cm.) Fine Arts Museums of San Francisco. Museum purchase, Mildred Anna Williams Collection. 1970.9

Fig. 47. *Albert Bierstadt*, c. 1875. Image originally photographed by Bierstadt Brothers and is courtesy of the Miscellaneous Photographs Collection in the Archives of American Art, Smithsonian Institution.

Fig. 48. *Malkasten*, the Victorian mansion built by Albert and Rosalie Bierstadt, Irvington, New York. Stereograph, The Brooklyn Museum of Art, Library Collections, Bierstadt Collection. 1996.169.2

Fig. 49. *Bierstadt's Studio at Malkasten*. Stereograph by Charles Bierstadt. The Brooklyn Museum of Art, Library Collections, Bierstadt Collection. 1996.169.5

Fig. 50. *Domes of the Yosemite*, 1867, Albert Bierstadt (1830–1902), oil on canvas, 116 × 180 in. Collection of St. Johnsbury Athenaeum, St. Johnsbury, Vermont.

Fig. 51. *Mounts Adam and Eve*, 1872, Jasper Francis Cropsey (1823–1900), oil on canvas, 12 ⅛ × 20 ⅛ in. (30.8 × 51.1 cm.) Reynolda House, Museum of American Art, Winston-Salem, North Carolina.

Fig. 52. *Frederic Church and his son Frederic Joseph in Beirut*, date unknown. Attributed to Felix Bonfils. Olana State Historic Site, New York State Office of Parks, Recreation and Historic Preservation. OL 1984.446

Fig. 53. *Thunder Storm on Narragansett Bay*, 1868, Martin Johnson Heade (1819–1904), oil on canvas, 32 ⅛ × 54 ¾ in. Amon Carter Museum, Fort Worth, Texas. 1977.17

Fig. 54. *Lake George*, 1869, John Frederick Kensett (1816–1872), oil on canvas, 48 ⅛ × 66 ⅜ in. (112.1 × 168.6 cm.) The Metropolitan Museum of Art. Bequest of Maria Dewitt Jesup, from the collection of her husband, Morris K. Jesup, 1914. Photograph © 1992 The Metropolitan Museum of Art. 14.30.61

Fig. 55. *Sanford R. Gifford*, 1868, *carte de visite* from Mrs. Vincent Coyler's Album. Photographer unknown. The Metropolitan Museum of Art, David Hunter McAlpin Fund, 1952. (52.605)

Fig. 56. *South façade of Olana,* Frederic E. Church's house, Hudson, New York. Photograph by Stan Ries. Courtesy of Olana State Historic Site, New York State Office of Parks, Recreation and Historic Preservation.

Fig. 57. *Sierra Nevada*, c. 1871–1873, Albert Bierstadt (1830–1902), oil on canvas, 38 ½ × 56 ½ in. (97.8 × 143.5 cm.) Original purchase fund from the Mary Reynolds Babcock Foundation, Z. Smith Reynolds Foundation, Arca Foundation, and Anne Cannon Forsyth. Reynolda House, Museum of American Art, Winston-Salem, North Carolina.

Fig. 58. *George Inness seated in his studio with* Sundown *(1884) in the background*, c. 1890. Image originally photographed by E. S. Bennett and is courtesy of the Macbeth Gallery records, 1838–1968 (bulk 1892–1953), in the Archives of American Art, Smithsonian Institution.

Fig. 59. *Orchid with Two Hummingbirds*, 1871, Martin Johnson Heade (1819–1904), oil on prepared panel with Winsor & Newton label, 13 ¾ × 18 in. (34.9 × 45.7 cm.) Reynolda House, Museum of American Art, Winston-Salem, North Carolina.

Fig. 60. *In the Studio*, c. 1884, William Merritt Chase (1849–1916), oil on canvas, 39 × 22 in. (99.1 × 55.9 cm.) Original purchase fund from the Mary Reynolds Babcock Foundation, Z. Smith Reynolds Foundation, Arca Foundation, and Anne Cannon Forsyth. Reynolda House, Museum of American Art, Winston-Salem, North Carolina.

Fig. 61. *William Merritt Chase's Tenth Street studio in New York, N.Y.*, c. 1880. Image originally photographed by George Collins Cox and is courtesy of the Miscellaneous Photographs Collection in the Archives of American Art, Smithsonian Institution.

Fig. 62. *The Storm*, 1885, George Inness (1825–1894), oil on canvas, 20 × 30 in. (50.8 × 76.2 cm.) Reynolda House, Museum of American Art, Winston-Salem, North Carolina.

Fig. 63. *The Last of the Buffalo*, c. 1888, Albert Bierstadt (1830–1902), oil on canvas, 71 ¼ × 119 ¼ in. In the Collection of the Corcoran Gallery of Art, Washington, D.C. Gift of Mrs. Albert Bierstadt.

SELECTED BIBLIOGRAPHY

For the reader's convenience, the bibliography is divided into sections on each major artist, art institutions of their time, and a general section on surveys of art history and topics related to the period.

Bierstadt, Albert, 1830–1902

Hendricks, Gordon. 1972. *A. Bierstadt*. Fort Worth, TX: Amon Carter Museum. An exhibition catalogue.

————. 1974. *Albert Bierstadt, Painter of the American West*. New York: Harry N. Abrams, Inc., in association with Amon Carter Museum of Western Art.

King, Clarence. 1872. *Mountaineering in the Sierra Nevada*. Boston: James R. Osgood and Company.

Ludlow, Fitz Hugh. 1870. *The Heart of the Continent: A Record of Travel across the Plains and in Oregon, with an Examination of the Mormon Principle*. New York: Hurd and Houghton; Cambridge: Riberdine Press. Reprinted in 1971, New York: AMS Press Inc.

Chase, William Merritt, 1849–1916

Pisano, Ronald G. 1983. *William Merritt Chase, 1849–1916*. Seattle: Henry Art Gallery, University of Washington.

Roof, Katharine M. 1917. *The Life and Art of William Merritt Chase*. New York: Charles Scribner's Sons.

Church, Frederic E., 1826–1900

Avery, Kevin J. 1993. *Church's Great Picture: The Heart of the Andes*. New York: The Metropolitan Museum of Art. An exhibition catalogue.

Carr, Gerald L. 1980. *Frederic Edwin Church: The Icebergs*. Dallas, TX: Dallas Museum of Fine Arts. An exhibition catalogue.

Huntington, David C. 1966. *The Landscapes of Frederic Edwin Church: Vision of an American Era*. New York: George Braziller.

————. 1965. "Landscape and Diaries: The South American Trips of F. E. Church." *The Brooklyn Museum Annual, vol. 5: Articles and Reports (1963–4)*. Brooklyn, NY: Brooklyn Museum.

Judson, Isabella P. 1896. *Cyrus W. Field, His Life and Work (1816–1892)*. New York: Harper and Brothers, Publishers.

Kelly, Franklin. *Frederic Edwin Church*. 1989. Washington D.C.: National Gallery of Art. An exhibition catalogue.

Noble, Louis Legrand. 1861. *After Icebergs with a Painter: A Summer Voyage to Labrador and around Newfoundland*. Reprinted in 1979, Hudson, NY: Olana Galleries.

Stillman, William James. 1901. *The Autobiography of a Journalist*, 2 vols. Boston and New York: Houghton, Mifflin and Company; Cambridge: The Riverside Press.

Von Humboldt, Alexander. 1855. *Cosmos: A Sketch of a Physical Description of the Universe*, vols. 1 and 2. New York: Harper and Brothers, Publishers.

Cole, Thomas, 1801–1848

Kelly, Franklin. 1994. *Thomas Cole's Paintings of Eden*. Ft. Worth, TX: Amon Carter Museum.

Merritt, Howard S. 1969. *Thomas Cole*. Rochester, NY: Memorial Art Gallery, University of Rochester. An exhibition catalogue.

Parry, Ellwood III. 1988. *The Art of Thomas Cole, Ambition and Imagination*. Cranbury, NJ: Associated University Presses, Inc.

Tymn, Marshall B., ed. 1972. *Thomas Cole's Poetry: The Collected Poems of America's Foremost Painter of the Hudson River School*. George Shumway Publisher.

Vesell, Elliot S., ed. 1964. *The Life and Works of Thomas Cole* by Louis Legrand Noble. Reprint, Cambridge, MA: Belknap Press of Harvard University Press.

Waterbury, J. B. D.D. 1852. *The Voyage of Life: Suggested by Cole's Celebrated Allegorical Paintings*. Boston: Massachusetts Sabbath School Society.

Cropsey, Jasper Francis, 1823–1900

Bermingham, Peter. 1968. *Jasper F. Cropsey: A Retrospective View of America's Painter of Autumn*. College Park, MD: University of Maryland Art Gallery. An exhibition catalogue.

Talbot, William S. 1970. *Jasper F. Cropsey 1823–1900*. Washington, DC: Smithsonian Institution Press for the National Collection of Fine Arts. An exhibition catalogue.

Doughty, Thomas, 1793–1856

Goodyear, Frank H., Jr. 1973. *Thomas Doughty, 1793–1856: An American Pioneer in Landscape Painting*. Philadelphia: Pennsylvania Academy of Fine Arts. An exhibition catalogue.

Durand, Asher B., 1796–1886

Durand, Asher B. 1855. "Letters on Landscape Painting." *The Crayon* (July–December), 2:16–17.

Durand, John. 1894. *The Life and Times of A. B. Durand*. New York: Charles Scribner's Sons. Reprint, New York: Kennedy Graphics, Inc., and Da Capo Press, 1970.

Lawall, David B. 1971. *A. B. Durand, 1796–1886*. Montclair, NJ: Montclair Art Museum. An exhibition catalogue.

Gifford, Sanford R., 1823–1880

Cikovsky, Nicolai, Jr. 1970. *Sanford Robinson Gifford, 1823–1880*. Austin, TX: University of Texas Art Museum. An exhibition catalogue.

Heade, Martin Johnson, 1819–1904

McIntyre, Robert C. 1948. *Martin Johnson Heade*. New York: Pantheon Press.

Stebbins, Theodore E., Jr. 1948. *Martin Johnson Heade*. New York: Whitney Museum of American Art. An exhibition catalogue.

———. 1975. *The Life and Works of Martin Johnson Heade*. New Haven and London: Yale University Press.

Inness, George, 1825–1894

Cikovsky, Nicolai, Jr. 1971. *George Inness*. New York: Praeger Publishers.

Inness, George, Jr. 1917. *Life, Art, and Letters of George Inness*. Reprint, New York: Kennedy Galleries, Inc., and Da Capo Press, 1969.

Kensett, John Frederick, 1816–1872

Driscoll, John Paul, and John K. Howat. 1985. *John Frederick Kensett, An American Master*. New York: Worcester Art Museum in association with W. W. Norton Company. An exhibition catalogue.

Howat, John K. 1968. *John Frederick Kensett, 1816–1872*. New York: American Federation of Arts. An exhibition catalogue.

Leutze, Emanuel, 1816–1868

Groseclose, Barbara S. 1975. *Emanuel Leutze, 1816–1868: Freedom Is the Only King*. Washington, DC: Smithsonian Institution Press for the National Collection of Fine Arts. An exhibition catalogue.

Whittredge, Worthington, 1820–1910

Baur, John I. H., ed. 1942. "The Autobiography of Worthington Whittredge." *Brooklyn Museum Journal*.

Beecher, Henry Ward. 1852. *Lectures to Young Men, on Various Important Subjects*. New York: M. H. Newman & Co.

Art Institutions

Blaugrund, Annette. 1997. *Tenth Street Studio Building: Artist-Entrepreneurs from the Hudson River School to the American Impressionists*. Seattle: University of Washington Press.

Cowdrey, Mary Barlett, ed. 1943. *National Academy of Design Exhibition Record 1826–1860*, 2 vols. New York: New-York Historical Society.

———. 1953. *American Academy of Fine Arts and American Art-Union Exhibition Record, 1816–1852*. New York: New-York Historical Society.

Cummings, Thomas S. 1969. *Historic Annals of the National Academy of Design*. New York: Kennedy Galleries, Inc., and Da Capo Press.

Hoopes, D. F. 1972. *The Düsseldorf Academy and the Americans*. Atlanta, GA: The High Museum of Art. An exhibition catalogue.

Naylor, Maria, ed. 1973. *National Academy of Design Exhibition Record, 1861–1900*, 2 vols. New York: Kennedy Galleries, Inc.

Art History Surveys and Works Related to Early Landscape Painting

Callow, James T. 1967. *Kindred Spirits: Knickerbocker Writers and American Artists, 1807–1855*. Chapel Hill, NC: University of North Carolina Press.

Dunlap, William. 1834. *History of the Rise and Progress of the Arts of Design in the United States*, 2 vols. Reprint, New York: Benjamin Blom, Inc., 1965.

———. 1931. *Diary of William Dunlap (1766–1839): The Memoirs of a Dramatist, Theatrical Manager, Painter, Critic, Novelist, and Historian*, 3 vols. New York: New-York Historical Society.

Evers, Alf. 1972. *The Catskills: From Wilderness to Woodstock*. Garden City, NY: Doubleday & Company, Inc.

Flexner, James Thomas. 1962. *That Wilder Image*. Boston: Little, Brown and Company.

Nevins, Allan, ed. 1970. *The Diary of Philip Hone, 1828–1851*, 2 vols. New York: Arno Press and The New York Times.

Richardson, E. P. 1956. *Painting in America: From 1502 to the Present*. New York: Thomas Y. Crowell Company, fourth printing 1965.

Tuckerman, Henry T. 1867. *Book of the Artists*. Reprinted in 1965, New York: distributed by James F. Carr, Publisher.

Van Zandt, Roland. 1966. *The Catskill Mountain House*. New Brunswick, NJ: Rutgers University.

ABOUT THE AUTHOR

Barbara Babcock Millhouse has been the driving force behind the Reynolda House collection of American art in Winston-Salem, North Carolina. Recently retired, she has served as chairman of the board of directors of Reynolda House since its inception in 1965. She co-authored *American Originals; Selections from Reynolda House, Museum of American Art,* a catalog for a traveling exhibition sponsored by the American Federation of Arts. She is a graduate of Smith College and Parsons School of Design, and lives in New York City.

INDEX

A

Achenbach, Andreas, 78, 79–80, 83
Adam and Eve, Mounts (New
 York), 149, *150*
Adams, John, 36
Adams, John Quincy, 36
Adirondack Mountains (New
 York), 51, 86
Aesthetic Movement, 158, 176
Aetna, Mount (Italy), 57
Aetna Insurance Company, 64
Aladdin (mansion), 171. *See also*
 Cropsey, Jasper Francis
Albano, Lake (Italy), 84
Allen Memorial Art Museum, *10*
Alms House, on Broadway and
 Chambers Street, 13
American Academy of the Fine
 Arts, 7, 13–14, 15, 24, 32
American Art Galleries, 177
American Art-Union, 68, 69–71,
 70, 74, 80, 102
Amon Carter Museum, *21,
 154–55*
Andes (Mountains), xiii, 92, 94, *95*,
 105–07, *106*
Arno River (Italy), 55
Artists' Studio Building (also
 Tenth Street Studio Building),
 102–03, 104, 105, 107, *109*,
 110, 114, 124, 152, 153, 167,
 173, 176
Art Students League, 177
Aspen, Colorado, xiii
Avery, Kevin, xiv

B

Bank of New York, 24
Barbizon School, 78–79, 177
Barnes, David, xiv
Barranquilla, Colombia, 91–92
Bartow, Maria. *See* Cole, Maria
 Bartow
Baur, John I. H., xiii
Beebe family, 51
Beecher, Henry Ward, 76, 177
 Seven Lectures to Young Men, 76
Beecher, Rev. Lyman, 76
Bennett, E. S., *169*
Bicknell, Elhanan, 139
Bierstadt, Albert
 and American Indians, 112–13,
 114, 131–32, 137

in the American West, 111–14,
 130–35, 143, 161–62
and Artists' Studio Building,
 114, 167
birth of, 82
and Centennial Exposition, 165
and Church, Frederic Edwin,
 149–51, 161
and Civil War, 117
and contemporary art critics,
 114, 138–39, 146–48, 161, 162
The Crayon, letter to, 113
death of, 181
decline in popularity of, 169
in Düsseldorf, 82–83
in England, 151
and Leutze, Emanuel, 82–83
and Ludlow, Fitz Hugh,
 130–35, 143–44
and Malkasten, 145–46, *145,
 146*, 158, 169, 180
and National Academy of
 Design, 114, 130
in New York City, 114, 116,
 144
portrait of, *144*
in Rome, 84
and Whittredge, Worthington,
 82–84
wives of (see Bierstadt,
 Rosalie Ludlow; Stewart,
 Mary Hicks)
works by
 Domes of the Yosemite, 146, *147*
 Donner Lake from the Summit,
 162
 The Last of the Buffalo, 178,
 179
 Oregon Trail, 113
 *The Rocky Mountains,
 Lander's Peak*, 114, *115*, 129,
 138–39, 151, 161, 171
 *The Rocky Mountains, Long's
 Peak*, 171
 Sierra Nevada, *164*
 *Storm in the Rocky Mountains:
 Mount Rosalie*, 143
 in Yosemite Valley, 133–34, 143
Bierstadt, Charles, *146*
Bierstadt, Mount (Colorado), 130
Bierstadt, Rosalie Ludlow, 143–45,
 180
Bierstadt Brothers, *144*

Bliss, Elam, 24
Blodgett, William T., 106, 139
Bogotá, Colombia, 92, 93, 94
Bolton-le-Moor, Lancashire
 (England), 1
Boston, Massachusetts, 20, 24, 55,
 69, 111, 120, 124, 152, 180
 Museum of Fine Arts, *23*
Bradford, William, 63
Bread and Cheese Club, The,
 17–18, 31–32. *See also* Cooper,
 James Fenimore
Brevoort Hotel, 171
British Institution, 27
Broadway, 6, 7
Brooklyn Museum Journal, xiii
Brooklyn Museum of Art, The,
 145, 146
Brown College, 83
Browning, Elizabeth, 109
Browning, Robert, 109, 151
Bruen, George W., 7
Bryant, William Cullen, 18, 32, 39,
 72, *73*, 84, 141, 163–65
 "To Cole, the Painter, Depart-
 ing for Europe," 25–26
Bulletin (American Art-Union), 74
Burr, Aaron, 24
Bustamente, Pablo, 103

C

Café Greco, 108, 109
California Express, 134
Capitol (Washington, D.C.), 8
Capri, Italy, 84
Carson, Kit, 148–49
Carson City, Nevada, 132
Catskill cloves, 18
Catskill Landing (Catskill, New
 York), 63
Catskill Mountain House, xiii, 17,
 47, *48*, 88
Catskill Mountains (New York),
 7, 8, 89
Catskill Village, New York, 18,
 47–48, 83
Cayambe (Ecuador), 94
Cedar Grove (Catskill, New York),
 89, 157–58. *See also* Cole,
 Thomas
Centennial Exposition, 165–66
Central Park, 84, 157, 168
Century Association, 72, 139, 140,

168. *See also* Sketch Club
Charleston, South Carolina, 103
Charleston, West Virginia, 77
Chase, William Merritt
 and Artists' Studio Building,
 173, 176
 and Art Students League, 177
 In the Studio, *172*
Cheshire, Connecticut, 67
Chimborazo, Ecuador, 94, 103,
 104, 105
Chocorua, Mount (New Hamp-
 shire), 20, 22, 70, 139
cholera epidemic, 30–31
Chota Valley, Ecuador, xiv, 94, 96
Christian Intelligencer, 105
Church, Frederic Edwin
 and American Art-Union, 88
 in the American South, 89
 in the Arctic, 117
 artistic vision of, 173
 and Artists' Studio Building,
 104, 105, 107, 167
 and Bierstadt, Albert, 149–50
 birth of, 63
 at Cedar Grove, 63, 86
 and Centennial Exposition, 165
 children of, 142, 151, *152*
 and Cole, Thomas, 63–64, 86,
 88–89
 and contemporary art critics,
 89, 97, 99, 105, 107, 120, 128,
 153, 181
 death of, 180
 father of, 63–64, 89
 and Field, Cyrus W., 89, 91–96
 and Gifford, Sanford Robinson,
 153
 and Heade, Martin J., 99, 104,
 124, 173–76
 and Humboldt, Baron Alexander
 von, 91, 94, 96–97, 103,
 107
 in the Middle East, 151, *152,*
 153
 and Middle Eastern architec-
 ture, 153–58
 and Mignot, Louis R., 103–04
 and National Academy of
 Design, 64, 89, 96, 97
 in New York City, 88, 96, 98, 109
 and Noble, Rev. Louis Legrand,
 106, 117

and Olana, 153–59, *159*, 171,
179–80
painting method of, 96, 99–102
portrait of, *88*
in South America, xiv, 91–96,
97, 103–04
in the West Indies, 142
and Whittredge, Worthington,
180
works by
The Andes of Ecuador, xiv, 94,
95, 96–97, 98
Chimborazo, 165
Cotopaxi, *126–27*, 128
"Near Haciendo Chillo", 103
Heart of the Andes, 105–07,
106, 108, 114, 117, 138,
139, 162, 176
*Hooker and Company Journey-
ing through the Wilderness
from Plymouth to Hartford in
1636*, 86–88, *87*
The Icebergs, 117–21, *118–19*
To the Memory of Cole, 88–89
Morning in the Tropics, 168,
171
Niagara, 98–102, *100–01*,
149–51
The Parthenon, 165
Rainy Season in the Tropics,
142, *143*
Twilight in the Wilderness, 114
West Rock, New Haven, 89, *90*
Church, Frederic Joseph, 151, *152*
Church, Isabel Carnes, 107, 142,
151, 158
Church, Richard, 63
Church Buttes, Wyoming, 130
Cincinnati, Ohio, 69, 75, 108
City Hotel, 17
Civil War, 114, 116–17, 120, 122,
128, 131, 136–37, 141, 148,
168
Clarke, Thomas B., 178
Clemens, Samuel L. *See* Twain,
Mark
Cleveland Museum of Art, The, *52*
Clinton, De Witt, 7, 14, 16
Clinton Hall, 32, *32*, 157
Cole, Anne, 1, 3
Cole, James, 1–2
Cole, Maria Bartow, 50, 54, 56–57,
63
Cole, Mary (daughter), 54, 57, 63
Cole, Mary (mother), 1, 2
Cole, Sarah, 1, 3, 57
Cole, Theodore (Theddy), 54, 57,
63, 157–58

Cole, Thomas
and American Art-Union, 70,
102
apprenticeship of, 2
birth of, 2
and "The Bread and Cheese
Club," 18
and Bryant, William Cullen, 18,
25–26, 39, 72
in Catskill Mountains, 7, 18–20,
46, 64
in Catskill Village, 18, 38, 47–48,
49, 71
at Cedar Grove, 49–50, 54
and Centennial Exposition, 165
children of. *See* Cole, Theodore
(Theddy); Cole, Mary
(daughter)
and Church, Frederic Edwin,
63–64, 65, 86, 88–89
and contemporary art critics,
20, 24, 28, 46
and Cooper, James Fenimore,
18, 20, 39–46
death of, 71, 88
and Durand, Asher B., 11–12,
46, 50–51, 53, 54, 55, 66
education of, 2
emigration to America by, 2
in England, 1–2, 26–29
and Episcopal church, 66
in Florence, 30
and Gallery of the Society of
Artists, 28
and Gilmor, Robert, 20–24, 26,
27
journal of, 49
marriage of, 50
memorial exhibition for, 71
and National Academy of
Design, 15–16, 22, 23, 32, 39,
53, 55, 57–62
in New York City, 6–7, 11,
31–32, 48, 55
and New York Drawing Society,
14–15
and Niagara Falls, 99
and Noble, Louis Legrand, 66
in Paris, 29
in Philadelphia, 2–3, 5
in Pittsburgh, 4–5
portrait painting career of, 4–5
portraits of, *62*, *73*
on preservation of wilderness,
46
and Reed, Luman, 33–35, 38, 39
in Rome, 30, 56–57
and Royal Academy, 27–28

in Sicily, 157
and Sketch Club, 31–32, 55, 62,
65
in Steubenville, 3–4
and Trumbull, John, 7–8, 11–12
and Turner, Joseph M.W.,
28–29
in White Mountains, 20–22
wife of. *See* Cole, Maria Bartow
works by
The Course of Empire, 33–35,
39–46, 48, 50, 57
Arcadian or Pastoral State, 38,
41
Consummation of Empire, 38,
39, *42–43*, 50
Desolation, 39, *45*
Destruction, 39, *44*
Savage State, 38, *40*
*Expulsion from the Garden of
Eden*, 22–24, *23*, 46
The Garden of Eden, *21*, 22,
24
Home in the Woods, 70
Kaaterskill Falls, 8, *9*, 12, 64
Lake with Dead Trees (Catskill),
8, *10*, 12
*Landscape, Scene from "The
Last of the Mohicans"*, *19*, 20
Mt. Aetna from Taormina, 64
The Titan's Goblet, 32, *34*
Tornado in an American Forest,
28
*View from Mt. Holyoke,
Northampton, Massachusetts
after a Thunderstorm—
The Oxbow*, 37, 38–39
A View of Fort Putnam, 8
*View of Schroon Mountain,
Essex, New York, After a
Storm*, 51–53, *52*
The Voyage of Life, 55–63, 71,
102, 149
Childhood, 55–56, *58*
Youth, 56, *59*
Manhood, 56, *60*
Old Age, 56, *61*
Colman, William A., 7
Columbia, 24
Columbia College, 16, 18
Connecticut River, 86
Connecticut River Banking
Company, 64
Connecticut River Valley, 38
Constable, John, 27–28
Cooper, James Fenimore, 17–18,
25, 31–32, 39–46, 85
The Last of the Mohicans, 20

The Pioneers, 17
Corcoran, William, 162
Corcoran Gallery of Art, 67,
100–01, 162, *179*
Cotacachi (Ecuador), xiv, 94
Cotopaxi (Ecuador), 94
Cox, George Collins, *173*
Coxsackie, New York, 33
Crayon, The, 86, 113, 148
Crested Butte, Colorado, xiii
Cropsey, Jasper Francis
architectural apprenticeship of,
121
architectural plans of, 171
and Centennial Exposition, 165
and contemporary art critics,
121–22
death of, 180–81
in England, 121–22
and National Academy of
Design, 121
in New York City, 121
portrait of, 120
summer home of, 149, 171
works by
*Autumn—On the Hudson
River*, 121, *121*
*Mount Jefferson, New Hamp-
shire*, 151
Mounts Adam and Eve, 149,
150
Crystal Bridges Museum of
American Art, 72–73

D

Dallas Museum of Art, *118–19*
Davignon, *70*
Dayton, Ohio, 107
Delaware Indians, 20–22
Detroit Institute of Arts, The,
126–27
Dickens, Charles, 78
Dog Belly, 112
Doge's Palace, 141
Dom Pedro II, 124
Doughty, Thomas, 5
Dufferin, Lord, 169–71
Dunlap, William, 8, 12, 15, 18, 26,
27, 32, 85
Dunraven, Earl of, 171
Durand, Asher Brown
apprenticeship of, 11
birth and boyhood of, 8–11
and The Bread and Cheese
Club, 18
and Cole, Thomas, 8, 11–12, 46,
50–51, 53, 54, 55, 66, 72
and Cooper, James Fenimore, 18

death of, 178
engraver, career as, 11, 35–36, 72
family of, 35
and Kensett, John, 67, 163–65
and landscape painting, 51, 53, 66–67, 86, 107, 163
and National Academy of Design, 15–16, 32, 35, 50, 53, 69, 71, 139–40
and New York Drawing Society, 15
portrait of, 67
portrait painting, 36–38, 39, 50–51, 53
and Reed, Luman, 35–36, 39
and Trumbull, John, 8, 11
in Washington, D.C., 36–38
and Whittredge, Worthington, 78
works by
Kindred Spirits, xiii, 72, 73
Rocky Cliff, 67, 68
Durand, John, xiii, 86, 163
Durant, Thomas, 160–61
Düsseldorf, Germany, 74, 79–82
Düsseldorf Academy of Art, 74, 79, 137
Düsseldorf Gallery, 78

E

École Préparation des Beaux-Arts, 68
Ecuador, xiv, 89, 91, 94–96, 103–04
Edison, Thomas, 169
Elliot, Charles Loring, 67
Emerson, Ralph Waldo, 85, 105
Erie Canal, 7, 33
Estes Park, Colorado, 171
Evans, Mount (Colorado), 130
Evening Post, 25, 31

F

Farallon Islands, California, 162
Fenimore Art Museum, 19
Field, Cyrus W., 89, 91–96, 97, 103, 151, 169
Fine Arts Museums of San Francisco, 143
Flagler, Henry M., 173, 180
Florence, Italy, 78
Foot, Harriet Euphemia, 149
Foot, Samuel A., 149
Frank Leslie's Illustrated Newspaper, 109, 138

Franklin, John, 120–21
Fremont, John C., 114
Fremont Peak (Wyoming), 113
French Academy, 137
Frost, F. S., 111–14

G

Gallery of the Society of Artists, 28
Garden of the Gods (Colorado), 130
Gardner, Isabella Stewart, 180
Geneva, New York, 149
George III, 26
German Gallery, 107
Gifford, Sanford
and "air painting," 128
in the American West, 162
and Artists' Studio Building, 110, 153
in Catskill Mountains, 122, 125
and Centennial Exposition, 165
and Church, Frederic Edwin, 153
in Civil War, 116, 122
and contemporary art critics, 110, 163
death of, 165
and Durand, Asher Brown, 163–65
education of, 83
in Lake Lucerne, Switzerland, 83
in the Middle East, 153
and National Academy of Design, 83, 163
in New York City, 116, 122
portrait of, 157
in Rome, 84
and Whittredge, Worthington, 83–84, 110, 122, 153, 162–63
works by
A Gorge in the Mountains (Kauterskill Clove), 125, 128
Hunter Mountain, Twilight, 151
Gilmor, Robert, 20–24, 26, 27
Gladstone, William, 151
Goshoots, 131–32
Goupil, Vibert & Co., 102, 117, 128, 129, 153
Gramercy Park, 89
Great Plains, 112
Great Salt Lake, 131
Great Western, 57
Greenough, Horatio, 30
Green River (Wyoming), 113
Greenwich Village, 7

Guaranda, Ecuador, 103
Guayaquil, Ecuador, 94–96, 103
Guayas, Rio (Ecuador), 94, 103

H

Haines Falls (New York), 18
Hals, Frans, 82
Hamilton, Alexander, 24
Harper's Weekly, 48, 112
Harrison, William Henry, 75
Hartford, Connecticut, 12, 57, 63, 86
Haseltine, William Stanley, 84
Hasenclever, Johann Peter, 78, 82
Hawthorne, Nathaniel, 85
The Marble Faun, 109
Hayes, Rutherford B., 169
Heade, Martin J.
and Artists' Studio Building, 124, 152, 167
in Boston, 124
in Brazil, 122–24
and Church, Frederic Edwin, 99, 104, 124, 173–76
and contemporary art critics, 152
death of, 181
in England, 124
and landscape painting, 128
and National Academy of Design, 124, 152
portrait of, 124
in St. Augustine, 173, 180
wife of (see Smith, Elizabeth V.)
works by
Orchid with Two Hummingbirds, 170
Thunder Storm on Narragansett Bay, 152, 154–55
Hendrix, Gordon, xiii
Hicks, Edward, 99
Hicks, Thomas, 99
Hoffman Mountain. See Schroon Mountain
Holyoke, Mount (Massachusetts), 38
Homer
Odyssey, 27
Hone, Philip, 12, 20
Hood, Mount (Oregon), 135
Hooker, Rev. Thomas, 63, 86
Hosack, David, 24, 32
Hudson, New York, 83, 157
Hudson River (New York), 7, 17, 47, 49, 85, 86, 88, 145, 157
Hudson River School, xi–xii, 12, 128, 171, 177, 181

Humboldt, Baron Alexander von, 103, 107, 171
Cosmos, 89–91, 94, 96–97
Humboldt Mountains (Nevada), 132
Hunt, Richard Morris, 102–03, 157
Huntington, Collis P., 162
Huntington, Daniel, 140, 141, 163
Huntington, David C., xiii

I

Ibarra, Ecuador, xiv
Impressionism, 28, 128, 180
Indianapolis, 75, 76
Industrial Revolution, 166
Inness, George
and Barbizon School, 177, 181
and Beecher, Henry Ward, 177
and Hudson River School, 177
in Montclair, New Jersey, 178
and National Academy of Design, 168
and Paris Exhibition, 178–79
portrait of, 169
and Swedenborg, Emanuel, 177
works by
The Storm, 174–75
Irving, Washington, 17, 25, 72, 85, 105, 145. See also Rip Van Winkle
Irvington, New York, 145, 145

J

Jackson, Andrew, 36–37, 50
James, Henry, 168
Jefferson, Thomas, 36
Jefferson Village (Maplewood), New Jersey, 8
Jerusalem, 151, 153
Jesup, Morris K., 153
Johnson, Eastman, 80–82
Johnston, James Boorman, 102

K

Kaaterskill Clove (also Kauterskill Clove), 125
Kaaterskill Falls, xiii, 9, 17, 18, 72
Kensett, John F.
and American Art-Union, 68
in the American West, 162
birth of, 67
and Centennial Exposition, 165
and Century Association, 139
and contemporary art critics, 163

death of, 165
and Durand, Asher Brown, 67,
 163–65
at École Préparation des
 Beaux-Arts, 67–68
engraver, career as, 67–68
and landscape painting, 128
and National Academy of
 Design, 68, 72, 140, 163
in Paris, 67–68
portrait of, *137*
and Sanitary Fair, 137, 139
and Thackery, William Make-
 peace, 72
works by
 *Autumn Afternoon on Lake
 George*, 151
 Lake George, 152–53, *156*
King, Clarence, 161
Knoedler's. *See* Goupil, Vibert
 & Co.

L

Lake George, 86, 153, *156*
Lander, Frederick W., 111, 112–13,
 114, *115*
Landseer, Edwin, 151
Larrea, Modesto, 94
Lawall, David B., xiii
Lawrence, Sir Thomas, 27
Lee, Massachusetts, 64, 89
Leighton, Frederick, 109
Leslie, Charles Robert, 27
Lessing, Carl Friedrich, 80, 83
 Martyrdom of John Huss, 78
Leutze, Emanuel, 80–82, 83, 117
 *Washington Crossing the
 Delaware*, 80–82, *81*, 138
 *Worthington Whittredge in his
 Tenth St. Studio*, ii
Liszt, Franz, 151
Little Miami River (Ohio), 75
Lockwood, Legrand, 146, 161
(London) *Daily News*, 107
Longfellow, Henry Wadsworth,
 85, 151
Long Island Sound, 153
Longworth, Nicholas, 78
Lorrain, Claude, 28, 29, 30
Louvre, 29
Ludlow, Fitz Hugh
 and Bierstadt, Albert, 130–35,
 143–44
 works by
 The Hasheesh Eater, 130
 Heart of the Continent, 144

Ludlow, Rosalie Osborne, 130,
 143. *See also* Bierstadt, Rosalie
 Ludlow
Lumberville, Pennsylvania, 99

M

Machachi, Ecuador, 103
Madison, James, 36
Magdalena, Rio (Columbia),
 91, 92
Malkasten (Germany), 83
Malkasten (Hudson River Valley),
 145, 145–46, *146*, 158, 169, 180
Manifest Destiny, 91
Mansfield, Mount (Vermont), 110
Maplewood, New Jersey, 163–65,
 178
Martin, John, 24
Massachusetts Bay Colony, 63
Maury, Matthew Fontaine, 91
Maverick, Peter, 11, 67
McEntee, Jervis, 163
McHenry, James, 139, 151
Mechanics Society, 64
Merced River (California), 129,
 133, 146
Metropolitan Museum of Art, The,
 xiv, *34–35*, *37*, *81*, *106*, *115*,
 120, *125*, *156*, *157*, 168–69,
 179, 180
Mignot, Louis R., 103–04
Milton, John
 Paradise Lost, 22
Monroe, James, 36
Morse, Samuel F. B., 14–16, 18,
 31–32, 69, 72, 140
Mount, William Sidney, 62–63, 76
 The Card Players, 77
Mountain Meadows Massacre, 111
Munich, Germany, 167
Museum of the City of New York,
 70, *109*

N

Naples, Italy, 84
Nast, Thomas, *48*
National Academy of Design, 15,
 22, 23, 31, 32, *32*, 35, 39, 50,
 53, 55, 57–62, 64, 68, 69–71,
 72, 74, 78, 80, 83, 85–86, 89,
 96, 97, 102, 110, 114, 121, 122,
 124, 130, 139–41, *140*, 142,
 152, 163, 165, 168, 177. *See also*
 New York Drawing Society
National Gallery (London, Eng-
 land), 28, 29

National Gallery of Art (Washing-
 ton, D.C.), *58*, *59*, *60*, *61*, *121*
National Intelligencer, 91
Natural Bridge, Virginia, 89
Newark, New Jersey, 11
New Bedford, Massachusetts, 82,
 83, 111
New Britain Museum of Art, *90*
New Haven, Connecticut, 89
New York City, 6–7, 11, 13, 31, 33,
 48, 50, 55, 84, 85, 88, 89, 96, 98,
 102, 106, 109, 116, 121, 122,
 128, 131, 136–38, 144, 168–69
New York Department of Parks, 179
New York Drawing Society, 14–15
New York Evening Post, 130
New York Herald, 108
New-York Historical and Philo-
 sophical Society, 15
New-York Historical Society, *40*,
 41, *42–43*, *44*, *45*, 111, *138*
New York *Mirror*, 8, 12
New York Times, 128
Niagara Falls, 26, 98
Noble, Rev. Louis Legrand, 66, 106
 After Icebergs with a Painter, 117
 *The Life and Works of Thomas
 Cole*, xiii
North Platte River, 112
Nursery and Children's Hospital,
 143

O

Occidental Hotel, 132
Olana (State Historic Site), xiii,
 152, 153–59, *159*, 179–80. *See
 also* Church, Frederic Edwin
Olmsted, Frederick Law, 157
Oregon Trail, 112–13
Otavalo, Ecuador, xiii
Overland Coach, 130
Overland Trail, 111

P

Palazzo Doria (Rome, Italy), 108
Palmer, Erastus, 179–80
Panama, 96
Panic of 1837, 50, 62
Paris, France, 102, 107, 167
Paris Exposition (1878), 168;
 (1889), 178–79
Paris Universal Exposition (1867),
 149–51, 152–53
Pennsylvania Academy of the Fine
 Arts, 5
Petra, Jordan, 151

Philadelphia, Pennsylvania, 2, 69,
 80, 165
Pichincha (Ecuador), 94
Pikes Peak (Colorado), 130
Pittsburgh, Pennsylvania, 3, 4
Platte River, 112
Plymouth Church, 76
Plymouth Colony, 63
Ponce de Leon Hotel (St. Augus-
 tine, Florida), 180
Popayan, Columbia, 94
Pope, John (General), 148
Poughkeepsie, New York, 130
Poussin, Nicolas, 29
Powers, Hiram, 78
 The Greek Slave, 78
Princeton College, 130

Q

Quito, Ecuador, xiv, 94, 103

R

Rainier, Mount (Washington), 135
Reed, Luman, 33–35, 38, 39, 111
Reed, Rev. Luman, Mrs., 57
Rembrandt, 29, 82
Reynolda House Museum of
 American Art, *ii*, *68*, *76–77*, *95*,
 123, *150*, *164*, *170*, *172*, *174–75*
Reynolds, Sir Joshua, 55, 86
Ries, Stan, *159*
Riobamba, Ecuador, 94, 103
Rip Van Winkle, 17, 47
Rockwood, George Gardner,
 110, *120*
Rocky Mountains, 112, *115*, 130,
 143, 162
Rogers, Samuel, 27
Roman Coliseum, 30
Rome, Italy, 30, 56–57, 83–84,
 108, 109, 111, 137, 153
Rosalie, Mount, 143
Rossiter, Thomas R., 102
Royal Academy, 26–28, 29
Ruskin, John, 86, 99
 The Stones of Venice, 141

S

Salas, Rafael, 94
Salt Lake City, Utah, 130–31
San Francisco, California, 132, 134,
 135, 162
San Francisco Chronicle, 162
Sangay (Ecuador), 103–04
Sangre de Cristo (Mountains),
 148–49

Sanitary Commission, 136–39
Sanitary Fair, 136–39, *138*
Santa Fe, New Mexico, 148–49
Savanilla, Colombia, 91
Scarborough, William, 78
Schroon Lake (New York), 51
Schroon Mountain (New York), 51, *52*
Scott, Sir Walter, 55
Seneca Chief, 7
Seventh Regiment, New York City National Guard, 116, 122, 171
Shasta, Mount (California), 134
Shoenberger, George K., 62
Shoshone, 114
Sicily, 57
Sierra Nevada (Mountains), 132, 160, *164*
Sioux, 112
Sisson family, 134
Sketch Club, 31–32, 35, 55, 62, 65, 72
Smith, Elizabeth V., 176
Smithsonian Institution, *62, 110, 124, 137, 144, 169, 173*
Society of American Artists, 168, 177
South Pass (Wyoming), 112–13
Spanish Steps (Rome, Italy), 30
Springfield, Ohio, 75
Stanford, Leland, 160–61, 162
Stein, John, 3–4
Steubenville, Ohio, 2, 3–4
Stewart, A. T., 162
Stewart, Mary Hicks, 180
Stillman, William James, 86
St. Johnsbury Athenaeum, *147*
St. Joseph, Missouri, 111–12
St. Louis, Missouri, 107
Stowe, Harriet Beecher
Uncle Tom's Cabin, 77
Stuart, Gilbert, 13, 36
Sturges, Jonathan, 63, 71
Stuyvesant, Peter, 55
Sully, Thomas, 5
Sunnyside, 85, 145. *See also* Irving, Washington
Swedenborg, Emanuel, 177
Sweetwater River (Wyoming), 112

T
Talbot, Charles, 39
Taormina, Italy, 57
Tenth Street Studio Building. *See* Artists' Studio Building
Tequendama, Falls of (Colombia), 93
textile industry, 2
Thackery, William Makepeace, 72
Vanity Fair, 72
The Hague, The Netherlands, 82
Thomson, John Alexander, 49–50, 54
Thoreau, Henry David, 85
Titian, 29
Trenton, New Jersey, 69
Trumbull, John, 7–8, 11–12, 13, 14, 15, 26, 85
Declaration of Independence, 11
Turner, Joseph M. W., 27, 28–29, 107, 139
The Rise of the Carthaginian Empire, 28, 30, 33
Ulysses Deriding Polyphemus, 27
Twain, Mark (Samuel L. Clemens), 107

U
Unitarian Church, 72
Universal Exposition of Fine Arts, 124
Utes, 148

V
Vanderbilt, 109
Vaux, Calvert, 157
Velasquez, 29
Vesell, Elliot S., xiii, xiv
Victoria, Queen, 151
Vinegar River (Colombia), 94
Virginia City, Nevada, 132
Viva, 91

W
Wadsworth, Daniel, 12, 57, 63, 64, 88
Wadsworth Atheneum Museum of Art, *9*, 57, 63, 64, *87*, 88
Ward, Samuel, 56, 71
Warwick, New York, 149, 171

Washington, George, 36, 80, *81*
Waterville, New York, 169
Watkin, Sir Edward, 121
Watkins, C.W., 129
Wells, Mr. and Mrs. Bazaleel, 3
West, Benjamin, 13, 26, 78
Death on a Pale Horse, 133
White Mountains (New Hampshire), 20–22, 70, 111
Whitney, Josiah Dwight (surveying group), 161
Whitney, Mount (California), 161–62
Whittredge, Worthington
and Achenbach, Andreas, 78, 79–80
in American Southwest, 148–49
and Artists' Studio Building, 167, 176
autobiography of, xiii
and Beecher, Henry Ward, 76–77
and Bierstadt, Albert, 82–83
birth of, 74–75
and Carson, Kit, 148–49
and Centennial Exposition, 165
in Charleston, West Virginia, 77
children of, 149
and Church, Frederic Edwin, 180
in Cincinnati, 75, 76, 77–78, 110
and Civil War, 116–17
daguerreotype studio of, 75–76
in Düsseldorf, 74, 79–82
European paintings of, 108
and Gifford, Sanford, 83–84, 110, 122, 153, 162–63
as house painter, 75
in Indianapolis, 75–76
and Leutze, Emanuel, ii, 80–82
memoirs of, 181
and National Academy of Design, 78, 122, 163, 165, 168
in New York City, 116–17, 136
portrait painting, 75, 77
portraits of, *ii, 110*
in Rome, 84, 108–09
as a trapper, 75
wife of (*see* Foot, Harriet

Euphemia)
works by
The Old Hunting Grounds, 122, *123*, 151
View on the Kanawha, Morning, 78
Wight, Peter B., *140*, 141
Wilkes, Charles, 24
Williams, Stevens, Williams & Company, 99
Wind River (Wyoming), 113, 114
Winnipesaukee, Lake (New Hampshire), 20
Winthrop, Theodore, 106, 128

Y
Yosemite Falls (California), 129
Yosemite Valley (California), 129, 132, 133, 143, 146, *147*, 161
Young, Brigham, 131
Ysapan, Ecuador, 104